#CosplayisforEveryone

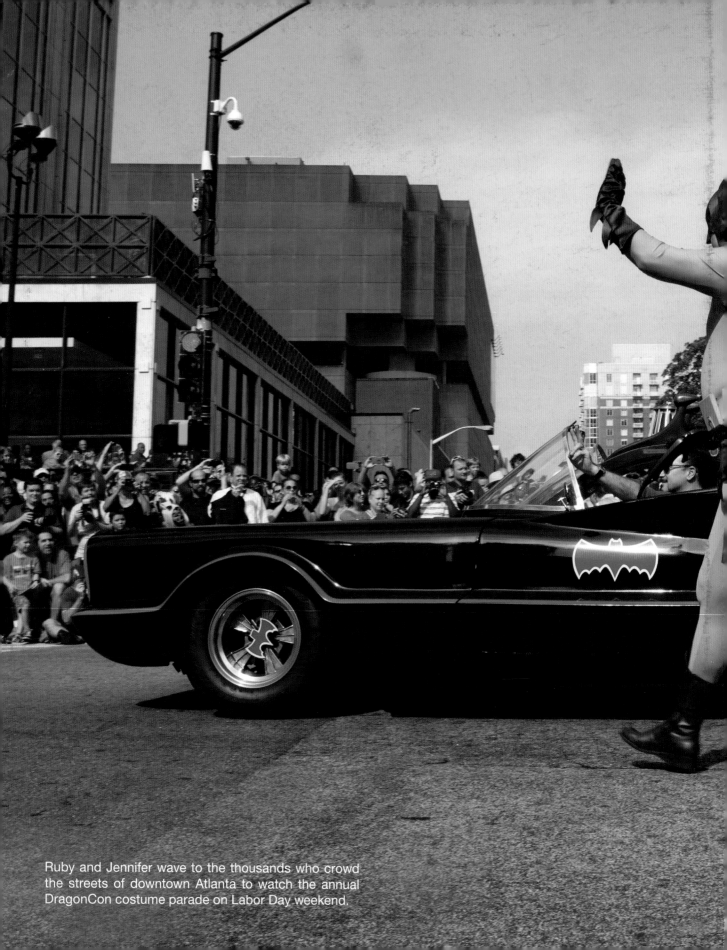

Ruby and Jennifer wave to the thousands who crowd the streets of downtown Atlanta to watch the annual DragonCon costume parade on Labor Day weekend.

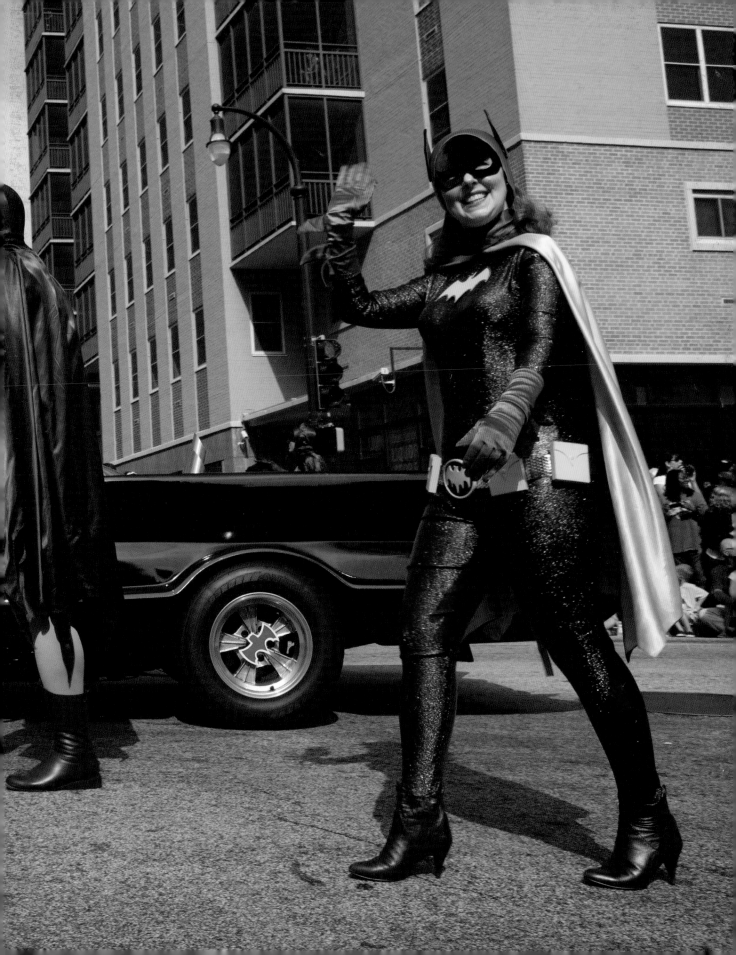

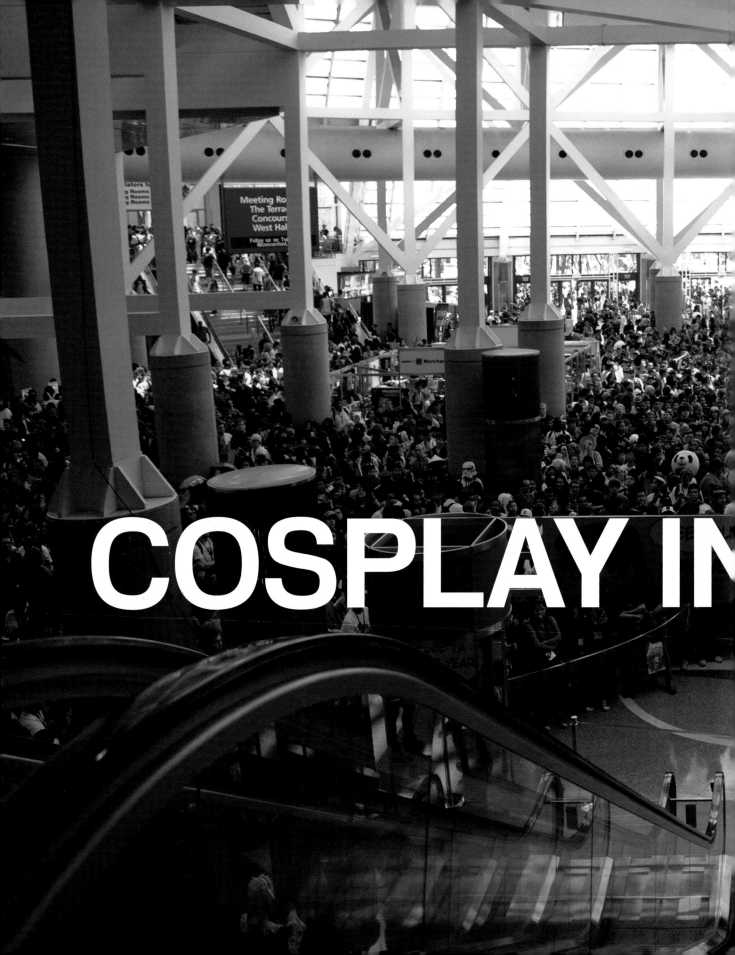

COSPLAY IN

I AMERICA V2

PHOTOGRAPHS BY

Ejen Chuang

ESSAYS BY

Andrea Letamendi, Ph.D

Liz Ohanesian

SHIKARIUS

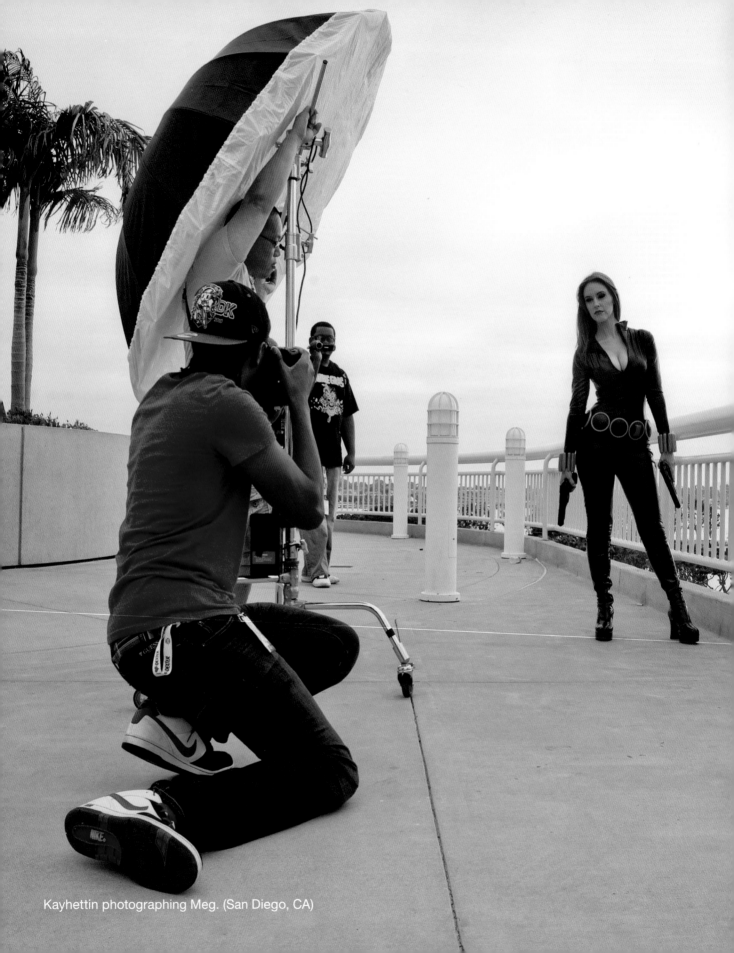

Kayhettin photographing Meg. (San Diego, CA)

CONTENTS

HOW COSPLAY CAN CHANGE LIVES

LIZ OHANESIAN

Ginger Burton remembers the first anime convention she attended. It was Anime Expo back in 2007. While Burton knew about anime, she was unfamiliar with cosplay.

Cosplay is when people dress up in costumes, frequently based on pop culture characters, for fan events. The history of cosplay goes back decades and is tied to conventions catering to fans of science fiction, fantasy, comic books, etc. As conventions have become more frequent, and more popular, cosplay has blossomed into a popular pastime. Some people make their own costumes. Others buy them. Few people have become professional cosplayers, most do it as a hobby.

In 2007, cosplay was still relatively unknown outside of the convention scene. "I didn't know that people dressed up and went to conventions," Burton says. "It was a whole subculture that I didn't know existed."

At first, Burton wasn't interested in showing up at the convention in costume. She asked her friend if she could just go in regular clothes. "My friend said, people will laugh at you," Burton recalls, adding, "I think she just said that to get me to dress up."

Of course, there are plenty of people who show up at convention in day-to-day wear and suffer no consequences. However, that little push led Burton, then a fashion design student, deep into the world of pop culture costumes. She dressed as Link, the hero from the famed video game franchise *Legend of Zelda*. "Looking back, it wasn't that great," says Burton. The fabrics she chose weren't the best and the collar she made didn't turn out quite right. None of that mattered

though. People still asked for photos. "They still recognized who I was," she says.

That year at Anime Expo was more than just a fun outing in costume. "It motivated me to keep trying new things," says Burton.

Since then, cosplay has become a major part of Burton's life. She once organized her own cosplay ball and occasionally runs costume-making competitions at conventions. She is part of the group Chocolate Covered Cosplay and competed in the World Cosplay Summit. She sits on convention panels and poses for a lot of photos. Plus, as a side job, Burton dresses as costumed characters for children's birthday parties.

Music fans talk about concerts as life-changing experiences. The first concert can often be a time where young people realize that there is a world beyond their neighborhoods, their schools. Suddenly, they're surrounded by people who share the interests that make them feel like misfits in day-to-day life. Conventions are like that too. People travel from far off locations to make offline connections with others who enjoy the same pastimes. One of those is cosplay.

Of course, the friendships go beyond the initial conversation starter. "It's not about the costuming or interests," says Andrew Valenzuela of his convention friends. "They're just nice people to be around." A three-year veteran of the cosplay scene, Valenzuela met new pals while seeking out help for his own costumes. The bonds that he has formed are strong; several fellow cosplayers traveled to attend the San Diego resident's wedding.

Cosplay can bring people together. Take Kit Quinn and Steven Meissner as an example. The Los Angeles-based couple have a photo of their first meeting at San Diego Comic-Con. He was dressed as The Monarch, a villain from *The Venture Bros.* She was dressed as Dr. Mrs. the Monarch.

Quinn says she feels fortunate to have a hobby that involves socializing with people. "I wonder how I would meet people if I weren't a cosplayer," she adds. "I really have no idea how adults make friends when you're not in school or have a job in an office."

For Quinn and Meissner, there's a professional aspect to cosplay as well. Quinn is an actor and recently starred in the cosplay-centric web series, *Sweethearts of the Galaxy.* Meissner works full-time making commissioned props and accessories for cosplayers. He runs his business through Facebook and most of his customers find him through word-of-mouth. The bulk of his customers are people he has never met. Some of those customers have become friends.

For those who make their costumes, the challenge can be exhilarating. Quinn was just about to start college when she went to San Diego Comic-Con dressed as Sailor Mars, a character from the popular anime *Sailor Moon.* "I made it as best as I could for my very first year making costumes." She bought a cheerleading skirt, added some extra stones to a tiara she found and made a bow out of fabric scraps. "It was very amateur," she says, "but it was awesome."

Since then, Quinn has been upping the ante on her costumes, choosing outfits that are more difficult to complete and learning new skills along the way.

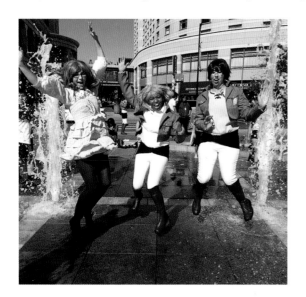

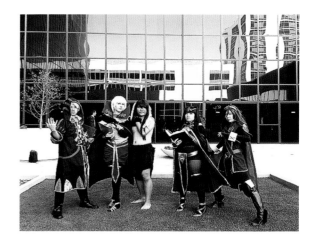

Some of her standouts include Maleficent, which required working with leather as well as corsetry, and the Baroness from G.I. Joe, Quinn's first attempt at making a breastplate.

Last summer, Quinn and two friends turned up at Anime Expo as the villainous Amazon Trio from *Sailor Moon.* Quinn was Fish Eye, complete with a thickly padded light blue suit. On the Monday before the convention, she made a mistake that would require starting over again. "Technically easy, but, still, so labor intensive," she says. Quinn enlisted friends to pull a couple all-nighters with her as they sewed and padded the costume. At the actual event, the costume proved to be a little too warm for the blazing Los Angeles heat and the crowded convention center. Quinn grew ill. "I wasn't prepared in the morning for how hot it was going to get and, by the time afternoon hit, it was too late and we were desperately trying to prop me full of $4 bottles of water."

Quinn says she felt ill for the next day or two. "I looked it good in it, so it's cool" she says.

People cosplay for a lot of different reasons. Some like the art of making the costume. For others, the performance aspect that comes with dressing up as heroes and villains is appealing. When people cosplay, sometimes the characters have a deep, personal significance.

Chris Riley, a 30-year-old from Los Angeles, started out cosplaying his character, Captain Lucky. Since then, he's gone on to dress up as established characters. He was part of the Amazon Trio at Anime Expo that included Kit Quinn. Riley has worn mashup costumes, like one that was a cross between Daryl Dixon from *The Walking Dead* and *Peter Pan.* He was also recently part of a gender-bent *Sailor Moon* cosplay group based on a piece of fan art that depicted the sailor scouts as

guys. The costume that is most significant for Riley, though, is a gender-bent version of *X-Men* character Emma Frost.

Riley, who is gay, was frequently bullied during his adolescence. For him, comic books were an escape. One of his favorite characters was Emma Frost and he would draw her repeatedly. "One time, in school, one of the girls was bullying me," he says. "She was trying to say that she was being harassed by Emma Frost's image so I got sent to the principal's office. I literally spent one or two hours in the principal's office, while he basically convinced me that everything that had to do with comic books and superheroes were evil."

For Riley, portraying Emma Frost as an adult is a way of reclaiming a part of his identity. "I took my power back," he says. Riley says that the styles of costumes he has chosen, often skimpy, are a response to the way he was treated as a youngster. "My costumes, my artistic expressions were so hyper-sexualized," he says of his early work. "Looking back on that, I really think it's because growing up in those religious schools and being gay, I have had to be become completely desexualized in order to just survive. Otherwise, I would get beaten up again or I would be an embarrassment

to my family and hurt them and that's something that I didn't want to do."

Cosplay gives people the chance to express themselves in an environment where they are appreciated. It's not always a safe space. Recently, there has been a lot of discussion as to how to curb harassment of cosplayers at conventions. Online, trolling and other related bad behavior are problems that cosplayers try to curb within their communities. Still, there's a camaraderie between cosplayers that withstands the pitfalls of the hobby.

Jarod Nandin started cosplaying at the end of the 1990s. He took a break from the hobby, but returned in full force when he started attending conventions as a minor *South Park* character known as Jenkins, the Griefer or "that which has no life." His costume was a hit, both at events and online. "It's part of an expression of my fandom," says Nandin. " It's always going to be something that I want to do."

While there may be times where he doesn't put on a costume and hit up cons, it's not something that he imagines quitting. "I am never going to stop being a geek, so I will probably never stop cosplaying." ∎

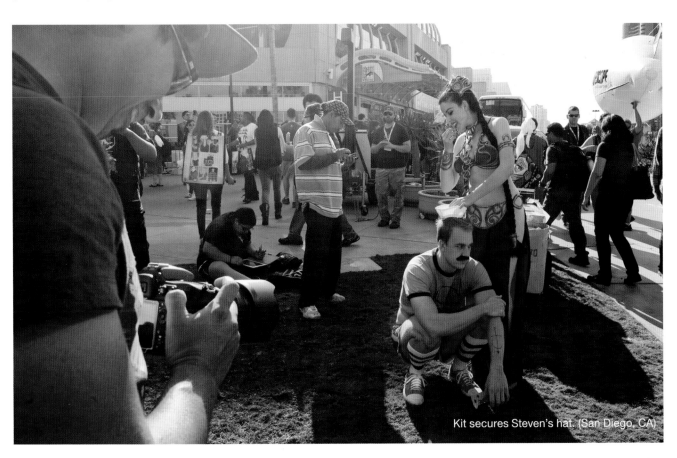

Kit secures Steven's hat. (San Diego, CA)

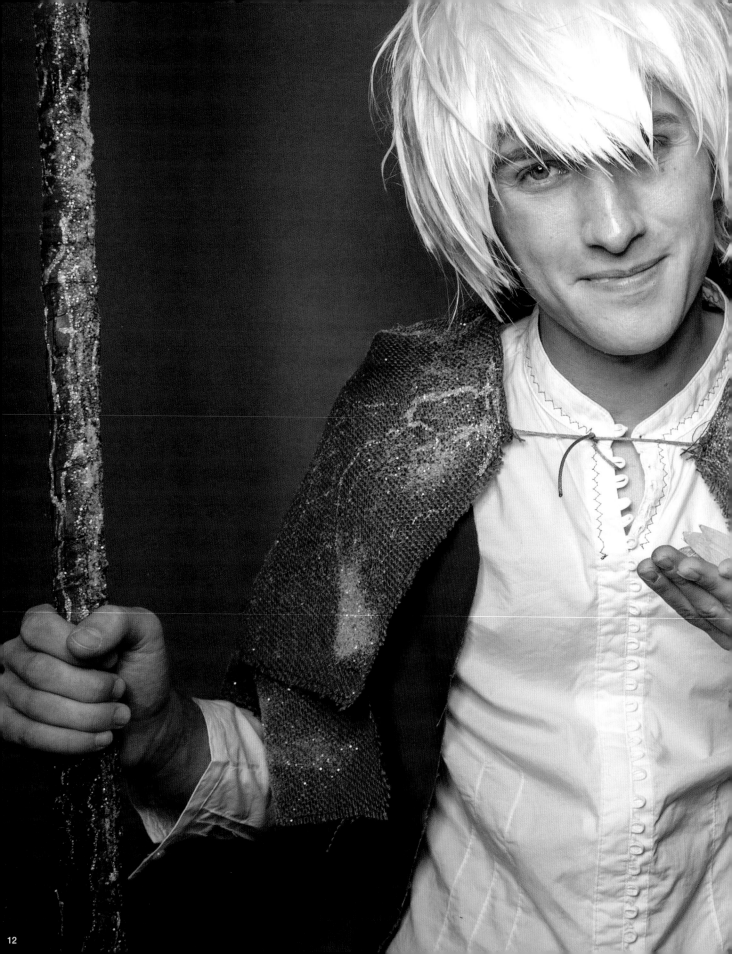

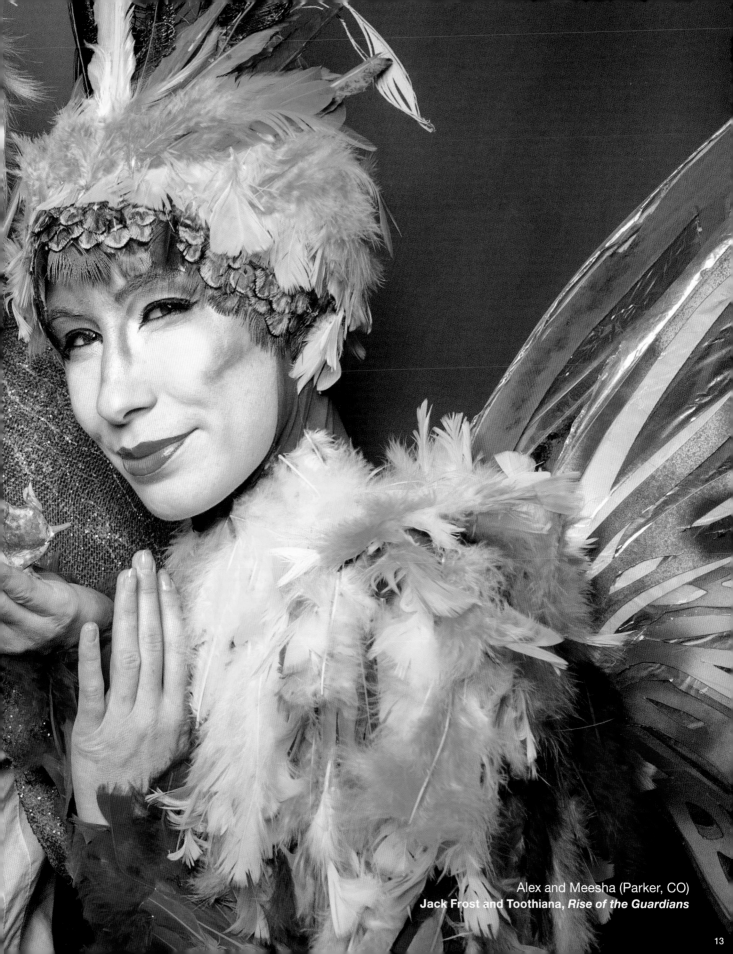

Alex and Meesha (Parker, CO)
Jack Frost and Toothiana, *Rise of the Guardians*

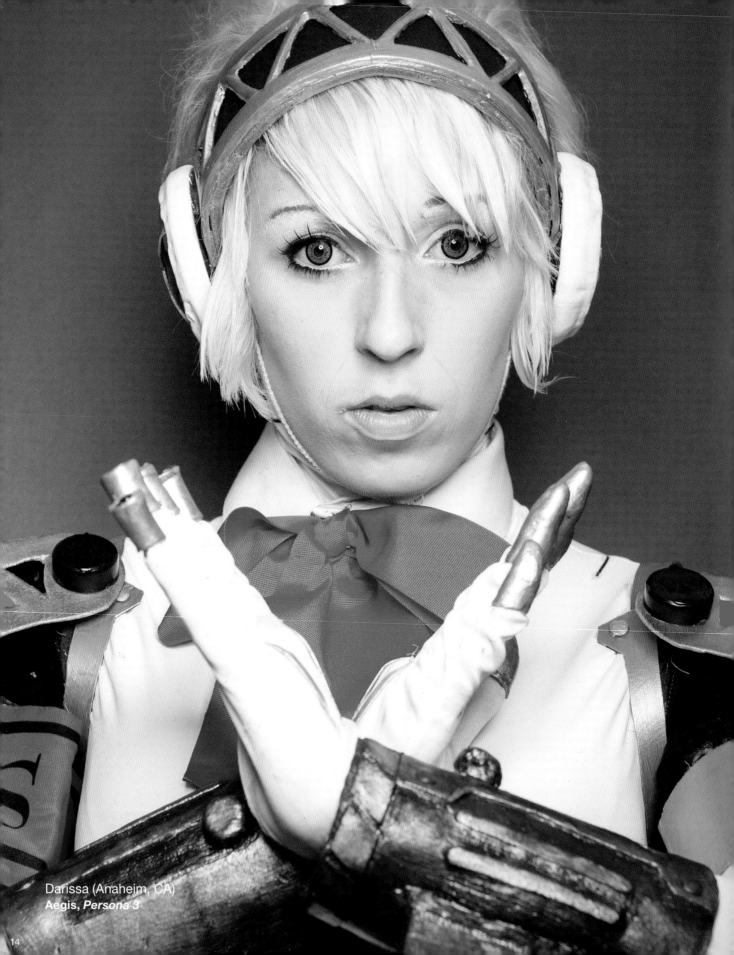

Darissa (Anaheim, CA)
Aegis, *Persona 3*

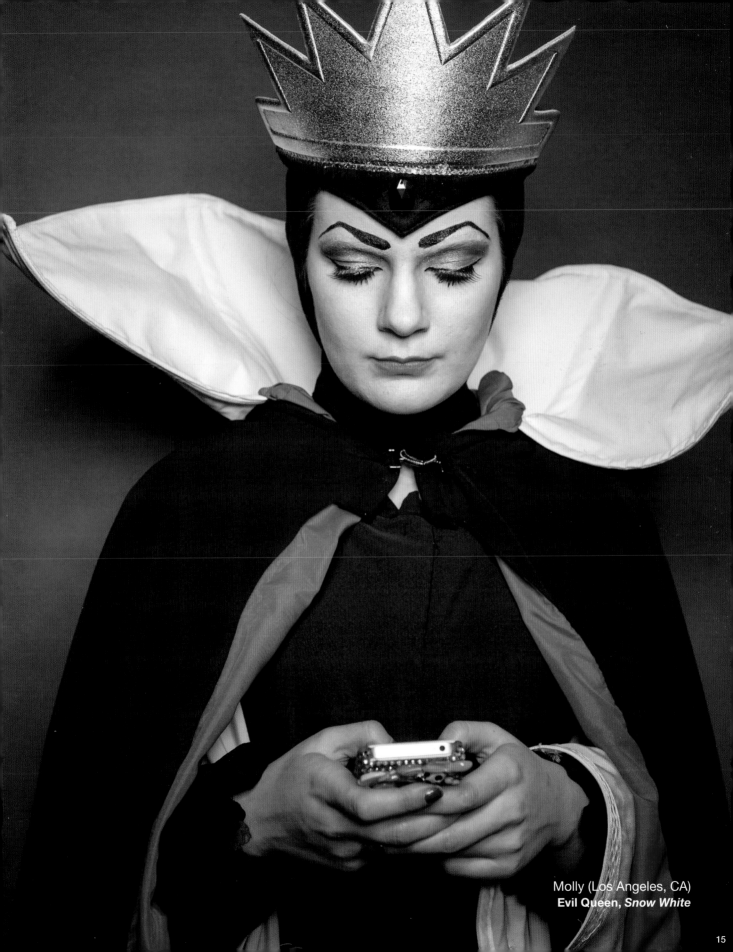

Molly (Los Angeles, CA)
Evil Queen, *Snow White*

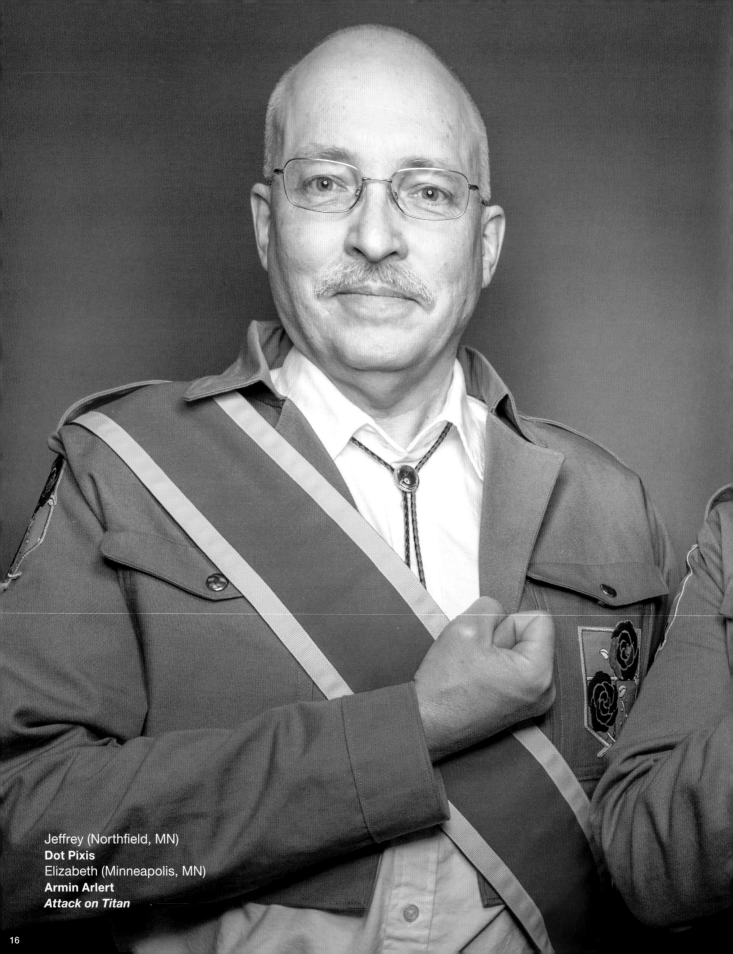

Jeffrey (Northfield, MN)
Dot Pixis
Elizabeth (Minneapolis, MN)
Armin Arlert
Attack on Titan

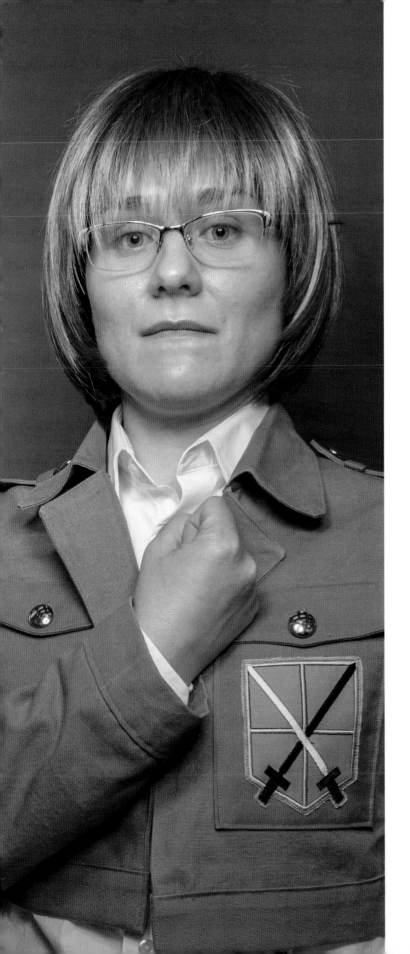

"It has sometimes made me sad that there aren't more people of my generation enjoying the convention experience. Just because you're older doesn't mean you should stop trying new things in life.

Earlier in my life, as a teenager, I observed that as the people around me aged they seemed to stop in place and tended to dwell more and more in the past. Perhaps this is a natural (or at least typical) function of aging.

I, myself, didn't want to end up stagnant like that, so I've cultivated an open-minded, inquisitive mindset over the years. There is so much in the world to enjoy and have fun with, new things to learn, people to meet and experiences to try that I'll never be able to get to them all. So I say to oldsters out there why not try it and have a great time doing it?"

Jeffrey

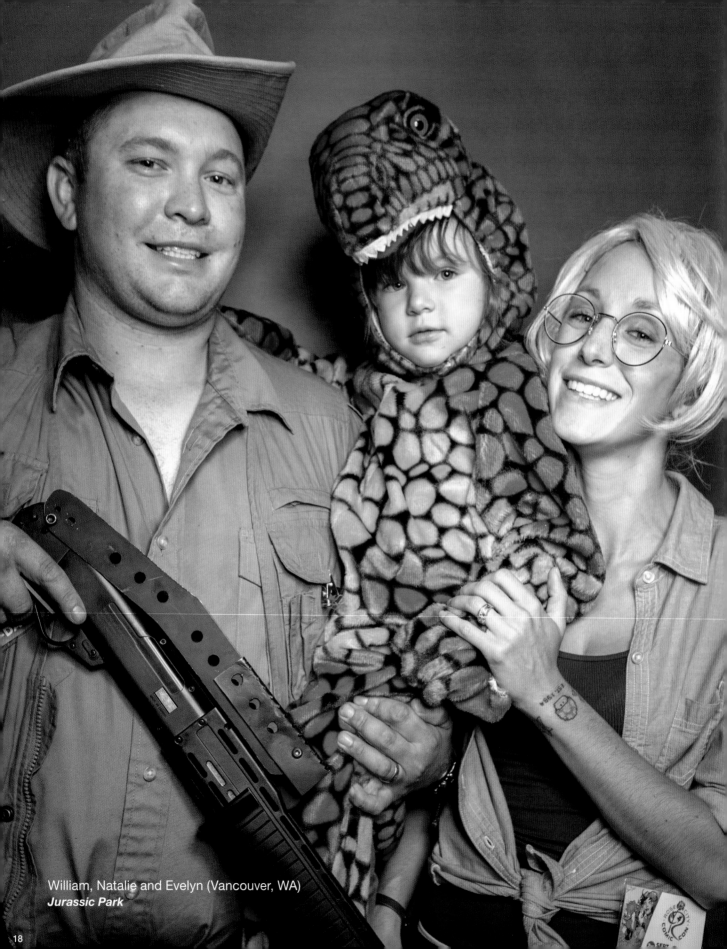

William, Natalie and Evelyn (Vancouver, WA)
Jurassic Park

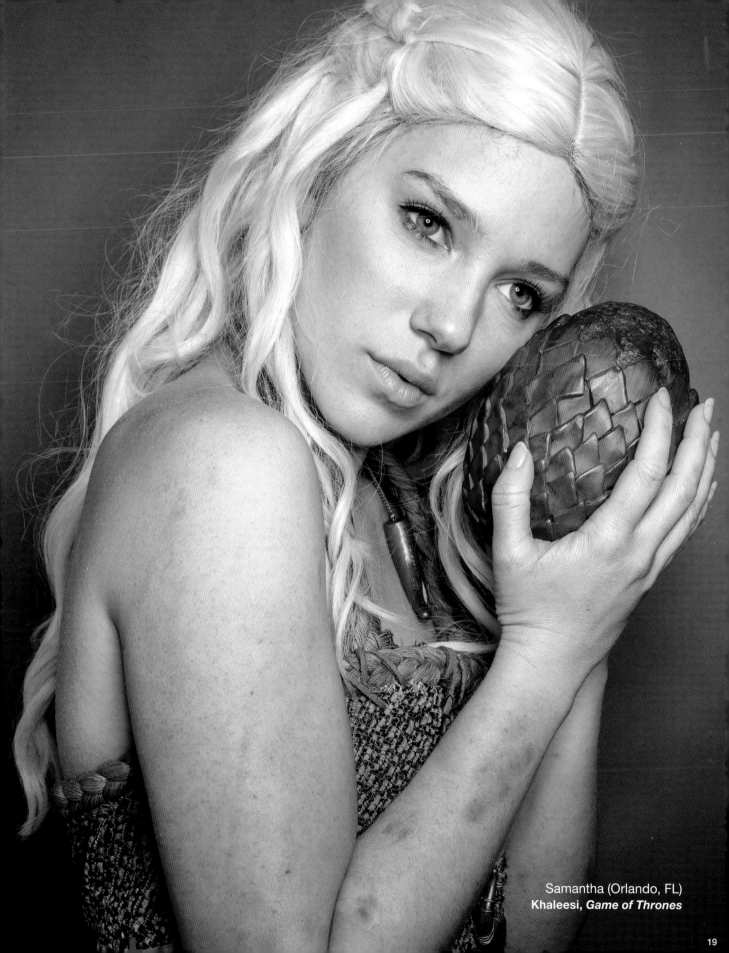

Samantha (Orlando, FL)
Khaleesi, *Game of Thrones*

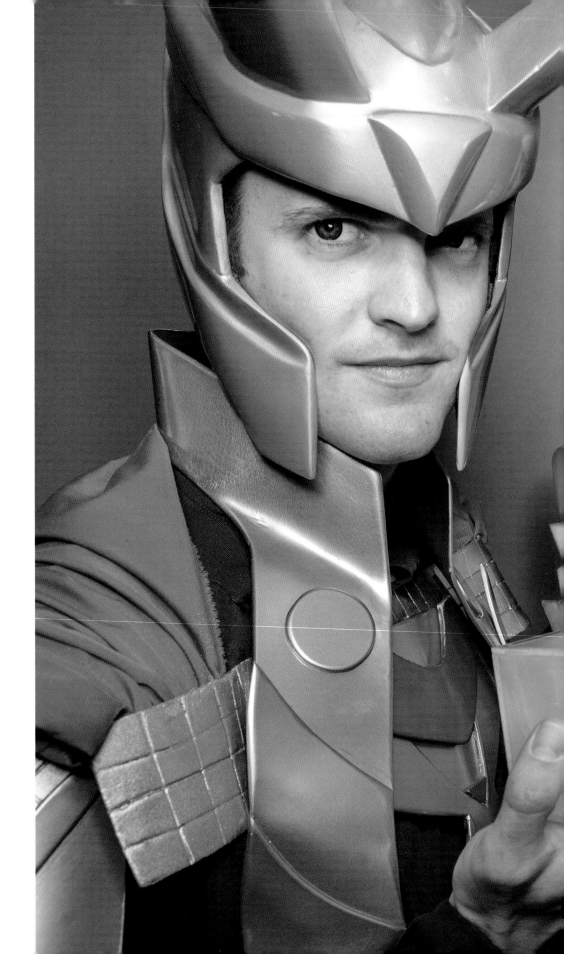

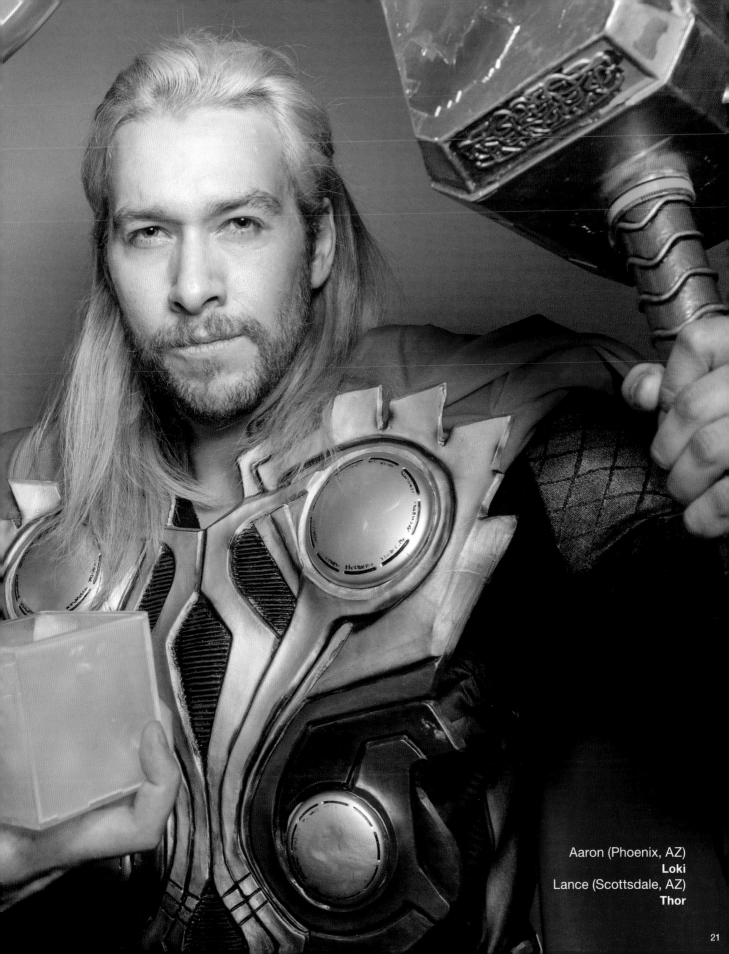

Aaron (Phoenix, AZ)
Loki
Lance (Scottsdale, AZ)
Thor

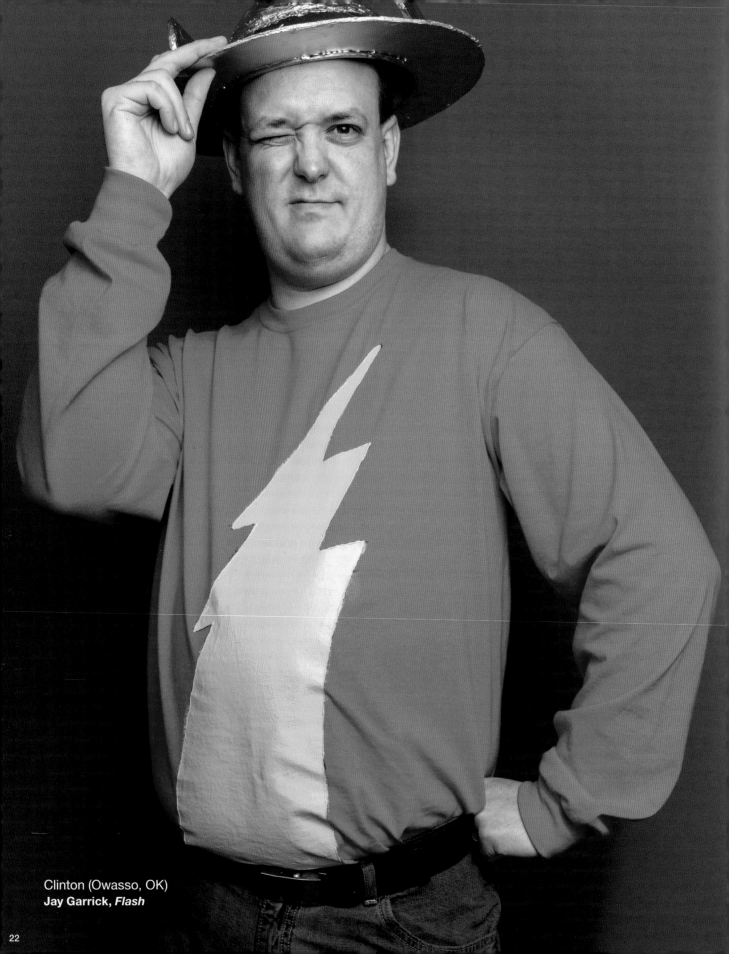

Clinton (Owasso, OK)
Jay Garrick, *Flash*

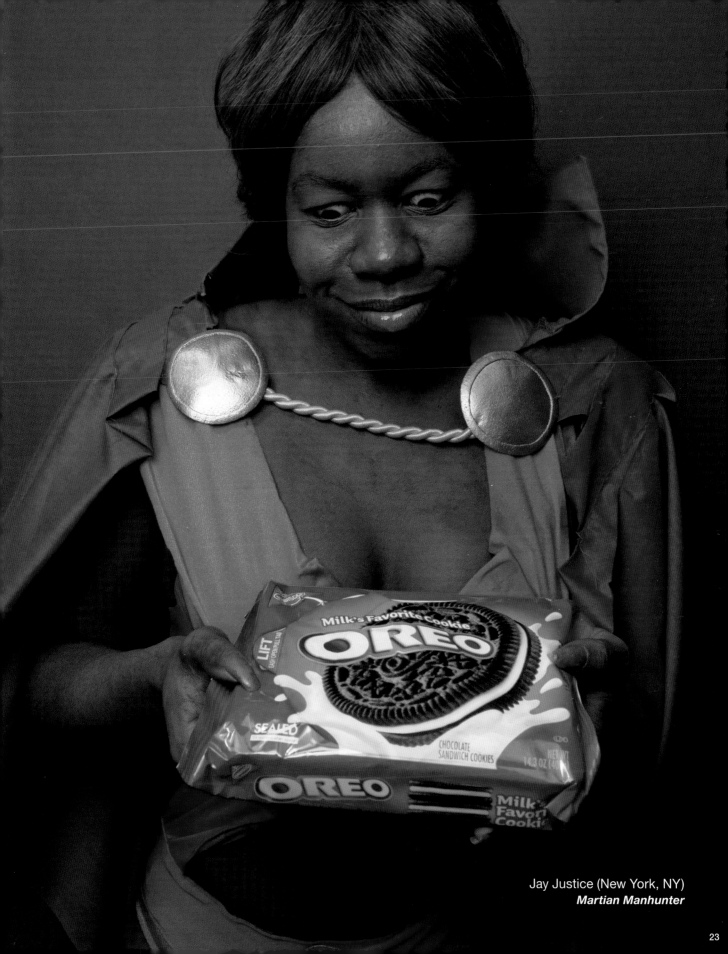

Jay Justice (New York, NY)
Martian Manhunter

JIN: I went to a cosplay meet up at Triangle Mall in Raleigh, NC. I went as a zombie Umbrella Soldier from Resident Evil. Linda at the last minute attended after being invited by one of her friends. She has a thing for zombies so naturally when she saw me instant attraction.

LINDA: Nevertheless, I did come across him-- "Zombie Hunk" whom I nickname at the time. I felt quite flustered and attracted to him. I tried to talk to him, but it was quite hard to do so with him being surrounded by a crowd of girls.

JIN: Later that night I had gotten a friend request from her on Facebook. She somehow tracked me down. Although, after I accepted her friend request she didn't really say anything to me for almost a week until I decided to break the ice and make the first move.

LINDA: I added him but waited it out for a week to try to speak to him. Luckily, he messaged me - and hence forth we been together 4 yrs together and forever more.

JIN: And BAM, 4 years later we're still dating.

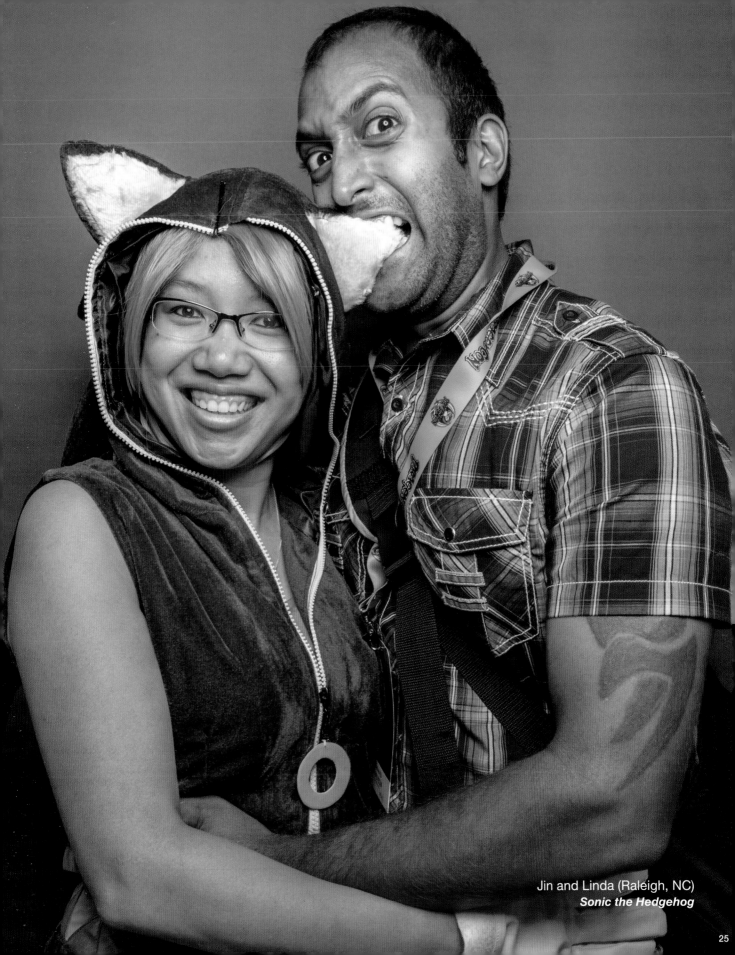

Jin and Linda (Raleigh, NC)
Sonic the Hedgehog

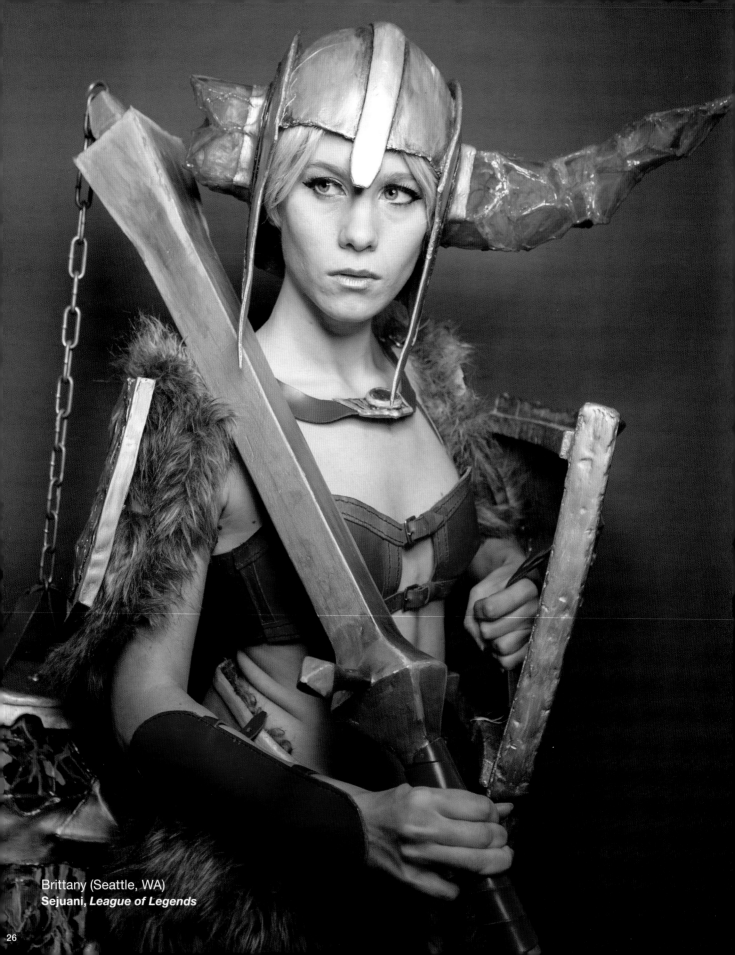

Brittany (Seattle, WA)
Sejuani, *League of Legends*

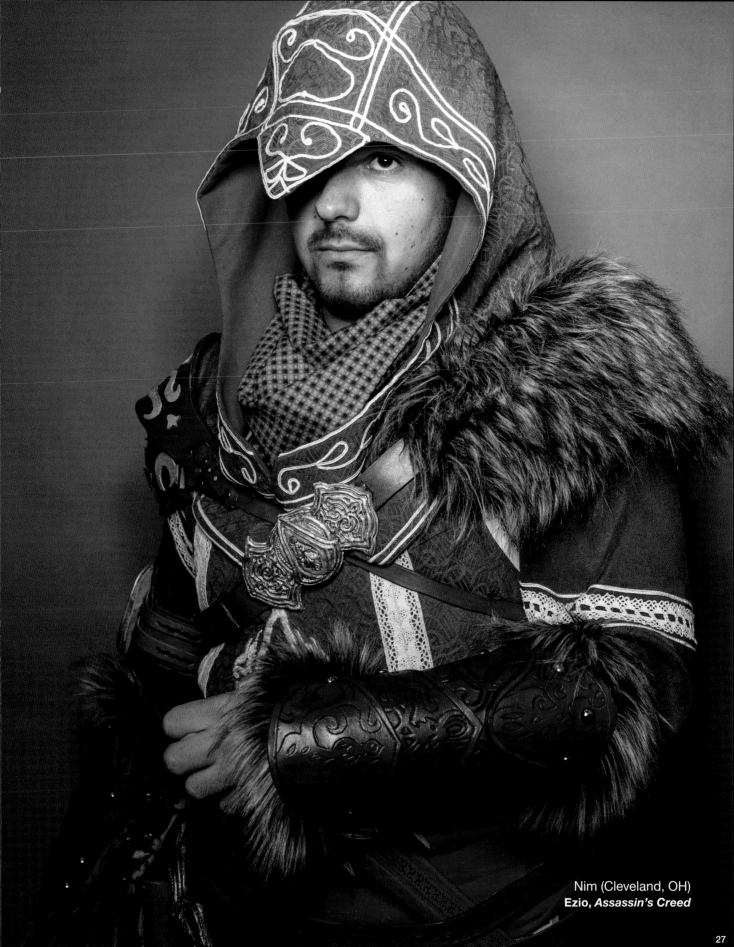

Nim (Cleveland, OH)
Ezio, *Assassin's Creed*

Stella Chuu and Jeff (Astoria, NY)
Alisa Bosconovitch, *Tekken 6*

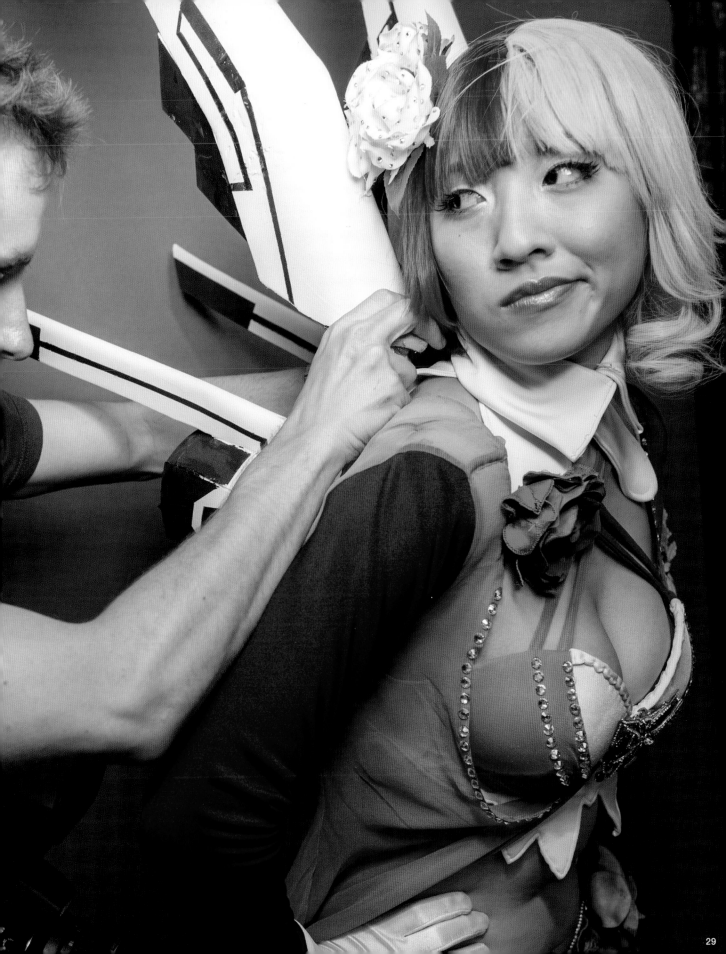

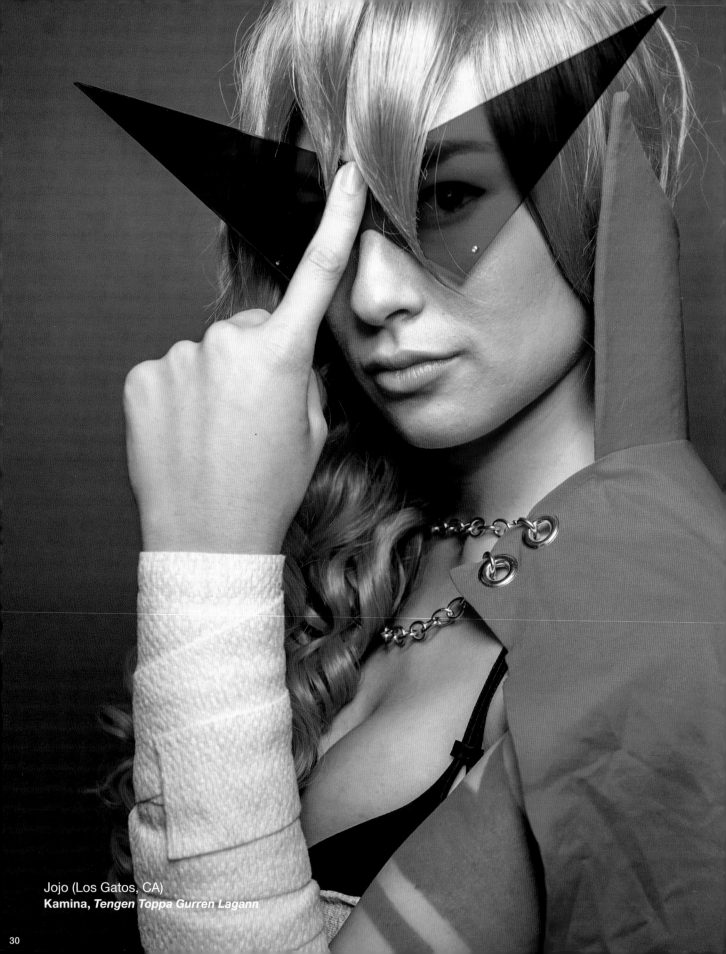

Jojo (Los Gatos, CA)
Kamina, *Tengen Toppa Gurren Lagann*

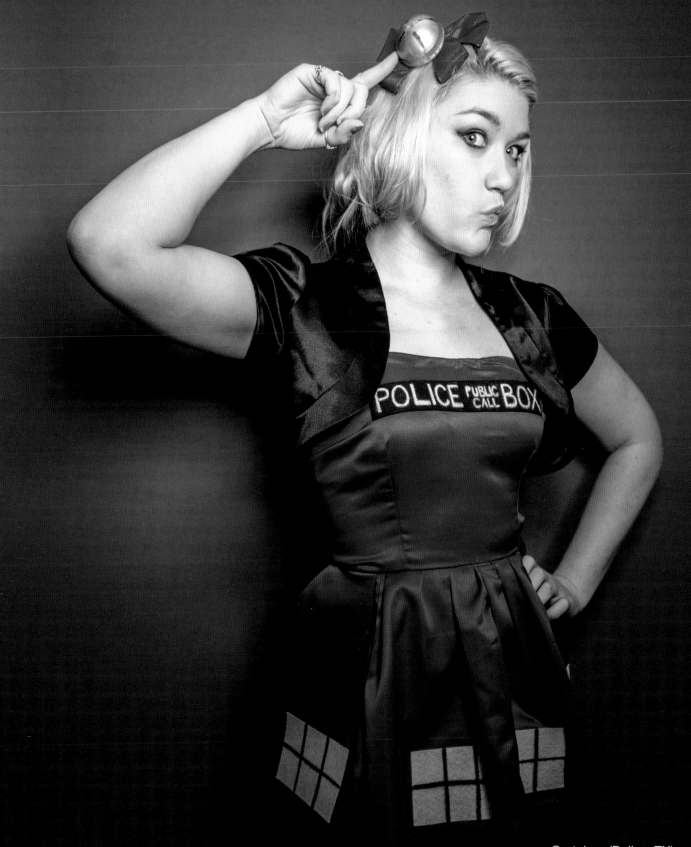

Gretchen (Dallas, TX)
Doctor Who Tardis dress

Ryan (Portland, OR)
9 from 9

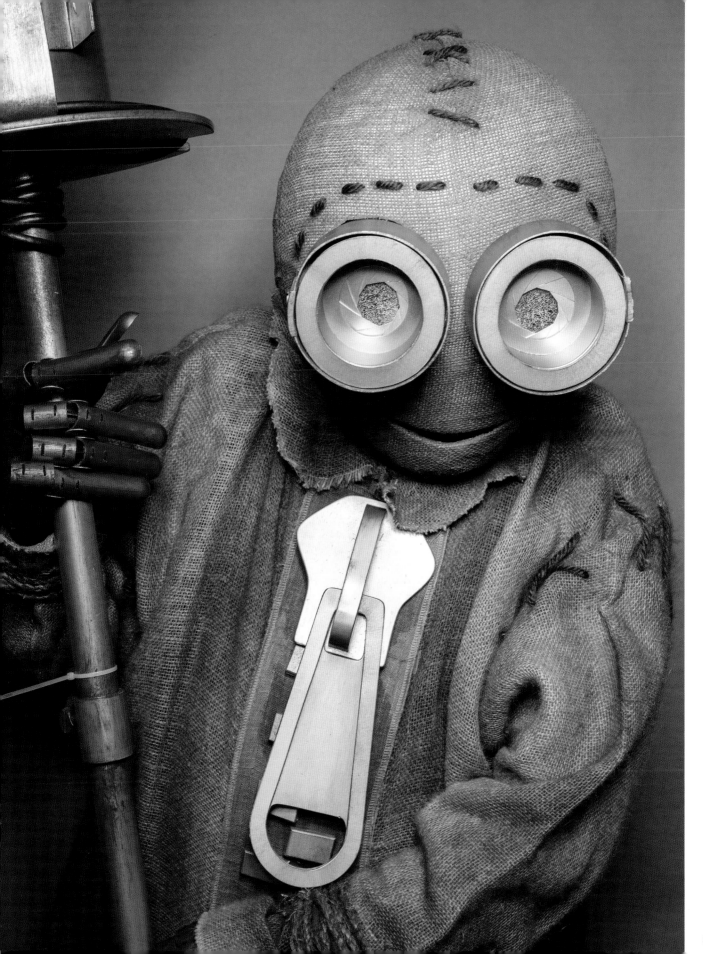

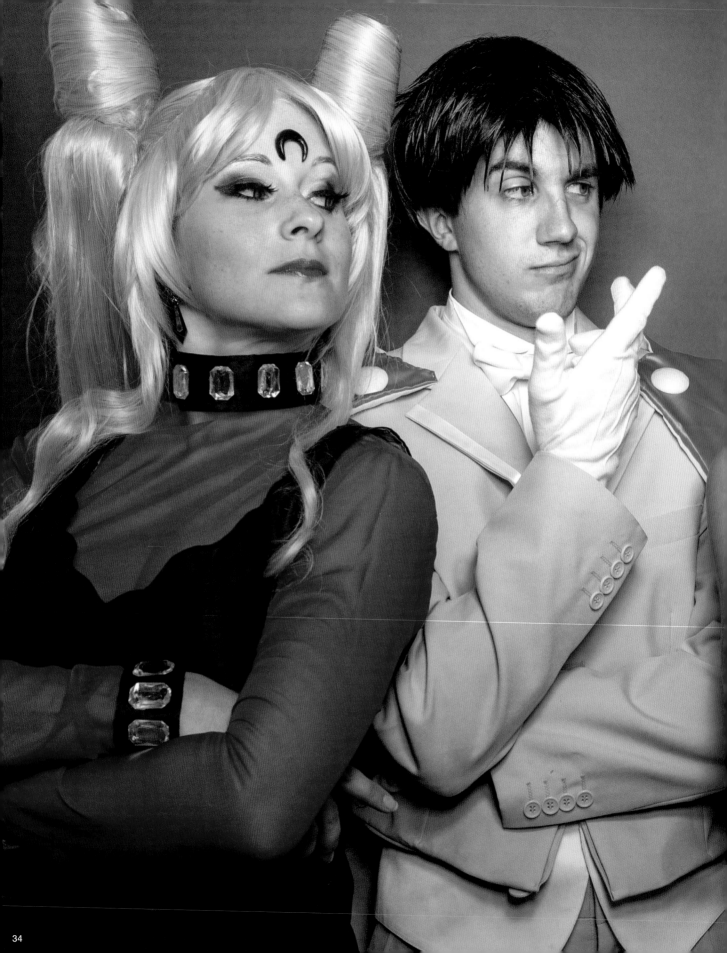

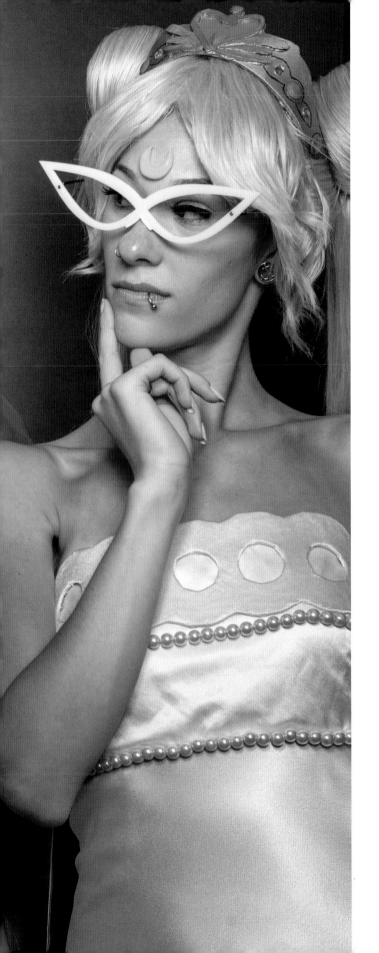

Miriam (Warwick, RI)
Black Lady
Ryan (Southington, CT)
King Endymion
Tarachu (Waterbury, CT)
Neo Queen Serenity
Sailor Moon

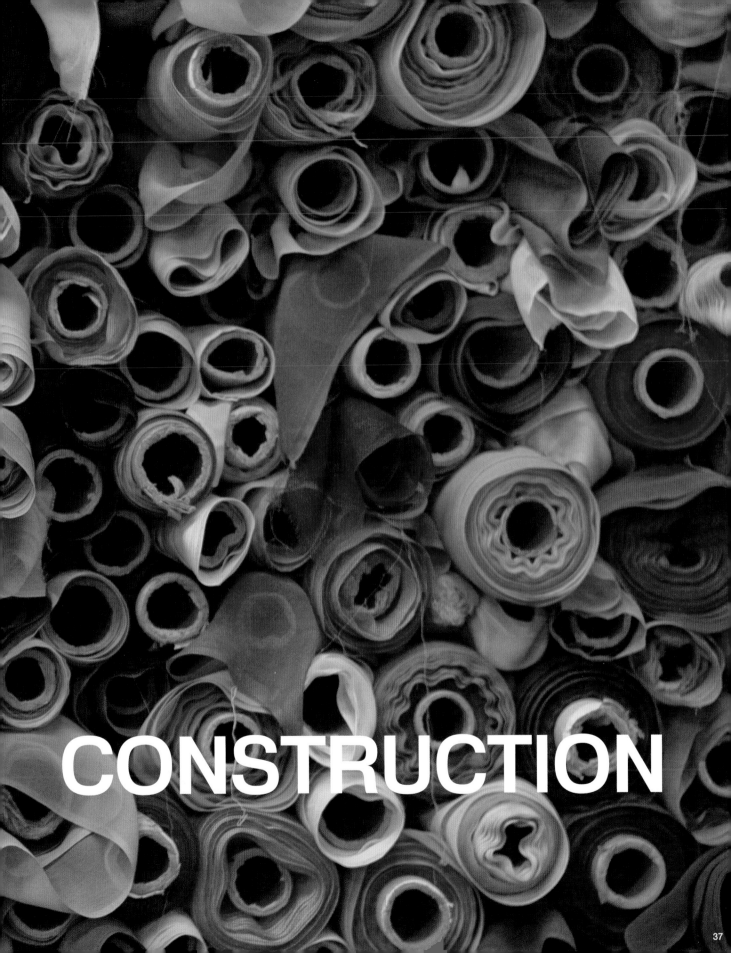

CONSTRUCTION

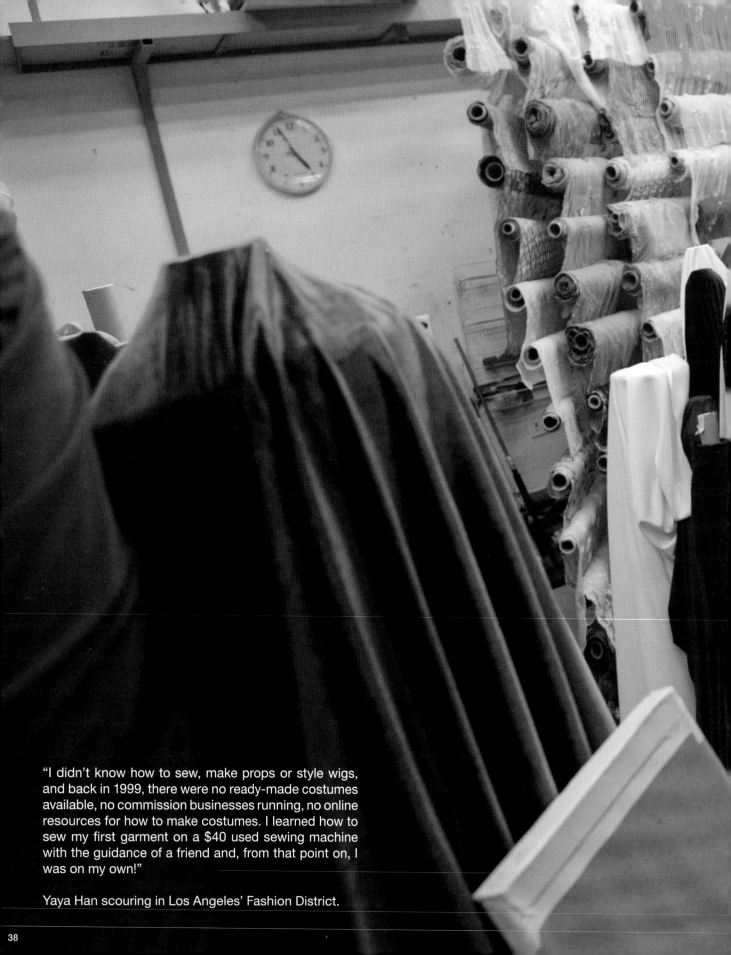

"I didn't know how to sew, make props or style wigs, and back in 1999, there were no ready-made costumes available, no commission businesses running, no online resources for how to make costumes. I learned how to sew my first garment on a $40 used sewing machine with the guidance of a friend and, from that point on, I was on my own!"

Yaya Han scouring in Los Angeles' Fashion District.

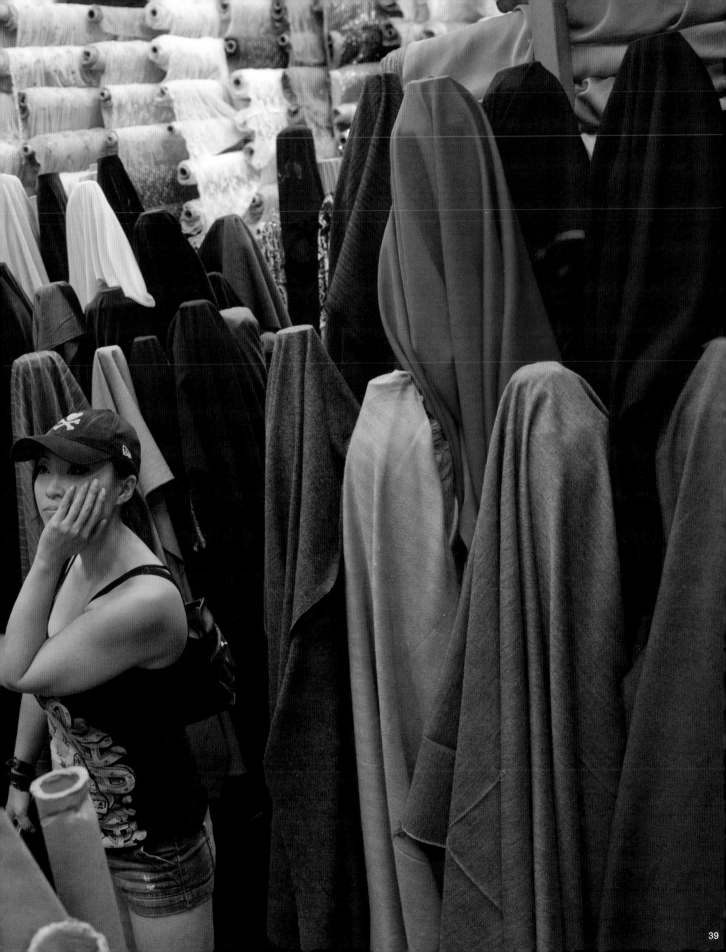

"Within the 10 years of my cosplay experience, my mother took a gander at one of my costumes and was surprised to see how far I've taken the hobby of mine, further into something she'd never thought I'd go to. She said to me, 'You know you've passed me in skill in the sewing department, right?'"

Brandon (Orlando, FL)

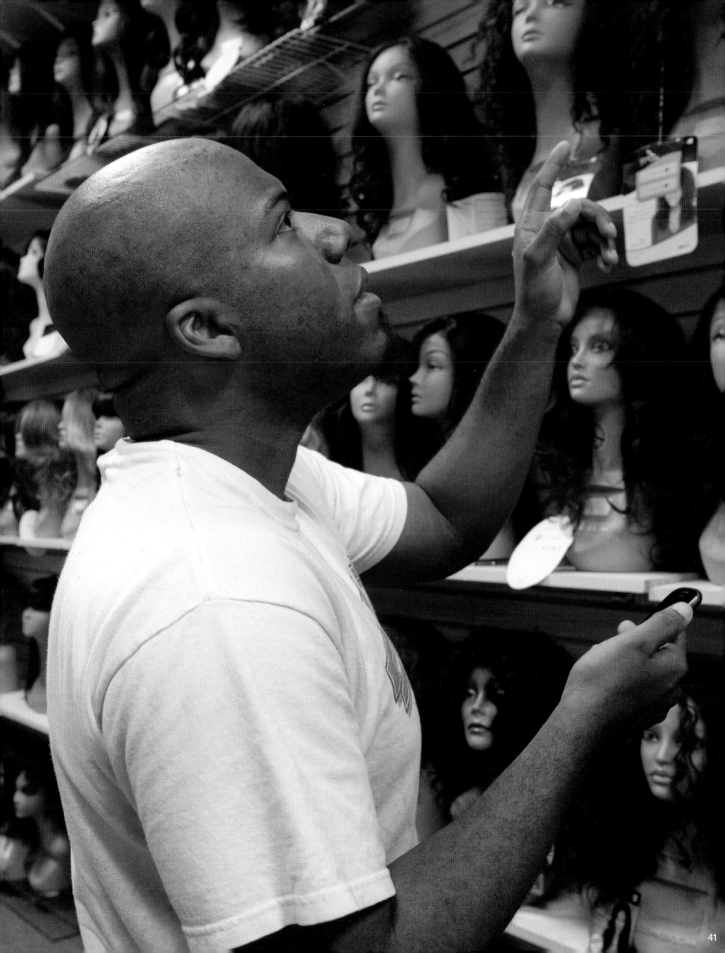

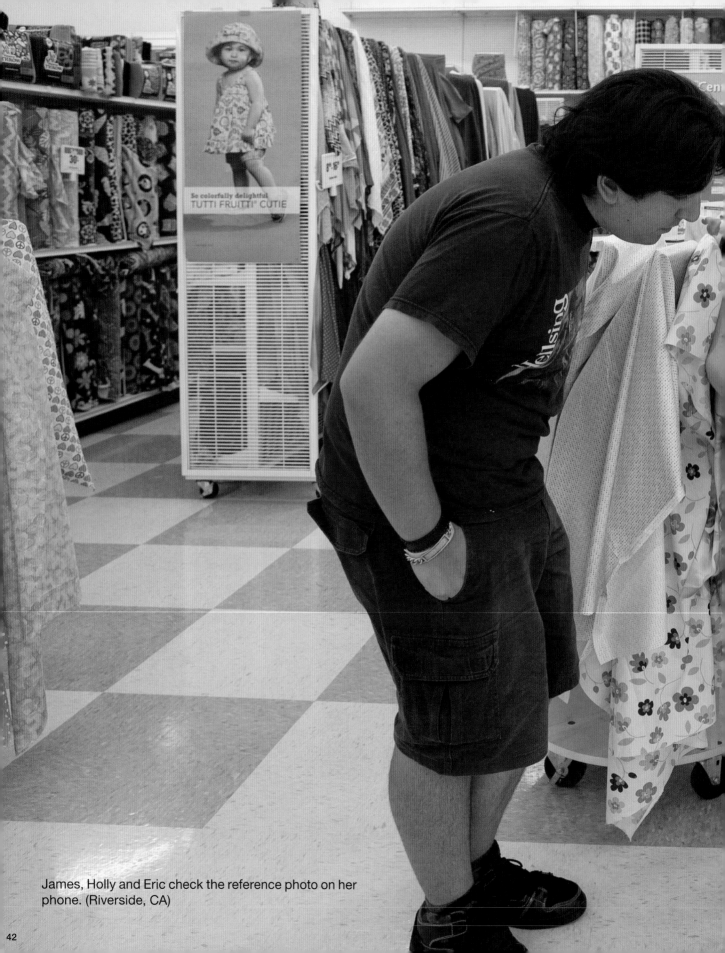

James, Holly and Eric check the reference photo on her phone. (Riverside, CA)

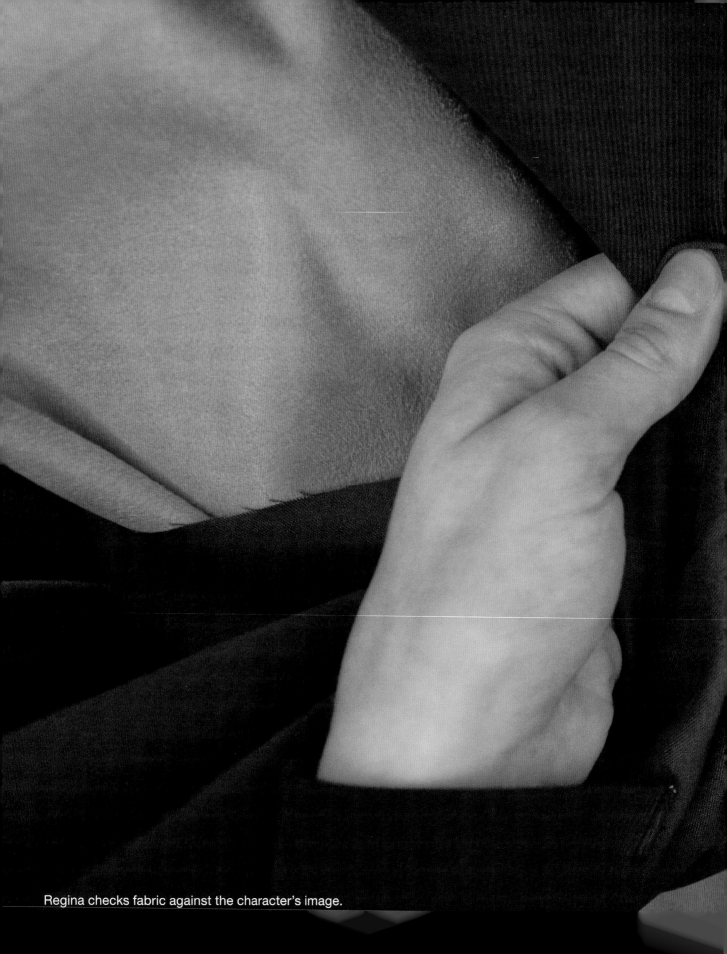

Regina checks fabric against the character's image.

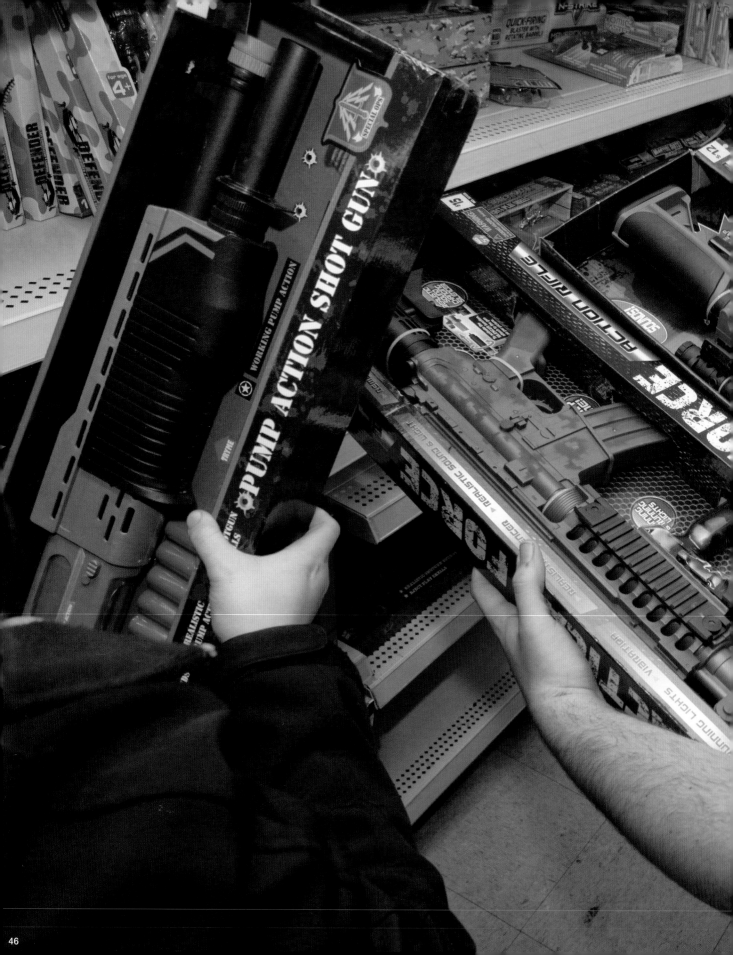

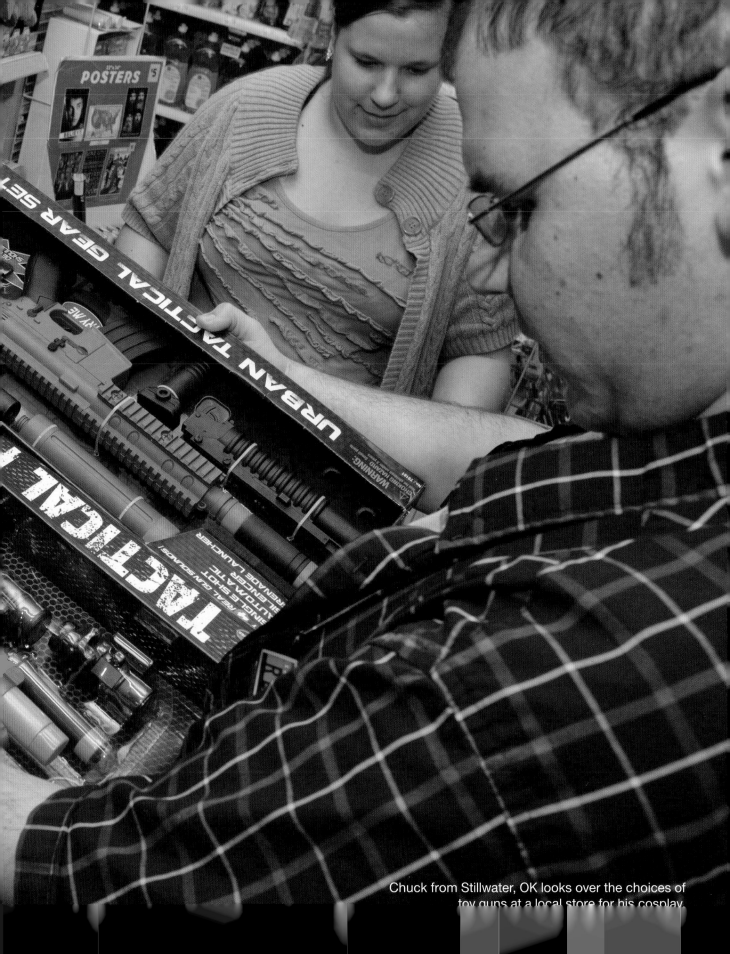

Chuck from Stillwater, OK looks over the choices of toy guns at a local store for his cosplay.

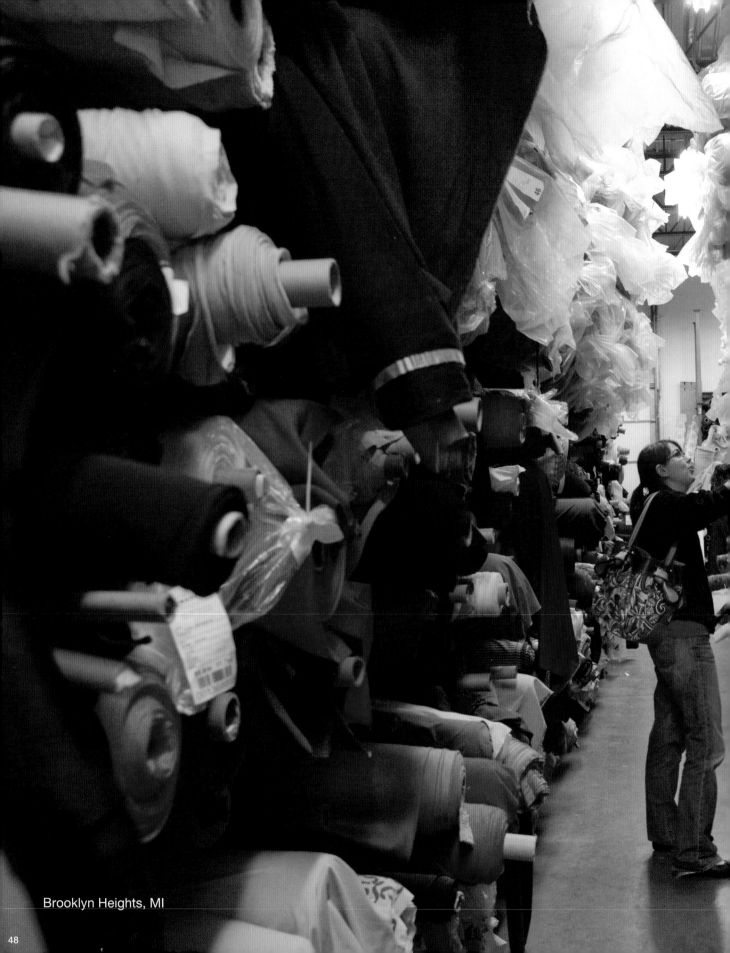

Brooklyn Heights, MI

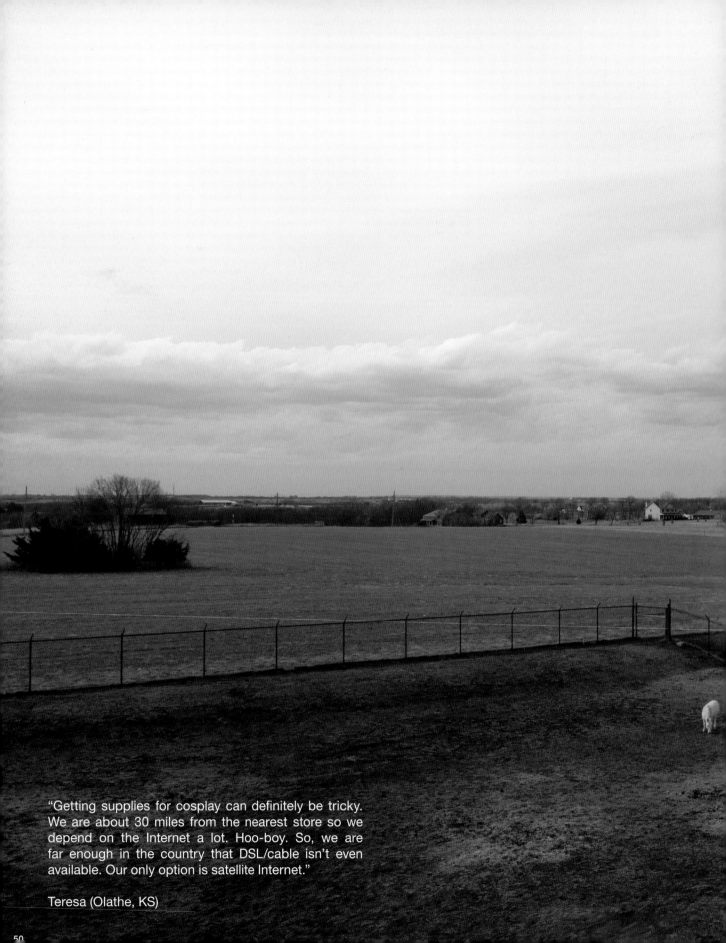

"Getting supplies for cosplay can definitely be tricky. We are about 30 miles from the nearest store so we depend on the Internet a lot. Hoo-boy. So, we are far enough in the country that DSL/cable isn't even available. Our only option is satellite Internet."

Teresa (Olathe, KS)

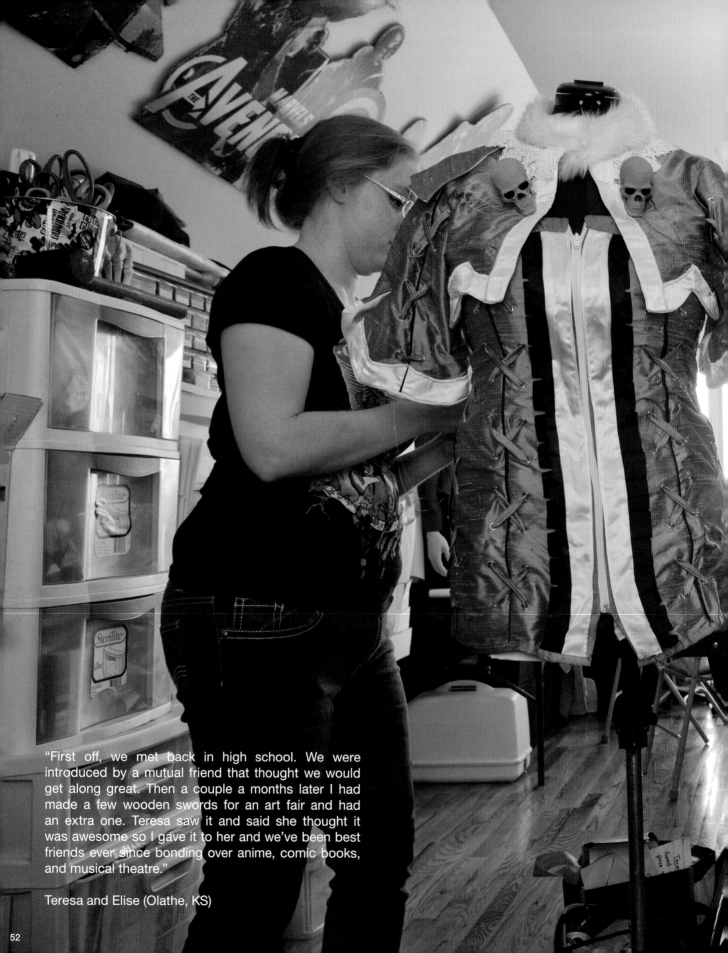

"First off, we met back in high school. We were introduced by a mutual friend that thought we would get along great. Then a couple a months later I had made a few wooden swords for an art fair and had an extra one. Teresa saw it and said she thought it was awesome so I gave it to her and we've been best friends ever since bonding over anime, comic books, and musical theatre."

Teresa and Elise (Olathe, KS)

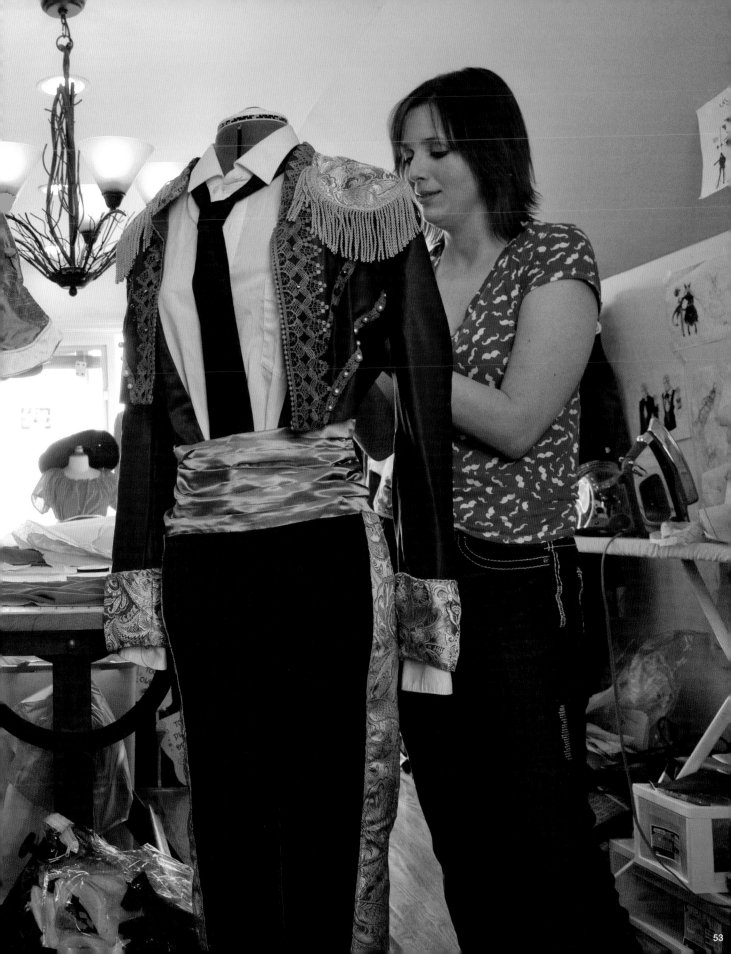

"There's a lot of stop and go and mistakes. Sometimes, it will take me weeks to solve a problem that didn't become apparent till much later in the build or something that did work fails when it's fully put together.

For building in New York City, it proves to be a big challenge. There's never enough space and [you] can't be too loud with the tools, which sucks when you need to sand or drill at 1 a.m."

Stephen (Manhattan, NY)

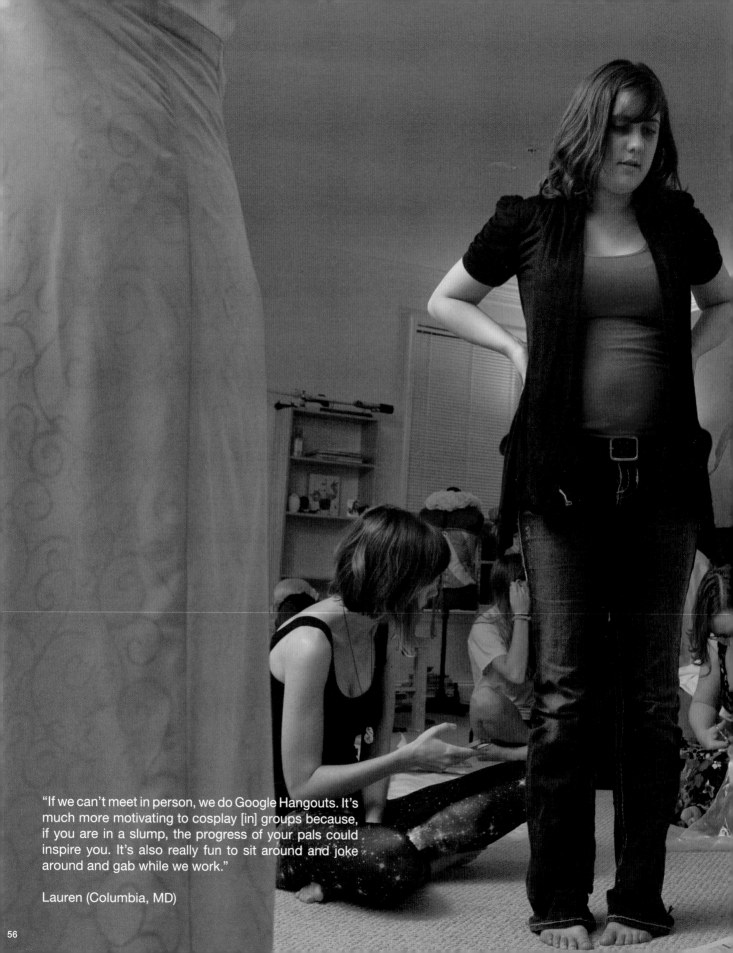

"If we can't meet in person, we do Google Hangouts. It's much more motivating to cosplay [in] groups because, if you are in a slump, the progress of your pals could inspire you. It's also really fun to sit around and joke around and gab while we work."

Lauren (Columbia, MD)

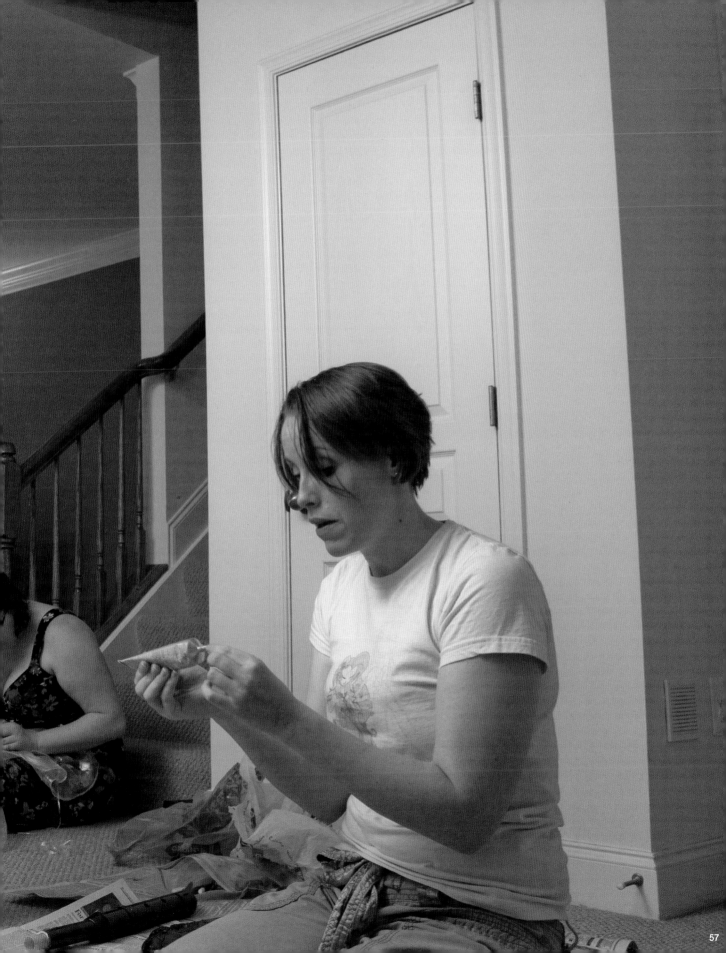

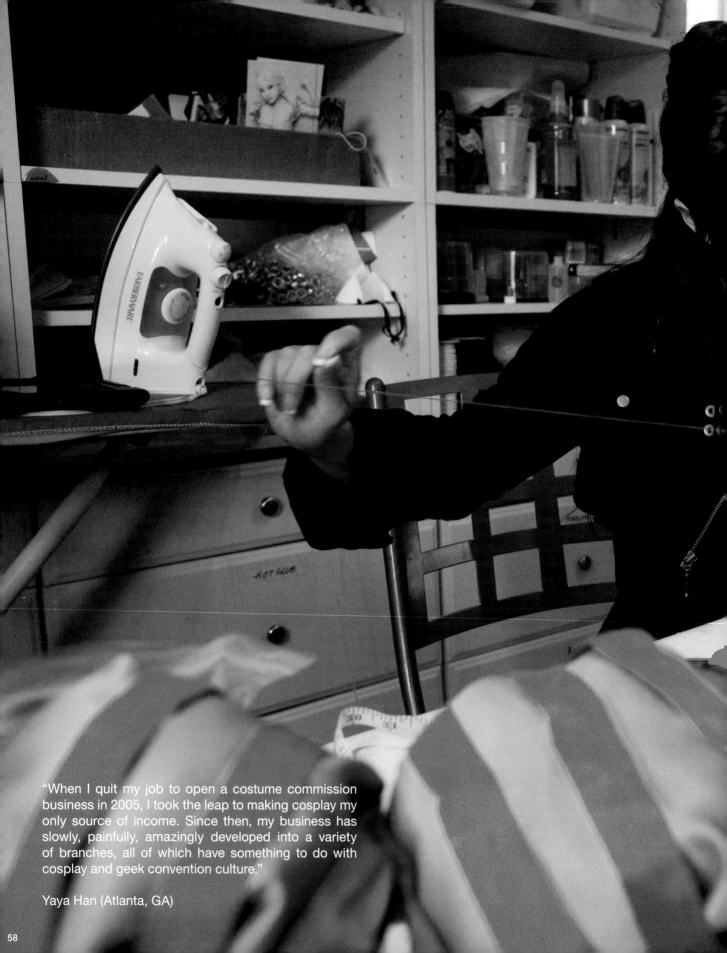

"When I quit my job to open a costume commission business in 2005, I took the leap to making cosplay my only source of income. Since then, my business has slowly, painfully, amazingly developed into a variety of branches, all of which have something to do with cosplay and geek convention culture."

Yaya Han (Atlanta, GA)

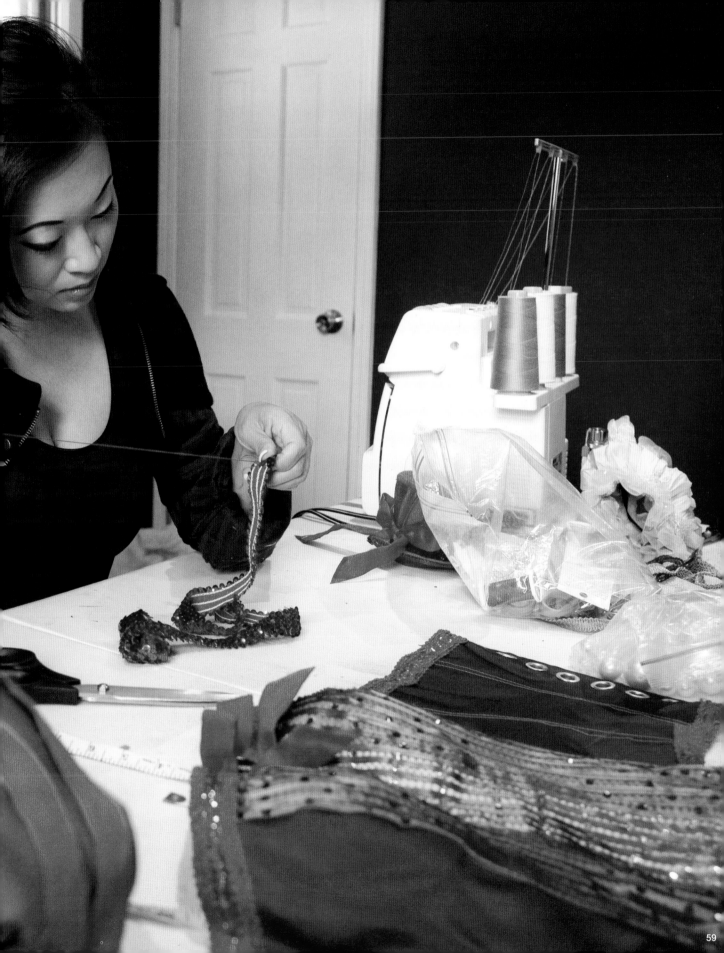

St Paul, MN

61

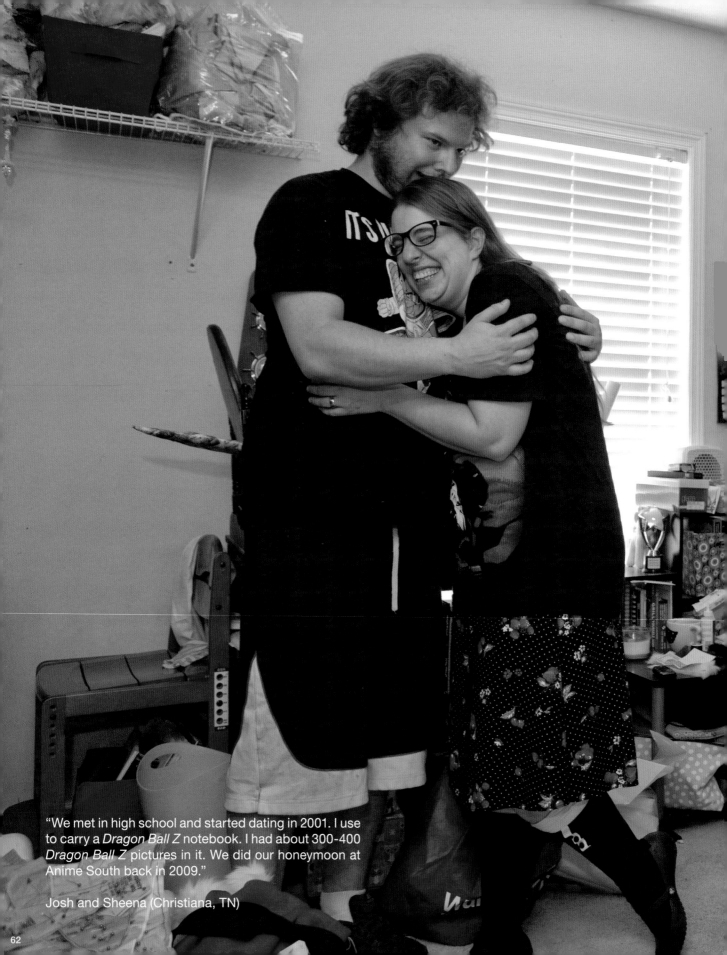

"We met in high school and started dating in 2001. I use to carry a *Dragon Ball Z* notebook. I had about 300-400 *Dragon Ball Z* pictures in it. We did our honeymoon at Anime South back in 2009."

Josh and Sheena (Christiana, TN)

"With superhero suits, it is also about creating the effect of the suit looking like a second skin and having as little possible wrinkles and loose points as possible in the suit.

Posing gives me an idea of how much is really necessary to bring in before it's too much or if it needs more. I can stand straight and the suit may look perfect and the moment I might contort my body or move a certain way the suit may shift, loosen, or be to tight."

Zack (Kissimmee, FL)

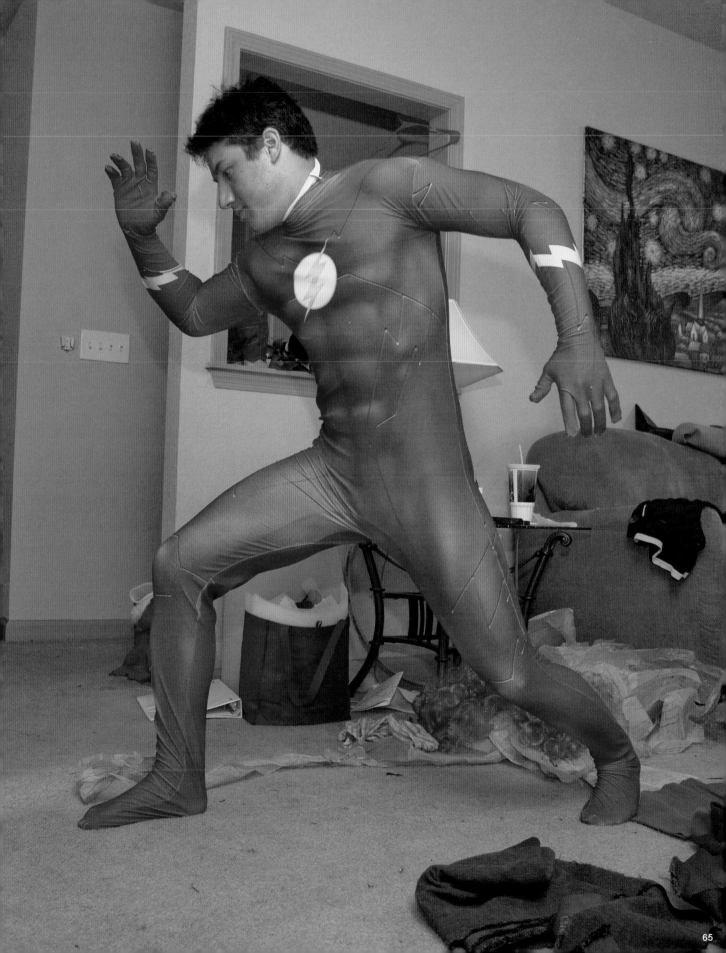

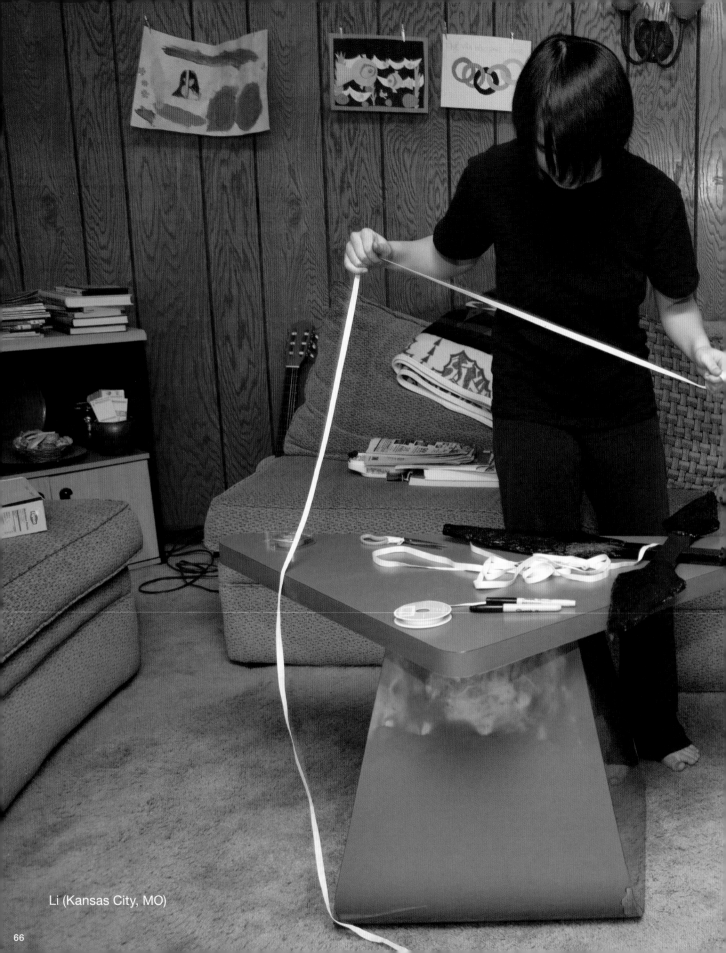

Li (Kansas City, MO)

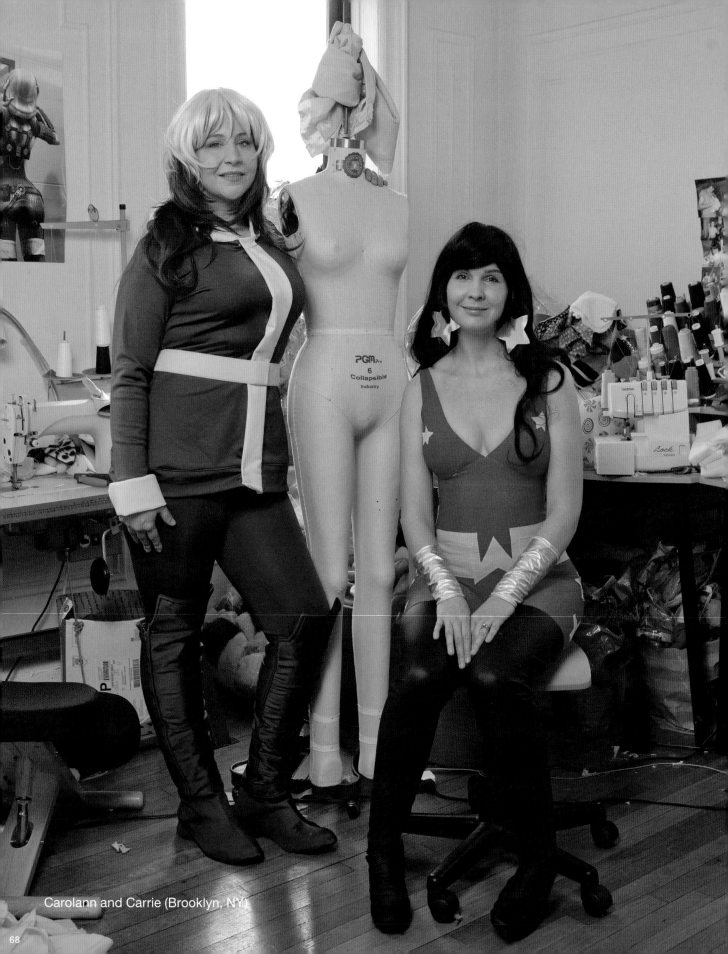

Carolann and Carrie (Brooklyn, NY)

"I was very much into drawing and craft growing up. My family teased me for liking to cosplay, but not my Uncle John. He got me a sewing machine for Christmas. I started sewing hats the next year to raise money to go to F.I.T or another college but sadly I never got in.

After the crash in 2009, when both Carolann and I lost our jobs, I asked her if she wanted to make hats with me. Today we make hats, flask and sell other crafts at 20 cons a year and spend about two months worth time on the road.

Thanks to cosplay I met my husband, started a business with my best friend Carolann, made tons of friends, travel the world and I found confidence in myself."

Carrie

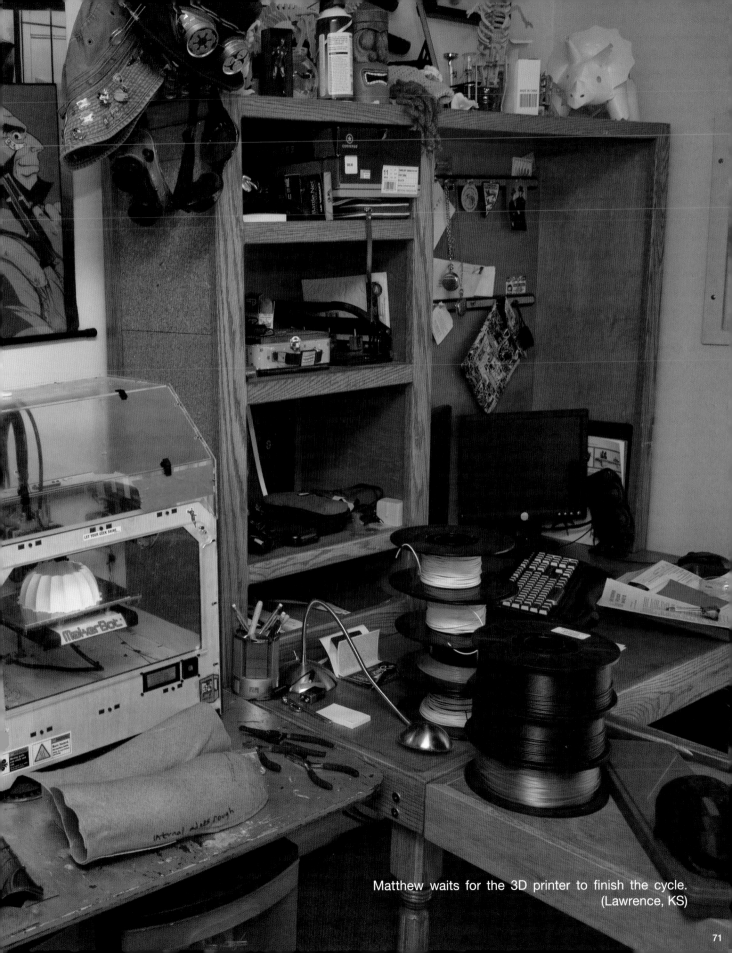

Matthew waits for the 3D printer to finish the cycle.
(Lawrence, KS)

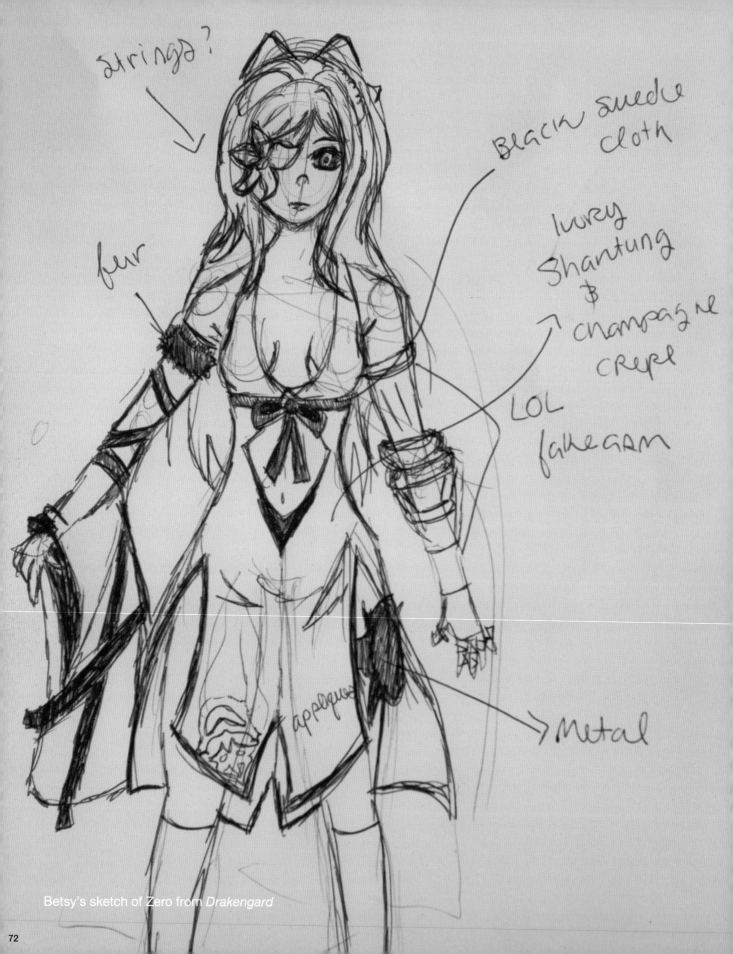

strings?

fur

Black suede cloth

Ivory Shantung & champagne crepe

LOL fakeasm

Metal

applique

Betsy's sketch of Zero from *Drakengard*

72

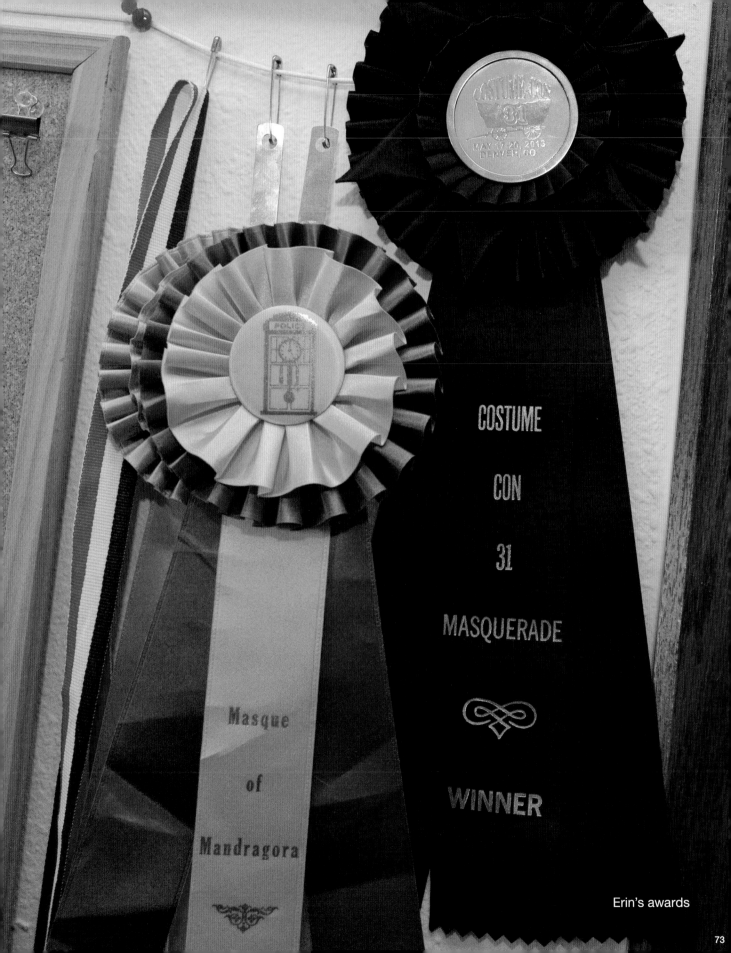

COSTUME

CON

31

MASQUERADE

WINNER

Masque

of

Mandragora

Erin's awards

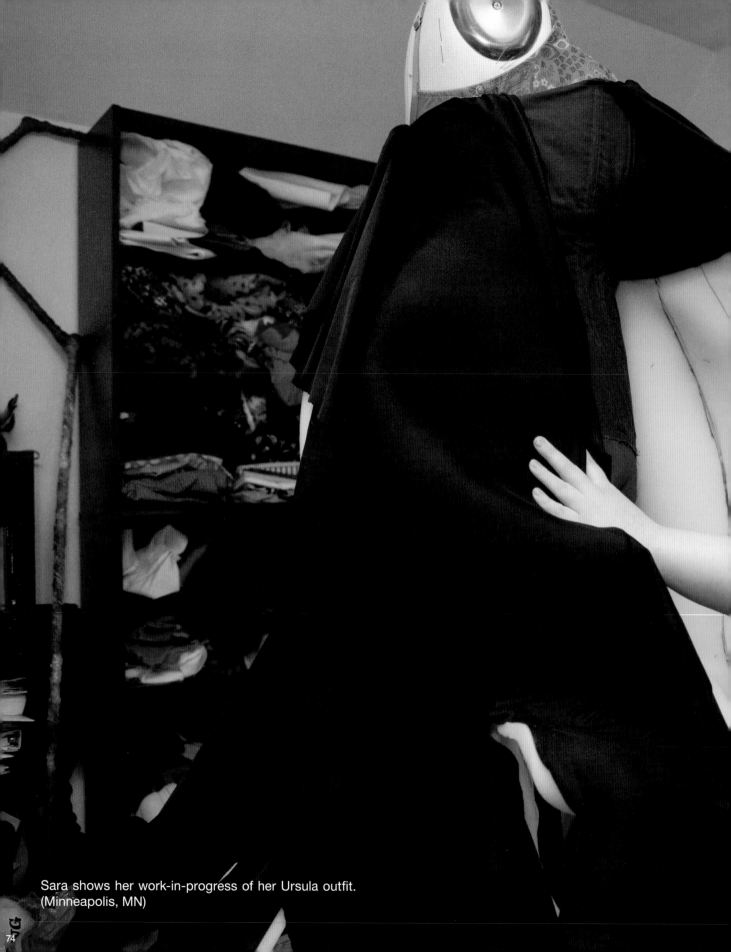

Sara shows her work-in-progress of her Ursula outfit.
(Minneapolis, MN)

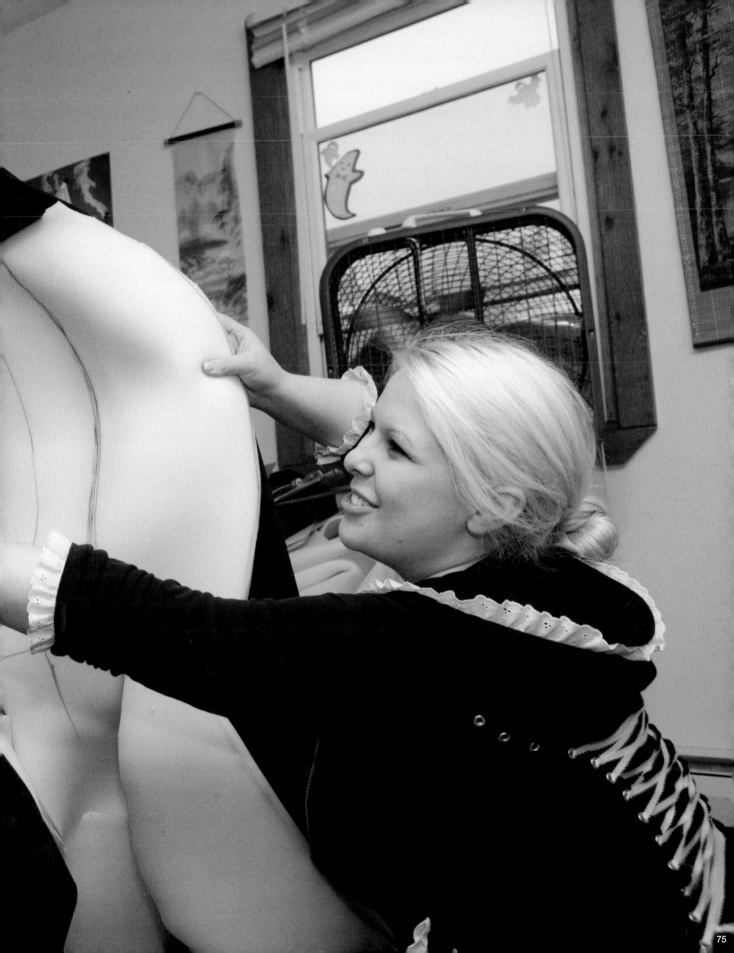

"I was actually pretty heavy into the rebuild of a 1975 BMW as well and I figured if I could build a car, then making some stuff from a video game would be a snap. I was completely wrong.

So we went to DragonCon and-- wow!-- the costumes and props there were mind-blowing. I came home from that experience with a desire to build everything I saw in the games I was playing. Everyone has played as Link, the Master Chief, "Insert Your Name Here" from numerous RPGs, and we've all held the weapons, armor and accessories. Bringing these things out of the game and being able to actually hold them is an experience not many people get to have.

It's a stretch to call my work anything more than glorified copying, but I love the intricacy and have always believed that the real beauty of things lies in the details."

Harrison (Norcross, GA)

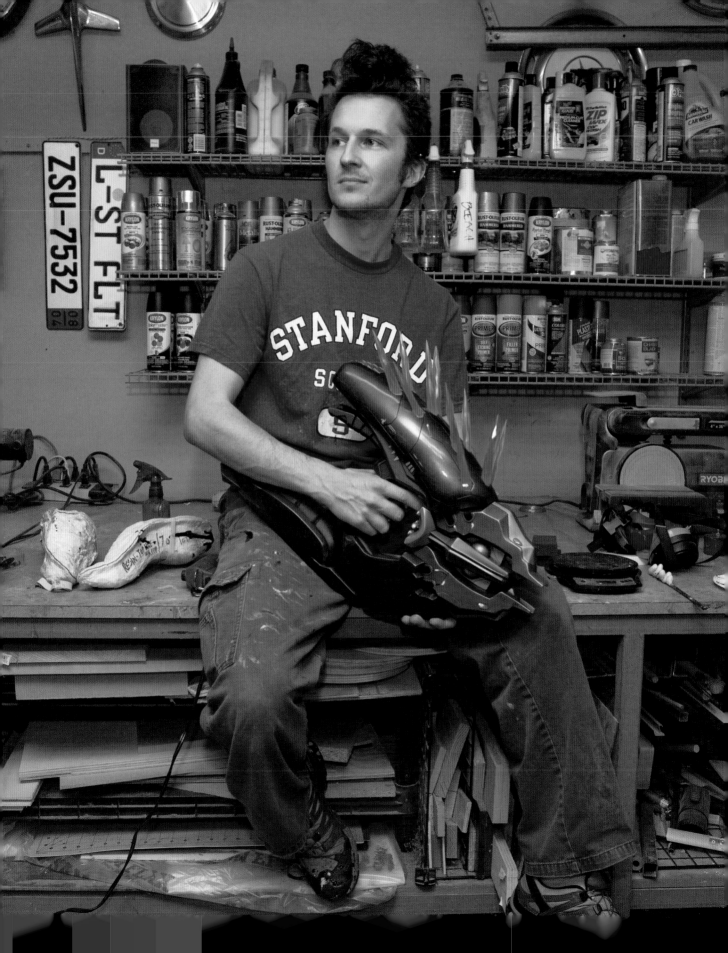

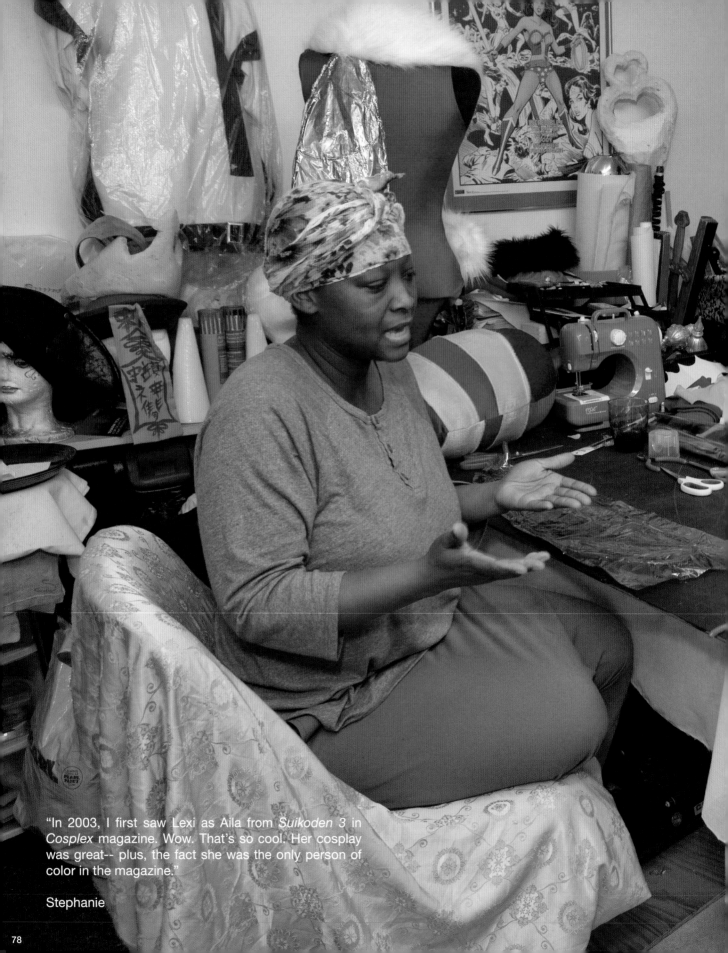

"In 2003, I first saw Lexi as Aila from *Suikoden 3* in *Cosplex* magazine. Wow. That's so cool. Her cosplay was great-- plus, the fact she was the only person of color in the magazine."

Stephanie

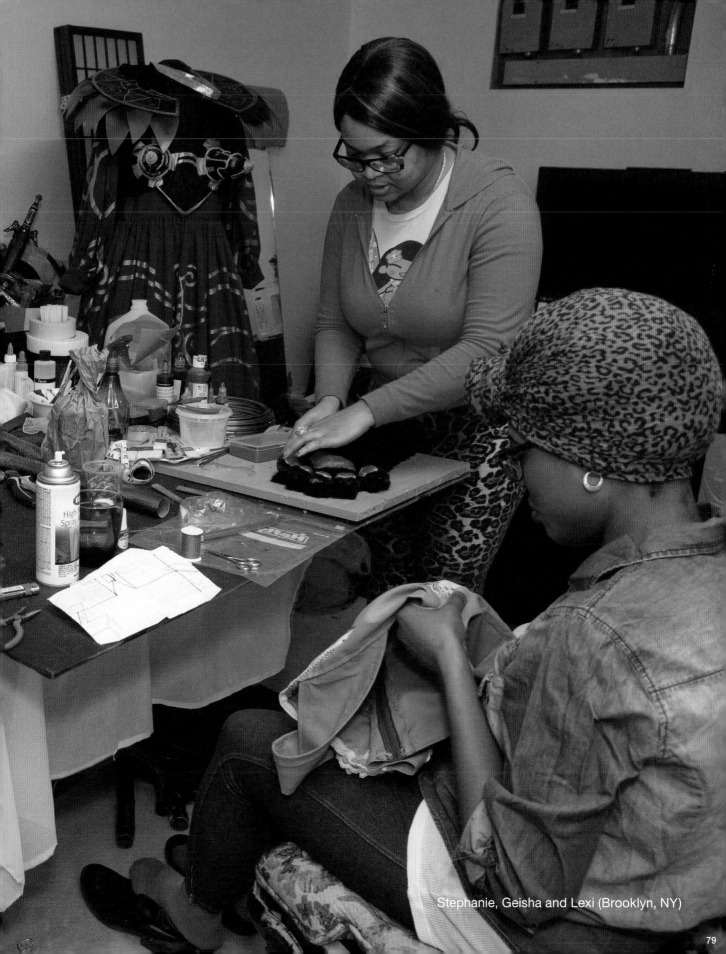

Stephanie, Geisha and Lexi (Brooklyn, NY)

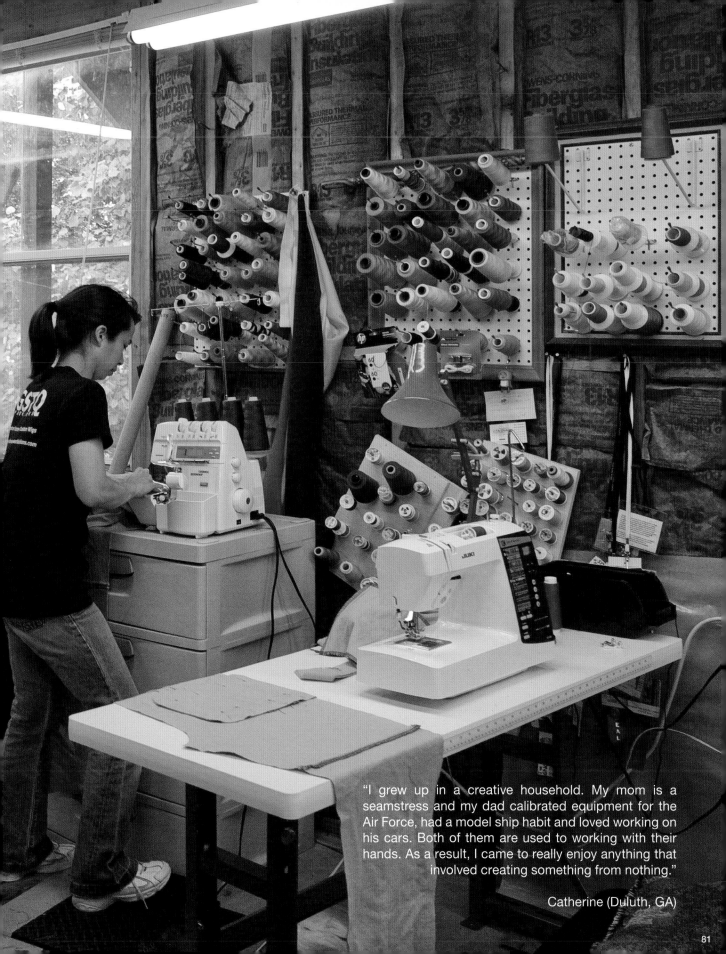

"I grew up in a creative household. My mom is a seamstress and my dad calibrated equipment for the Air Force, had a model ship habit and loved working on his cars. Both of them are used to working with their hands. As a result, I came to really enjoy anything that involved creating something from nothing."

Catherine (Duluth, GA)

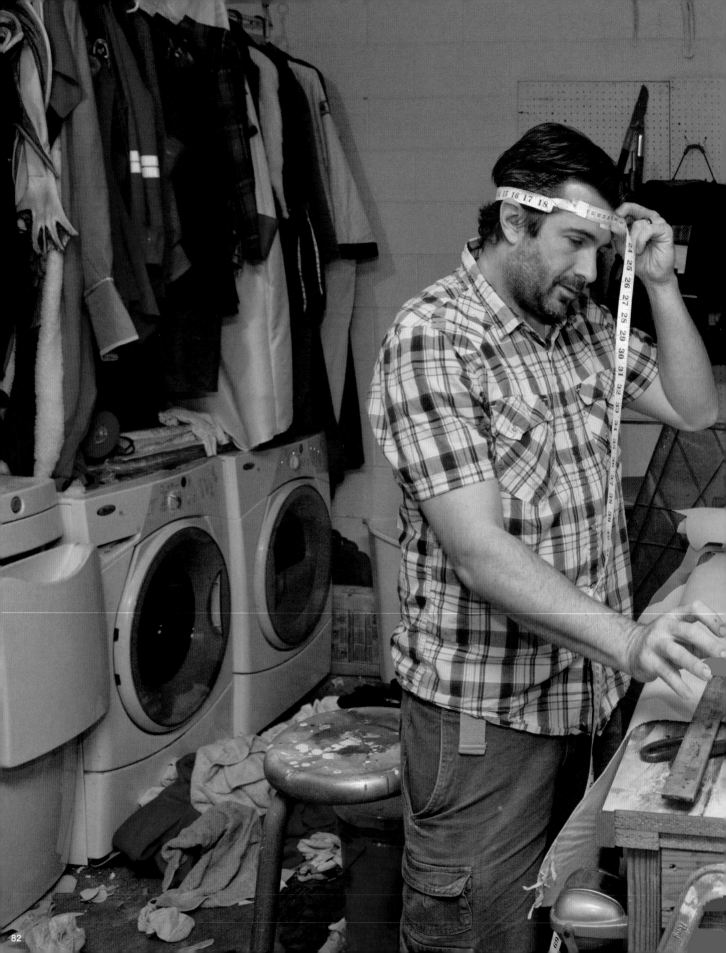

"As a parent, costuming has definitely changed for me. Partially, so much of your free time goes to your child-- teaching them, guiding them and simply having fun with them. It's become a lot harder to make as many costumes as I have in the past. But, also, it has given my family another reason to have fun together. My stepson Ender, who is now three, already is picking out the characters he wants to dress as and pretending to be his favorite heroes. Eko just loves the social aspect of the crowds and smiling for the camera, but I am sure with time he will begin his own personal journey through this hobby."

Shawn (Ocoee, FL)

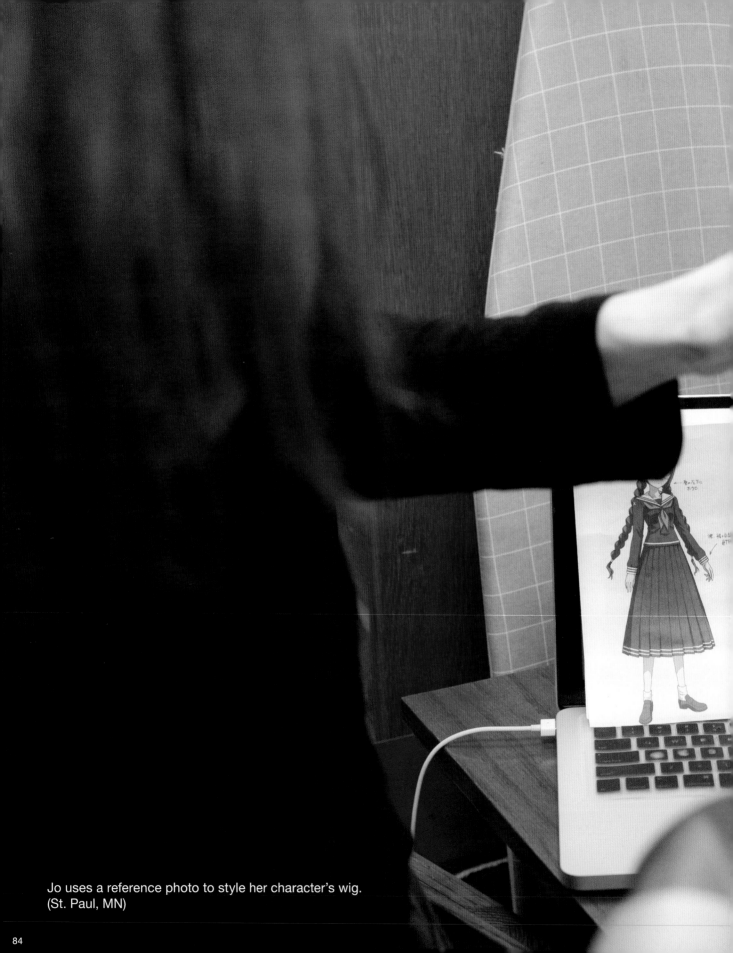

Jo uses a reference photo to style her character's wig.
(St. Paul, MN)

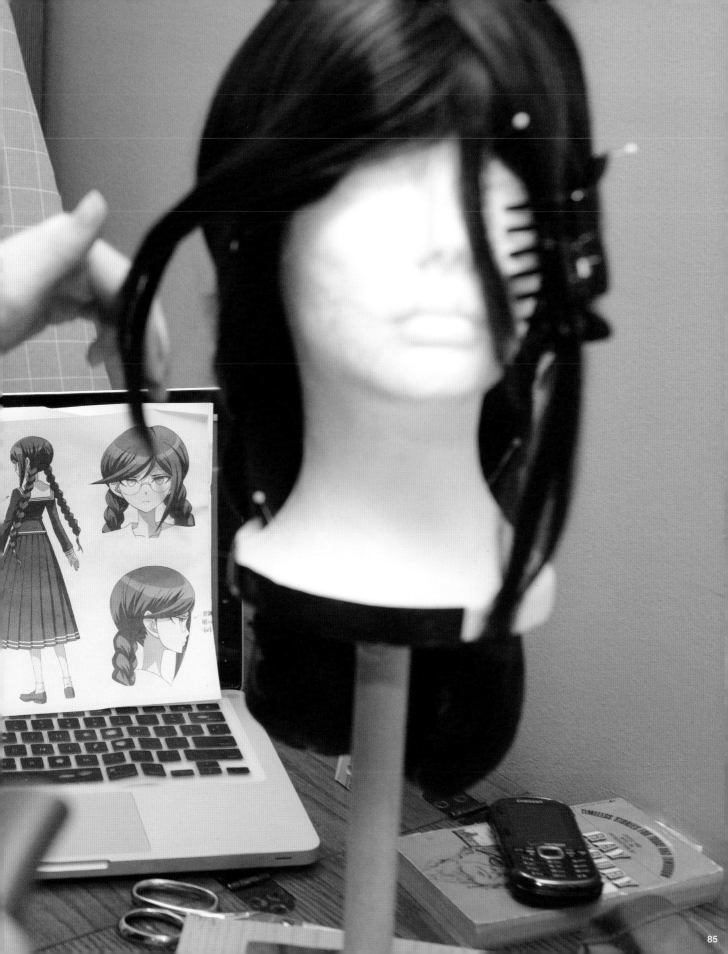

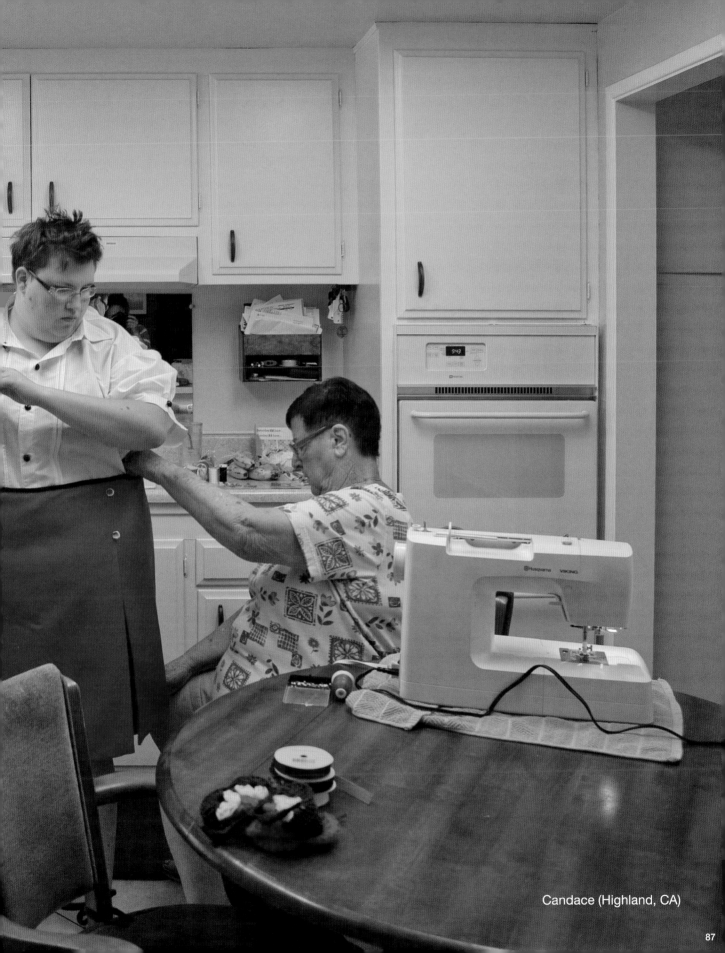

Candace (Highland, CA)

"Wearing the costume was certainly a lot of fun, I won't deny that and the fact that I get to do this great hobby with my brother Damon is a big bonus. In the beginning having him to introduce me into this world and to his new friends was a huge benefit.

What have I gained? I have a whole new circle of friends that I never would have met had it not been for cosplaying. They are a great group of people. There are also costuming groups here in Minnesota that I belong to that do charity work, most working with children. Whatever joy I get from cosplaying, those kids give back to me tenfold."

Damon and Yancey (Minneapolis, MN)

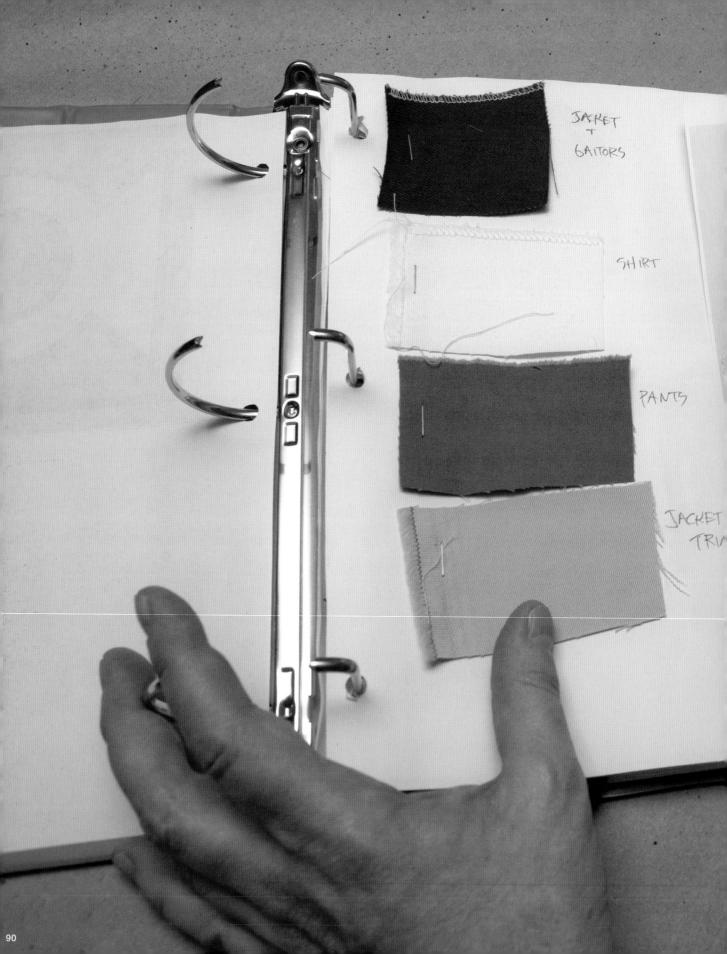

JACKET
+
GAITORS

SHIRT

PANTS

JACKET
TRIM

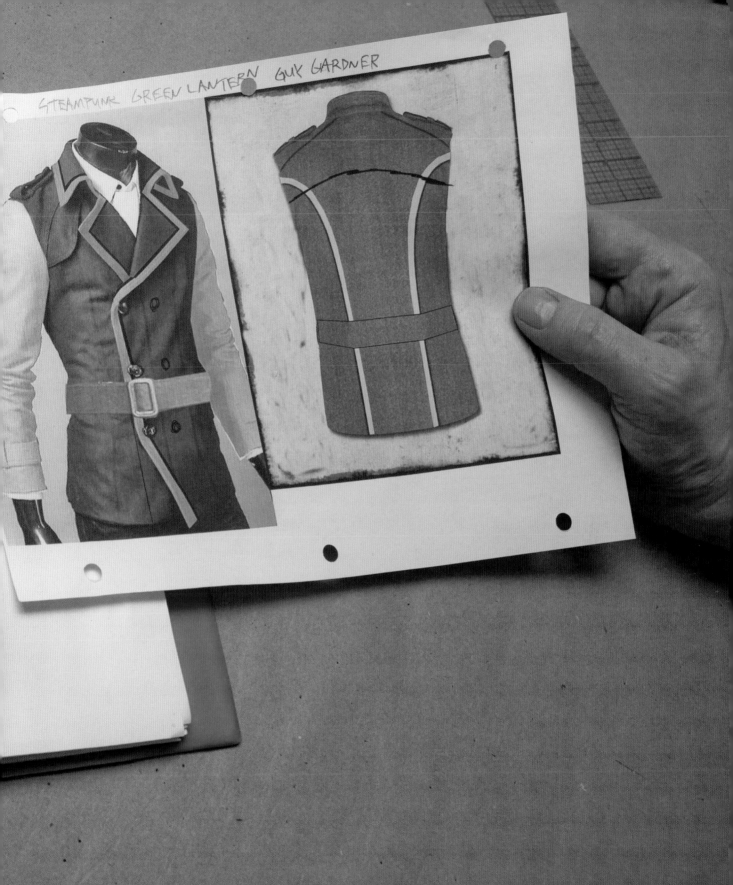

STEAMPUNK GREEN LANTERN GUY GARDNER

Damon's Steampunk version of Guy Gardner from *The Green Lantern*.

"I told my mom that she should try it out with me, for Halloween, at least. We made her an Ursula cosplay from Disney's *The Little Mermaid* and she suggested I make Ariel to accompany her. Stepping out in a full room of hundreds of people, she felt nervous, but remembered if her daughter can go out and have fun being a character she loved, then so can she. Overall, she loves being in characters you don't see cosplayed often and that she loves to go to conventions and make the fans happy. She said it doesn't matter if you're old or young, be happy in the costume you are in and be yourself or be the character you love to be."

Rachel (Baton Rouge, LA)

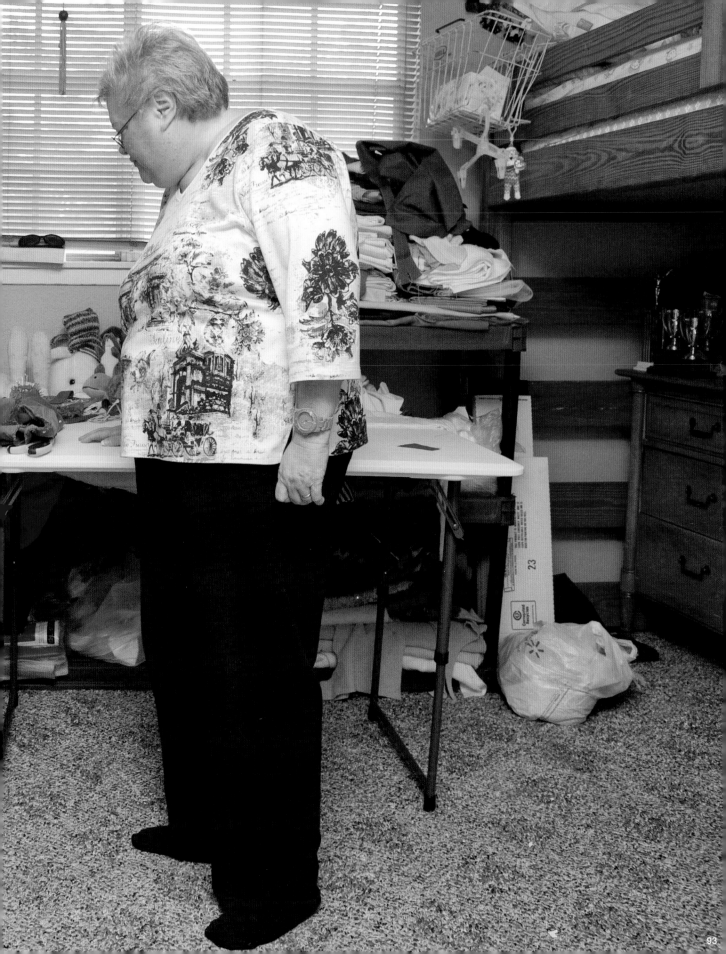

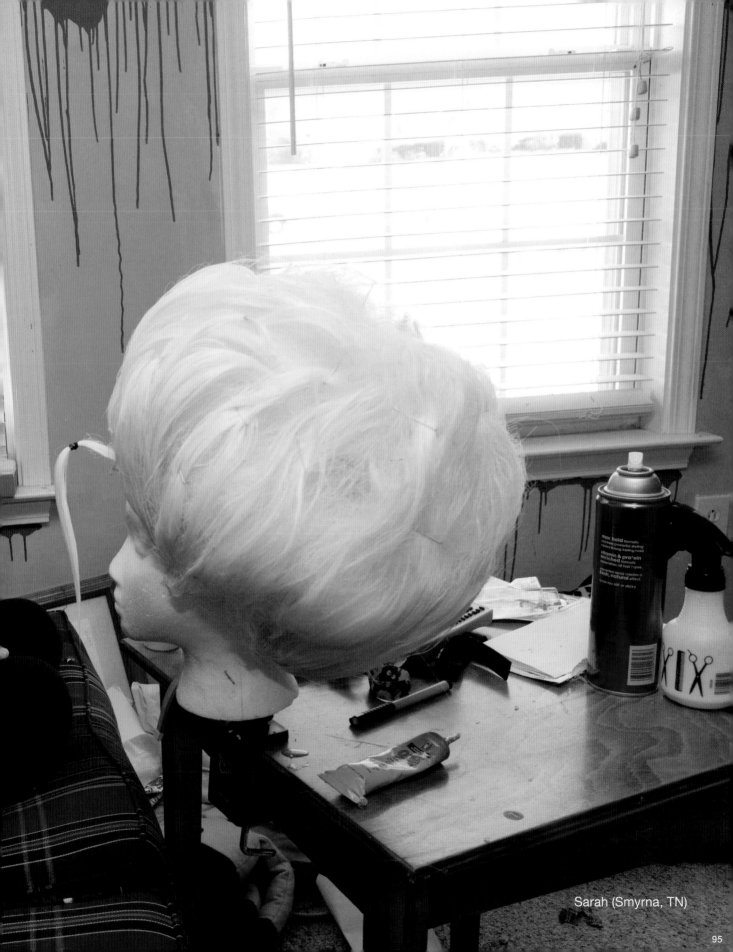

Sarah (Smyrna, TN)

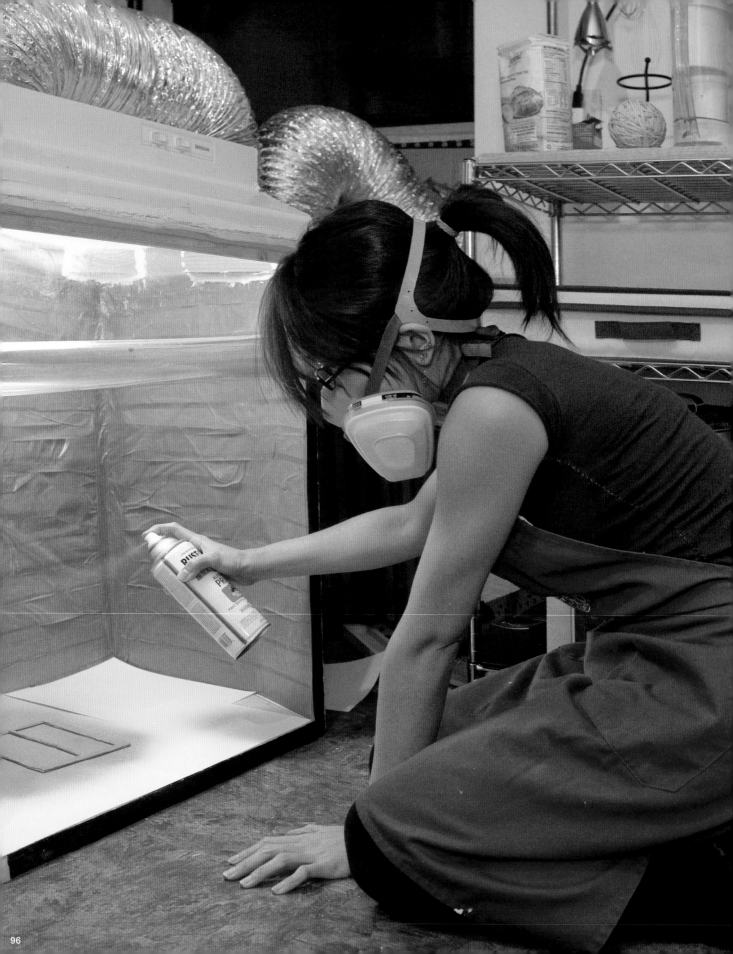

"The Fume Ventilation Hood was made for two main reasons: safety and lack of real crafting space. As I started to get more into full constructions of sculpting, molding and casting, my boyfriend began to point out the various safety precautions printed on 99% of my purchased supplies. "Toxic, use in well-ventilated areas, etc." was printed amongst most of the packaging.

We live in a typical Brooklyn brownstone apartment. Read: small. As I don't have much space to dedicate to my hobbies, my kitchen began doubling as my little workshop. Oftentimes, I found myself running down three flights of stairs to go outside to spraypaint something. With the cold winter months looming, I wasn't looking forward to limiting what I can and couldn't do. The boyfriend suggested a fume hood, like in chemistry class, which seemed like the perfect solution for my crafting dilemmas."

Say (Brooklyn, NY)

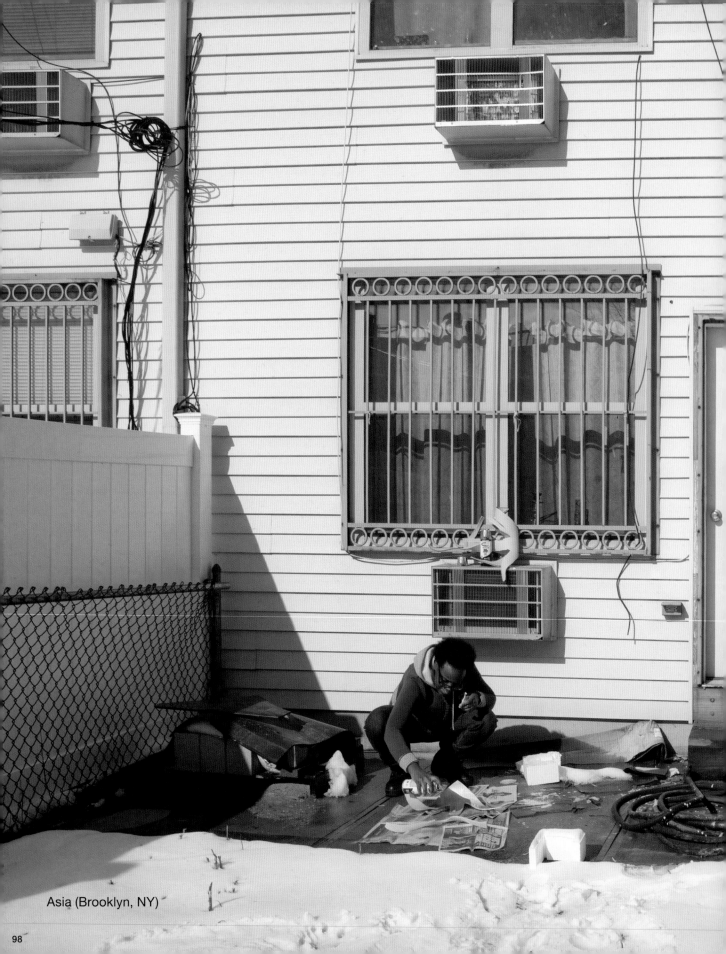

Asia (Brooklyn, NY)

Ryan (Cheektowaga, NY)
Jordan (Calgary, Canada)
Lori (California)
Andy Rae (Canada)
Blayne (California)
Olivia (Lafayette, CA)

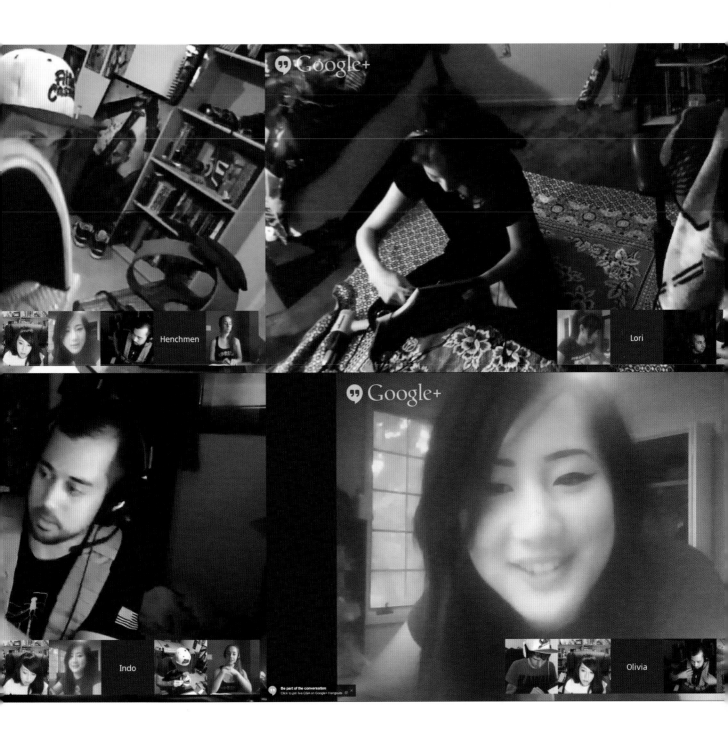

"I've been following cosplay since 1999 and it's amazing that, with technology, you can actually talk to the people you admire! It is also wonderful because you are able to share information, experience, and tips with people on your social media outlets. I am thankful that through Instagram, Facebook, and Twitter, I am able to meet and make friends in our cosplay community as well as share and help others when I can! There are good and bad things to social media, but I think the positive side of it outweighs the bad."

Olivia

Ari (Princeton, NJ)
Levi, *Attack on Titan*

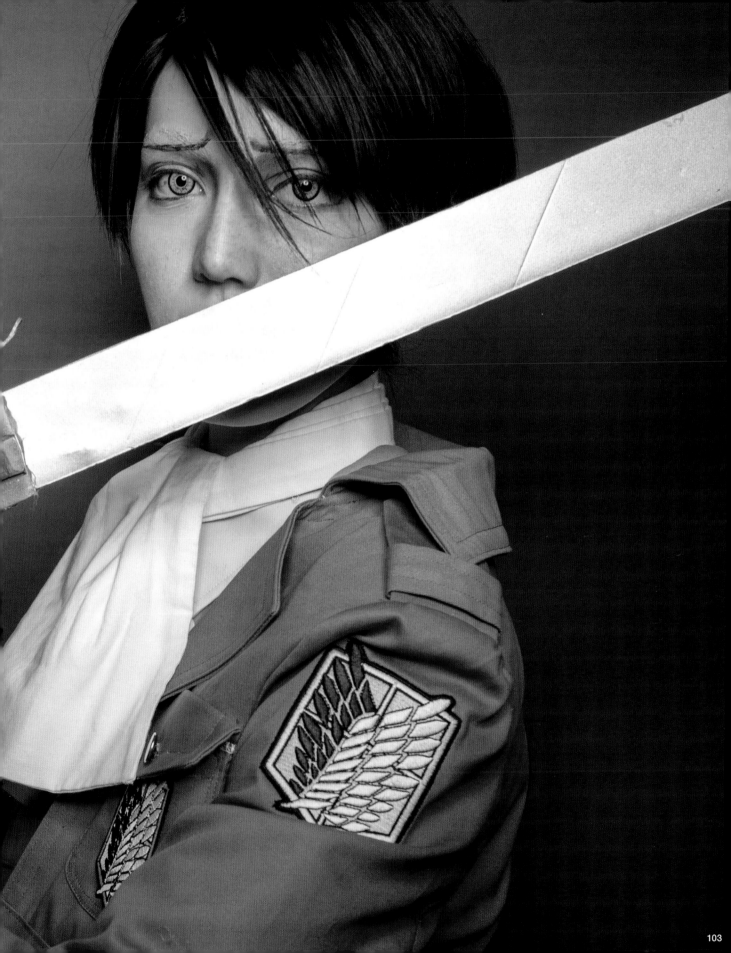

"Not everyone is going to praise your hard work or want to take your picture or realize how much money and effort you've put into your costume. It can get discouraging when people tell you your fabric is the wrong color or your shoes don't match or even that you're just too fat to cosplay that character. I've run across some people that are very blunt in their critiques and observations about my costumes. There are far more positive and respectful people out there and that's all that matters."

Koby

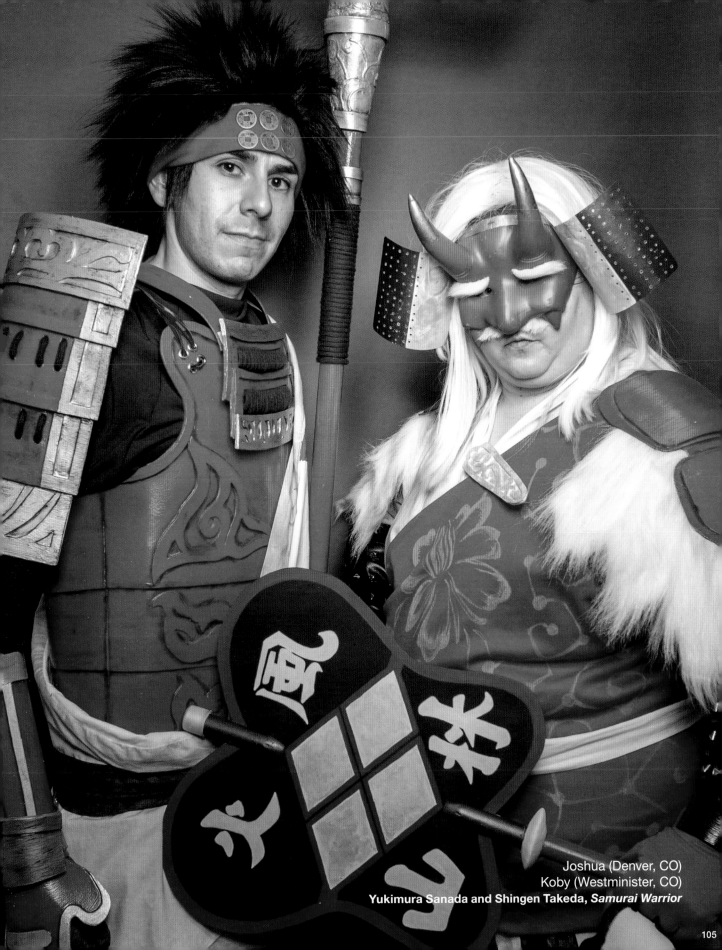

Joshua (Denver, CO)
Koby (Westminister, CO)
Yukimura Sanada and Shingen Takeda, *Samurai Warrior*

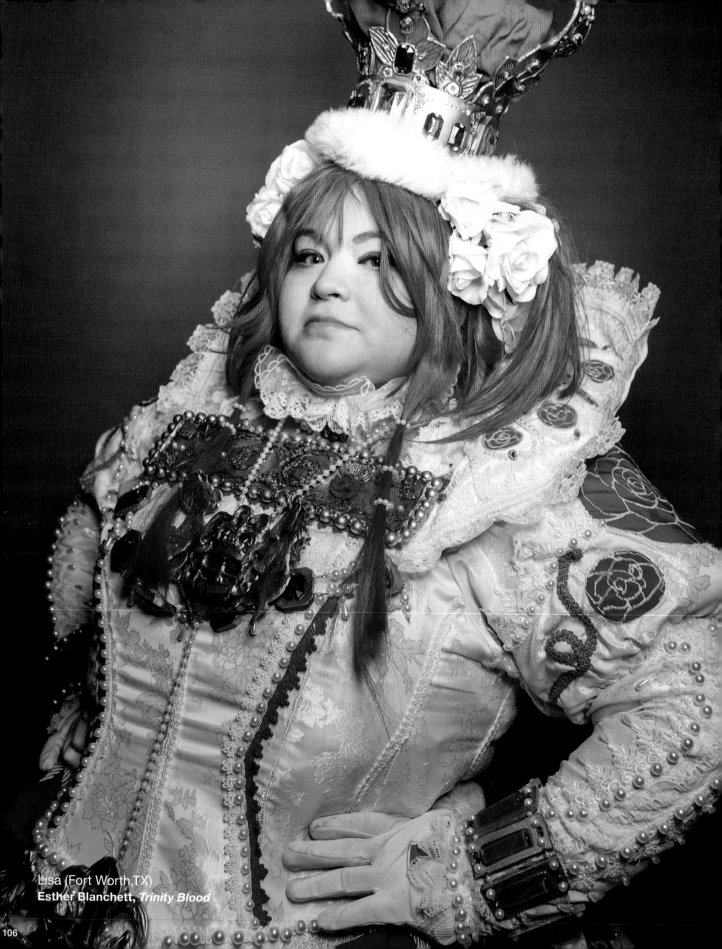

Lisa (Fort Worth,TX)
Esther Blanchett, *Trinity Blood*

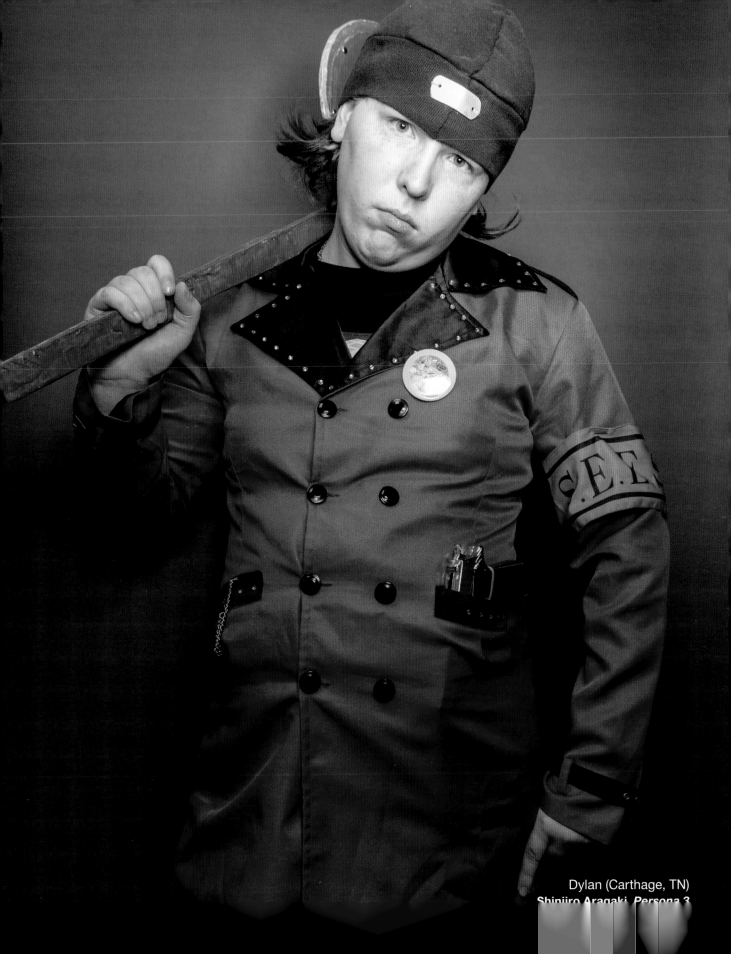

Dylan (Carthage, TN)
Shinjiro Aragaki, Persona 3

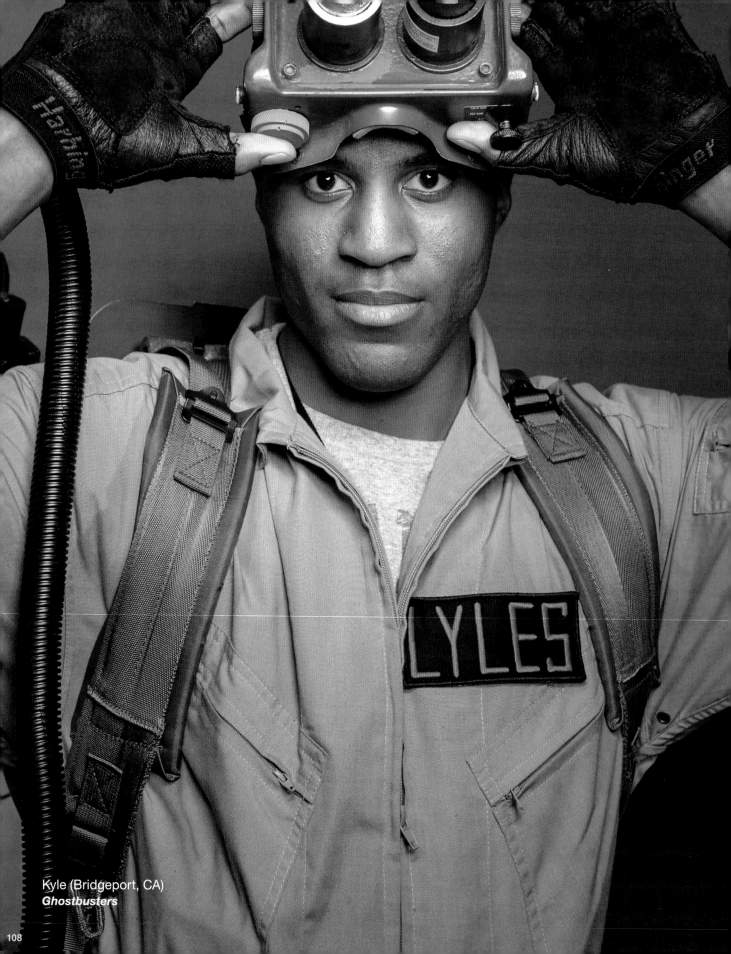

Kyle (Bridgeport, CA)
Ghostbusters

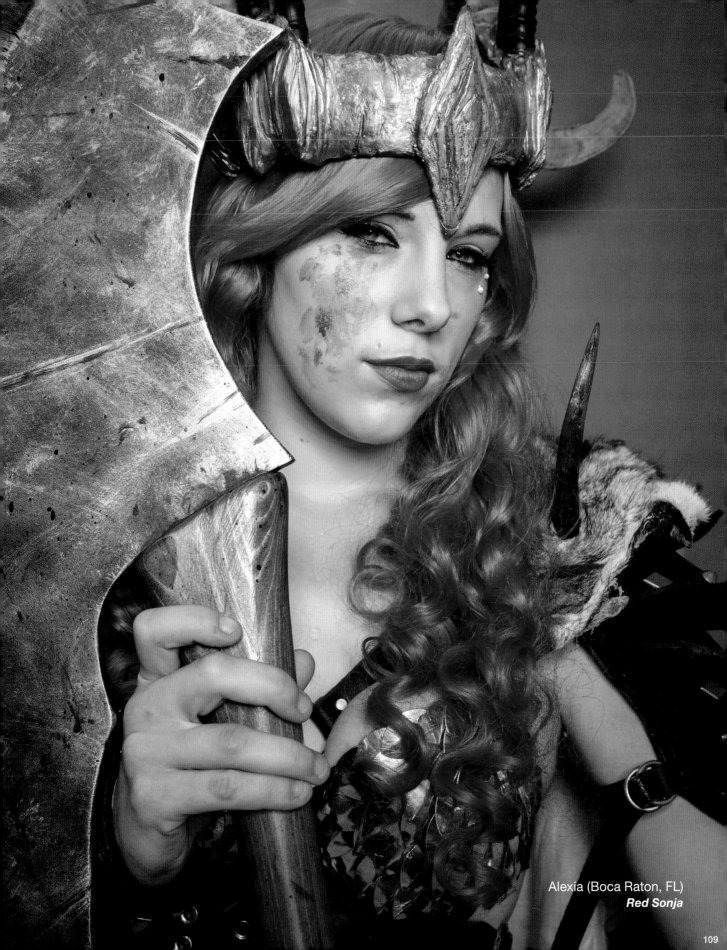

Alexia (Boca Raton, FL)
Red Sonja

"My husband played *League of Legends* and it has been a fun game to bond over. I chose Janna because she was one of the very first champions I played. I did her frost queen skin because I love the color blue and I love the ice theme."

Vanessa (Las Vegas, NV)

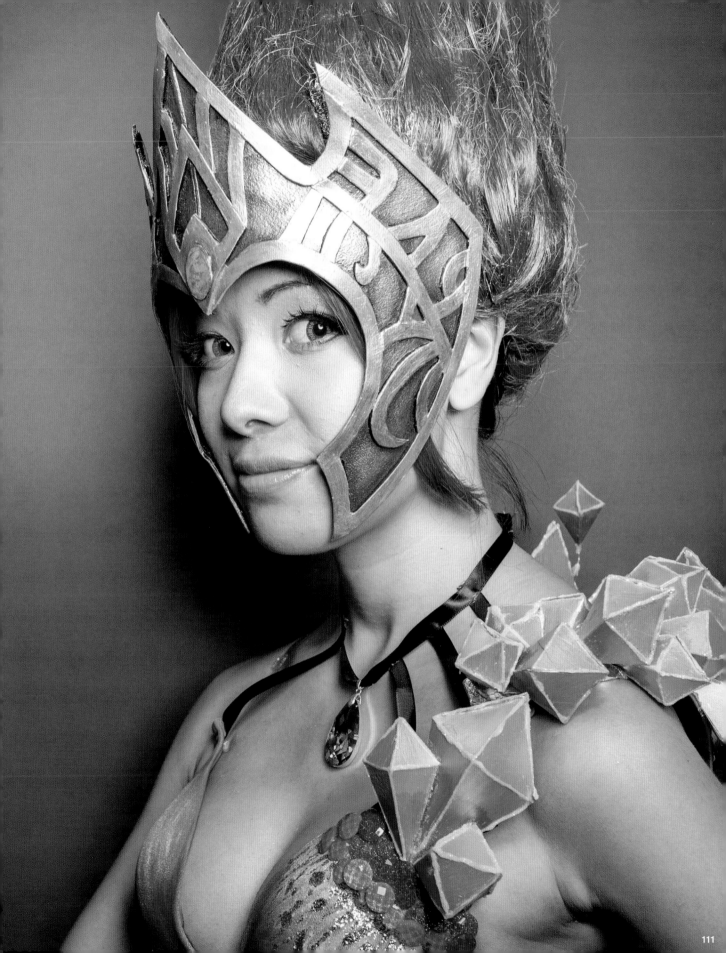

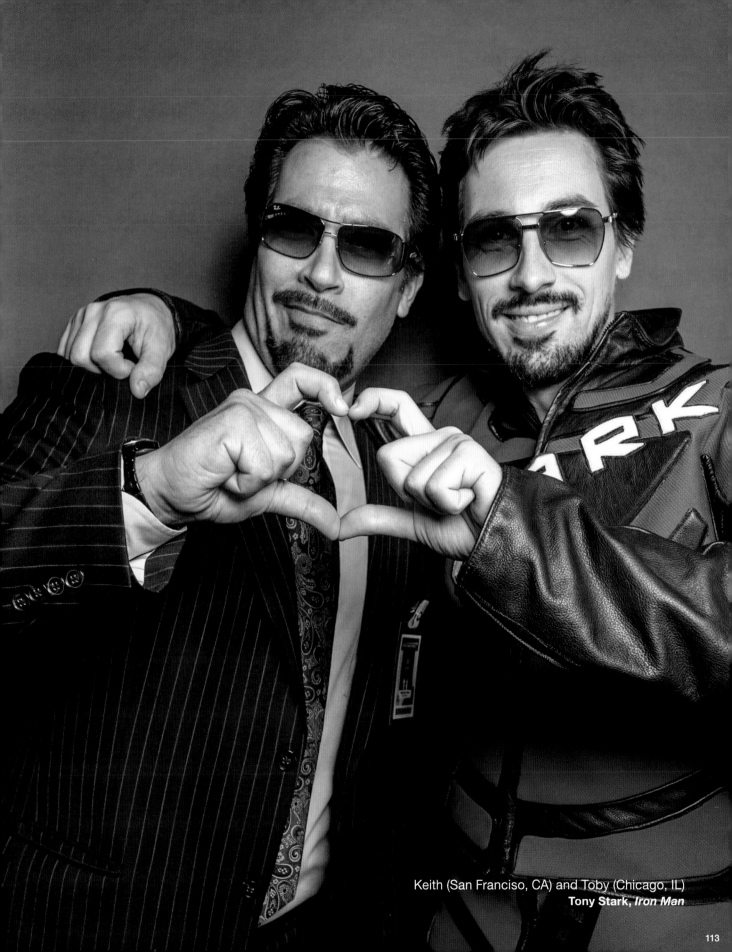

Keith (San Franciso, CA) and Toby (Chicago, IL)
Tony Stark, *Iron Man*

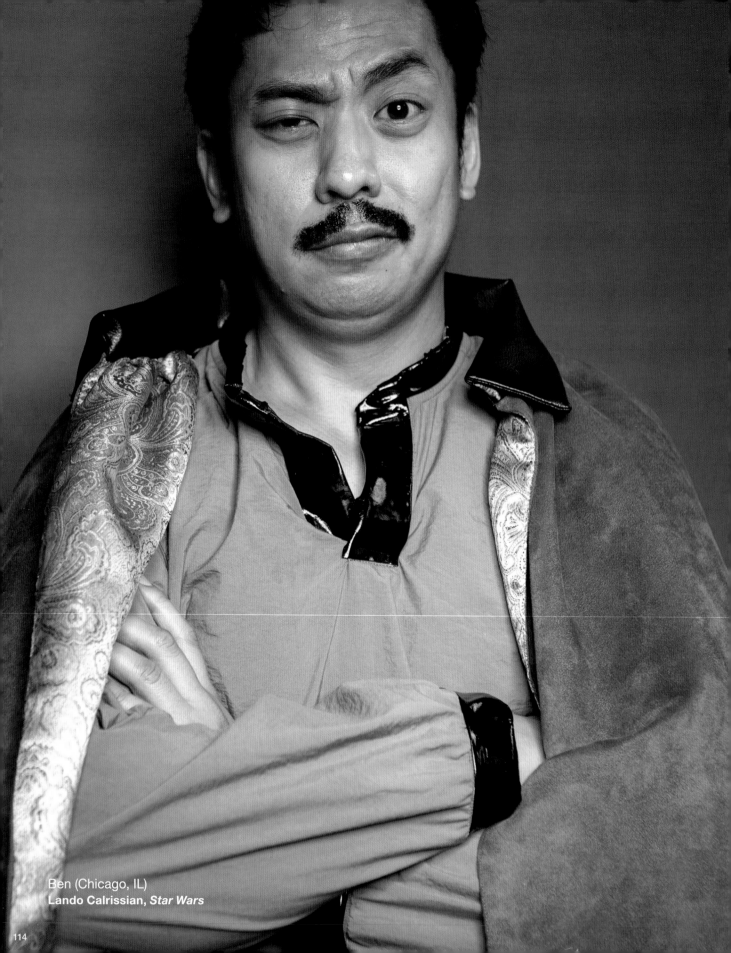

Ben (Chicago, IL)
Lando Calrissian, *Star Wars*

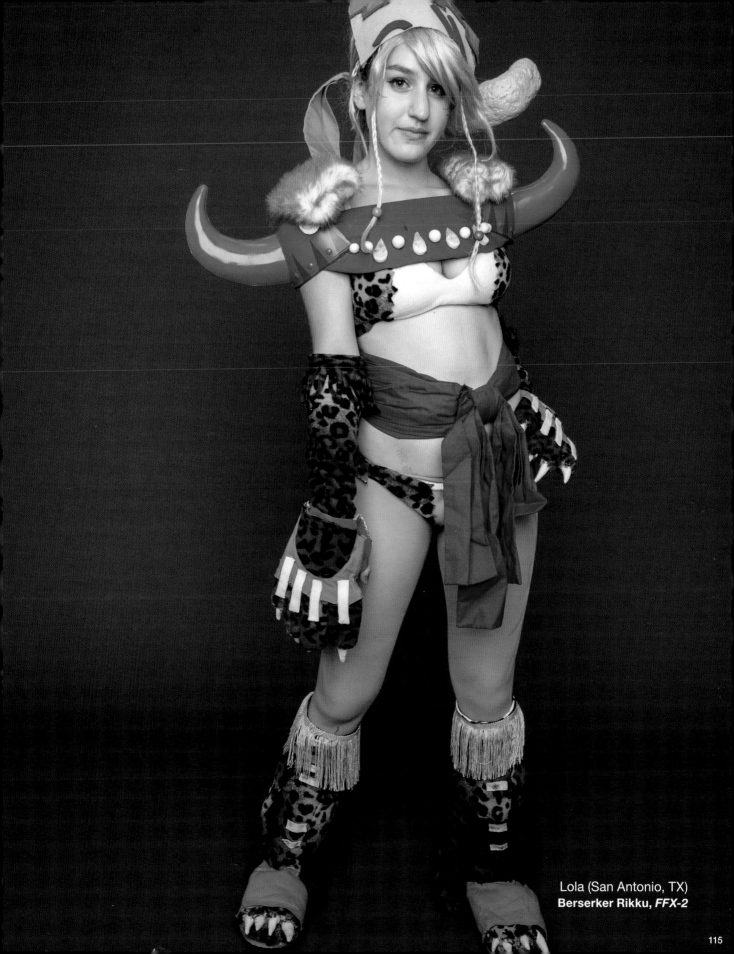

Lola (San Antonio, TX)
Berserker Rikku, *FFX-2*

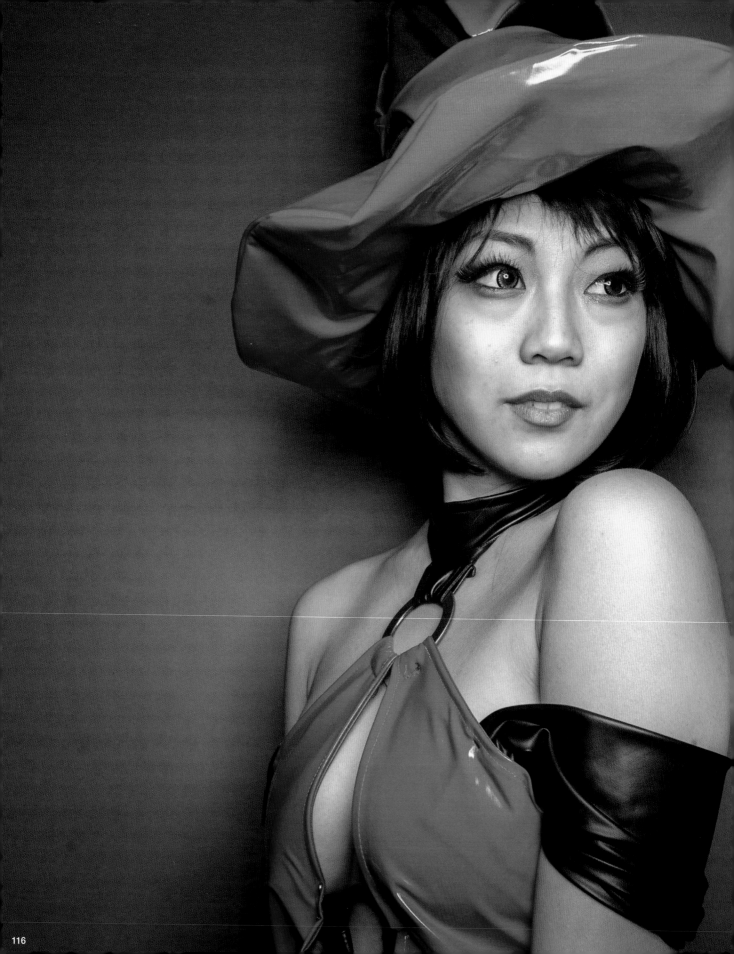

"My family has a love hate relationship with my cosplay. They see how much money it costs and it doesn't sit well with them. However, my family is loud and fun, so whenever we have themed parties, they easily ask me to sew costumes for them. I see how much they enjoy dressing up themselves. So, I think deep down they love cosplay just as much as I do."

Camille (Los Angeles, CA)
I-No, *Guilty Gear*

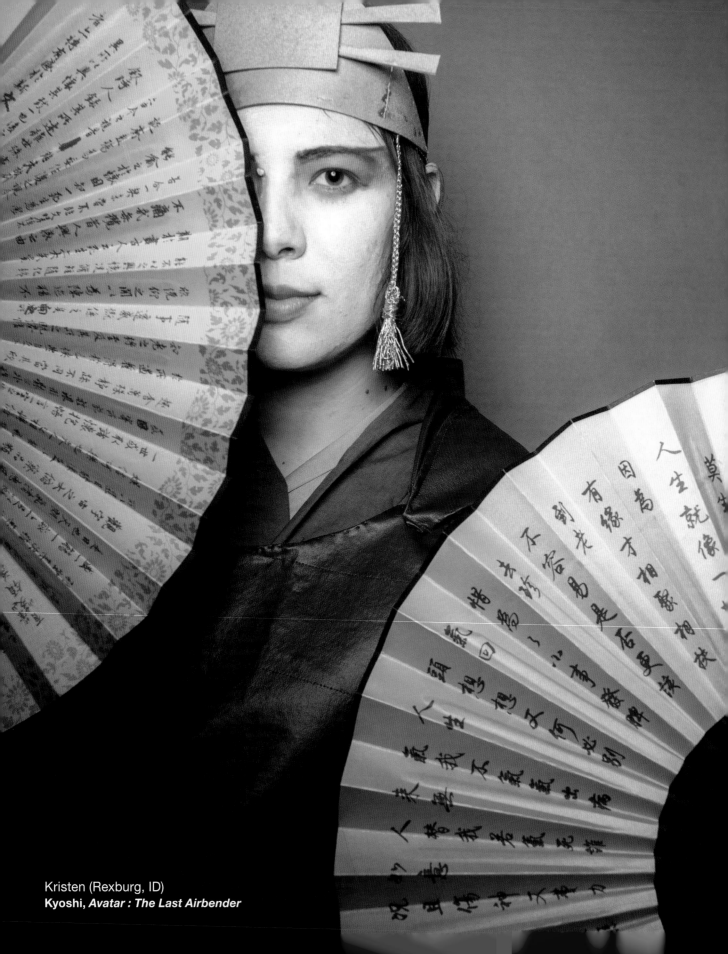

Kristen (Rexburg, ID)
Kyoshi, *Avatar : The Last Airbender*

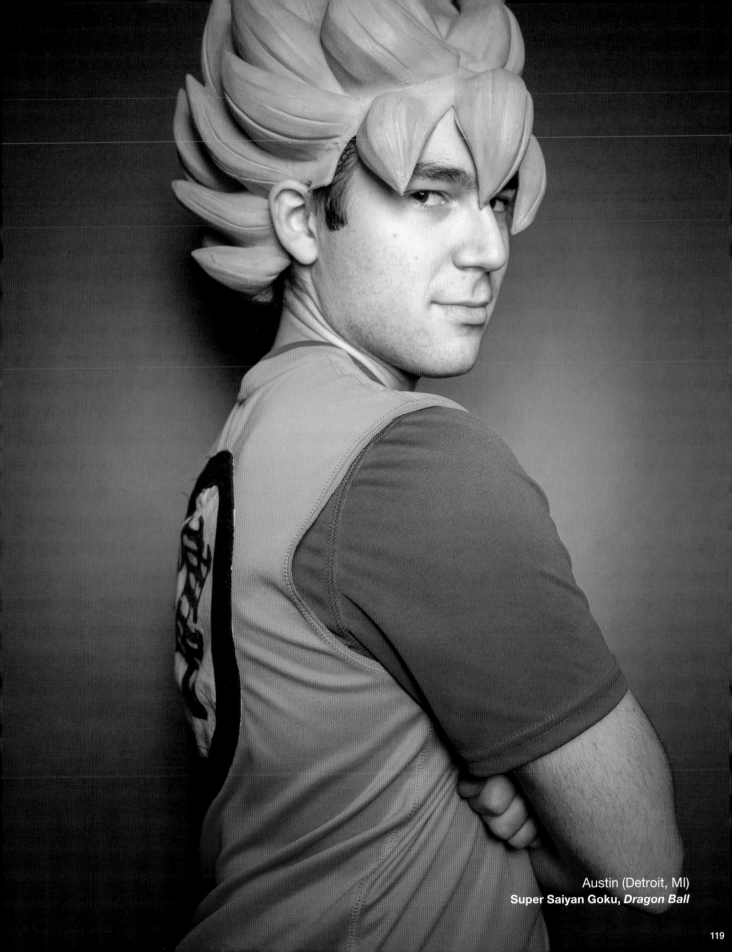

Austin (Detroit, MI)
Super Saiyan Goku, *Dragon Ball*

"Why *Superman*? He represents a person trying to live up to the best potential of himself he can be. He has so much power to do whatever he wants, but he chooses to help everyone. He has said "My powers are not just for me, but for all mankind... for anyone who needs to use them." He is a modern day savior figure for mankind to look towards for how to act in life. He gives you strength to be a hero in your own life, and see past yourself to the needs of others. It's a constant reminder for me to be the best human I can be to those around me."

Bryan (Los Angeles, CA)
Superman

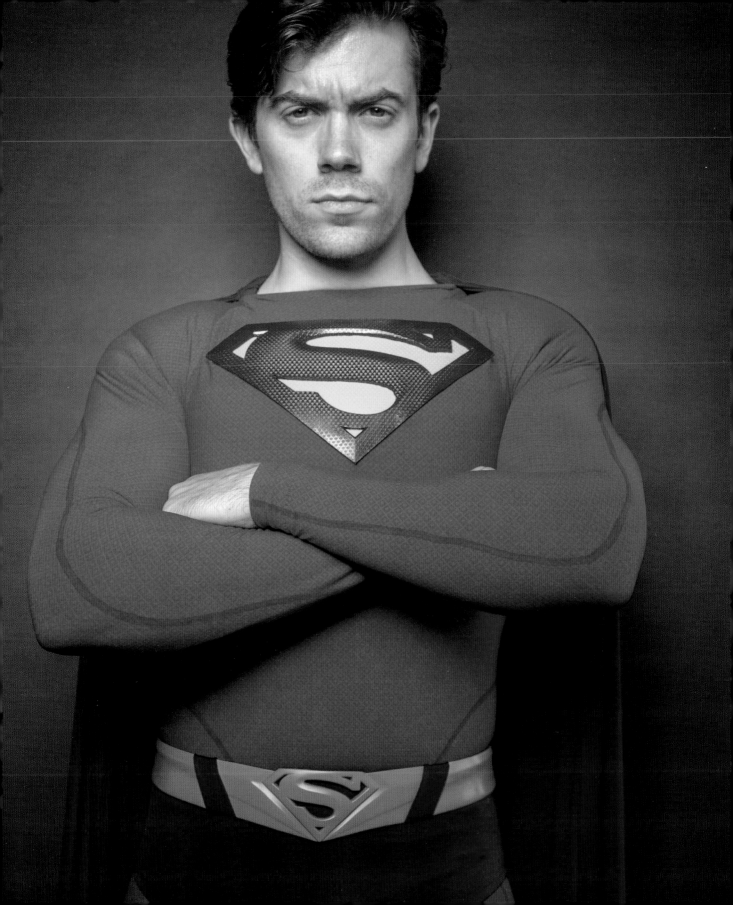

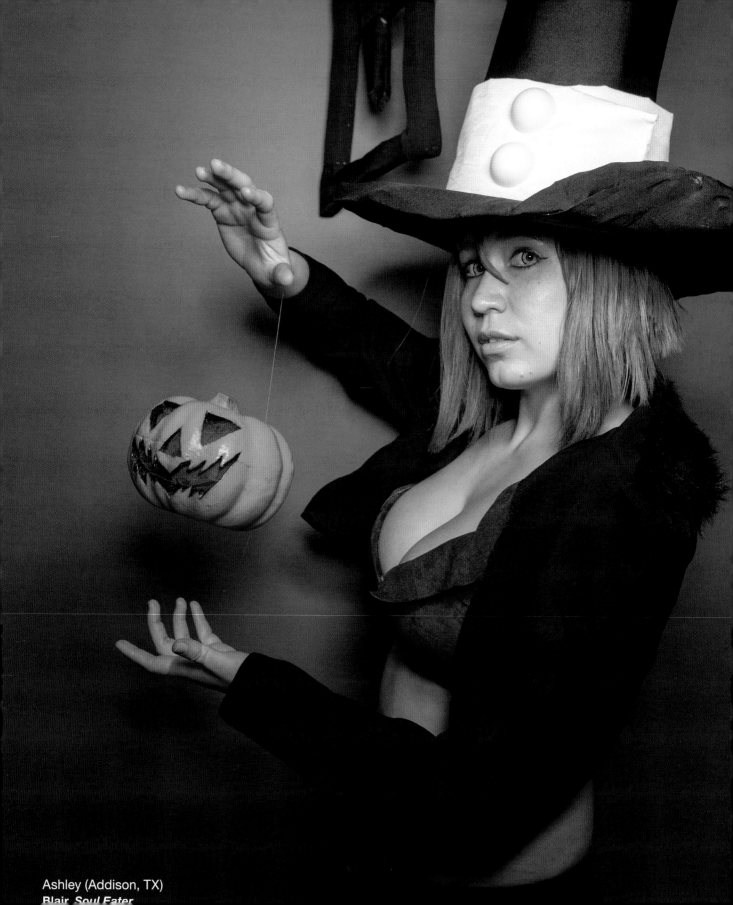

Ashley (Addison, TX)
Blair, *Soul Eater*

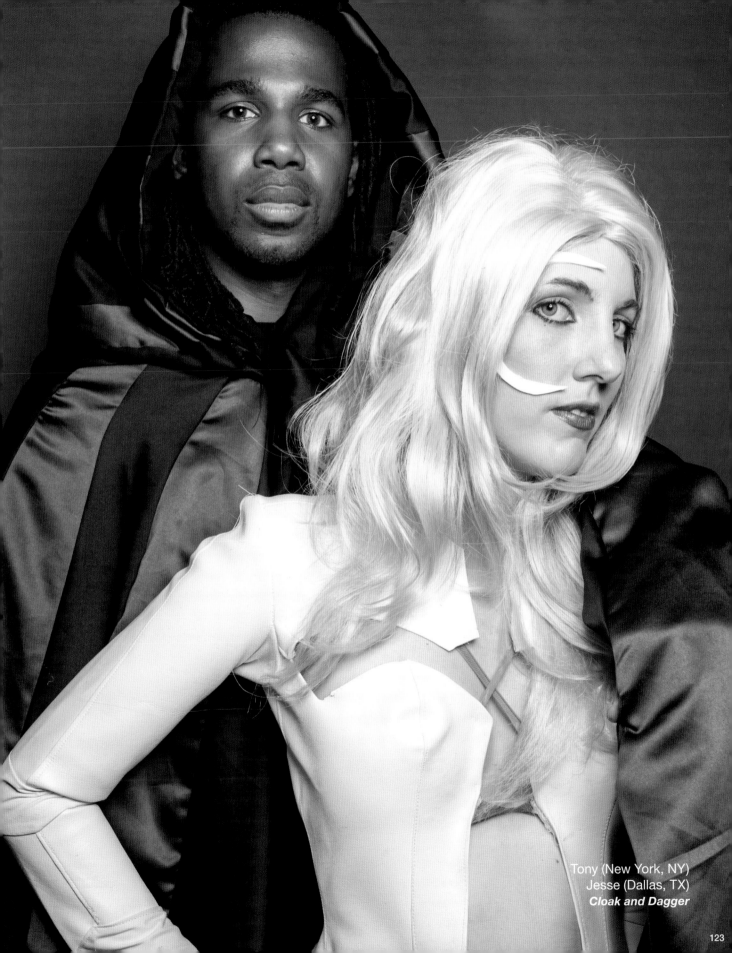

Tony (New York, NY)
Jesse (Dallas, TX)
Cloak and Dagger

123

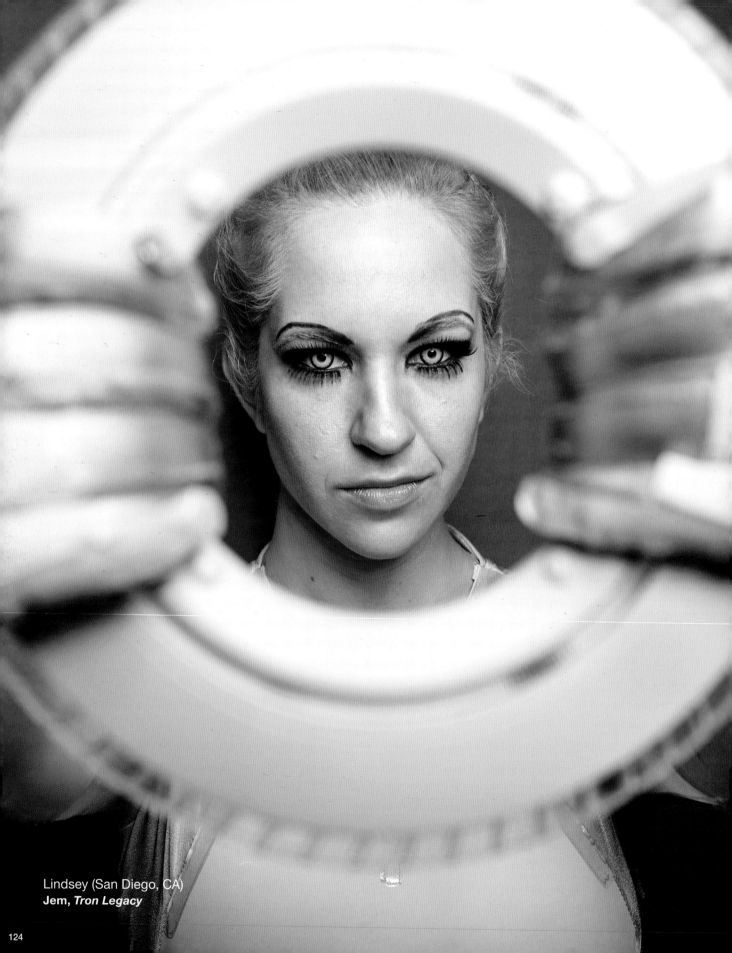

Lindsey (San Diego, CA)
Jem, *Tron Legacy*

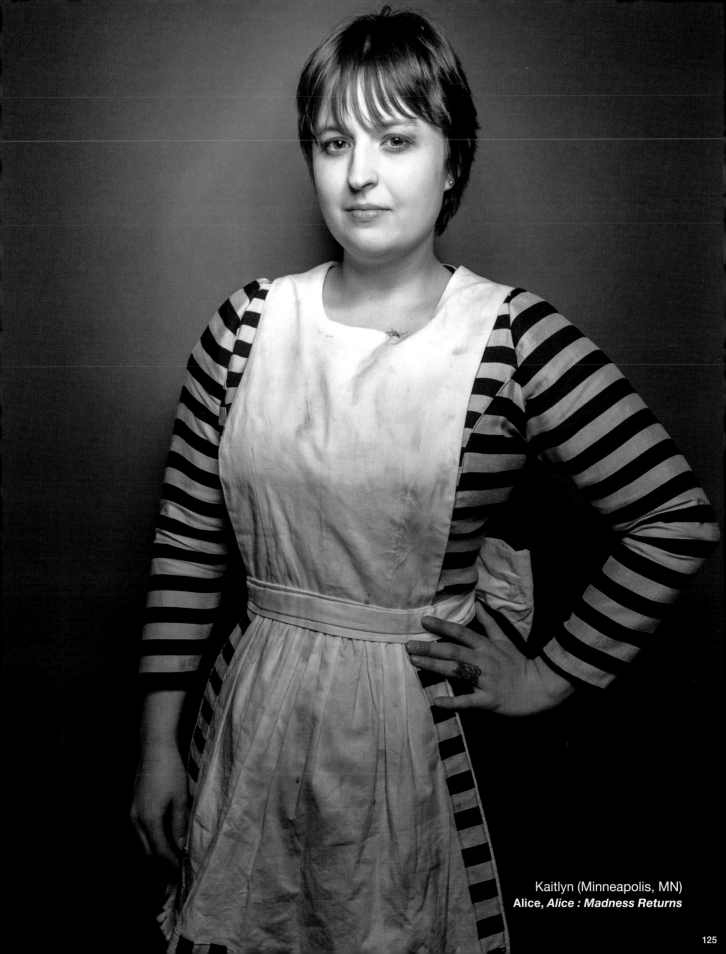

Kaitlyn (Minneapolis, MN)
Alice, _Alice : Madness Returns_

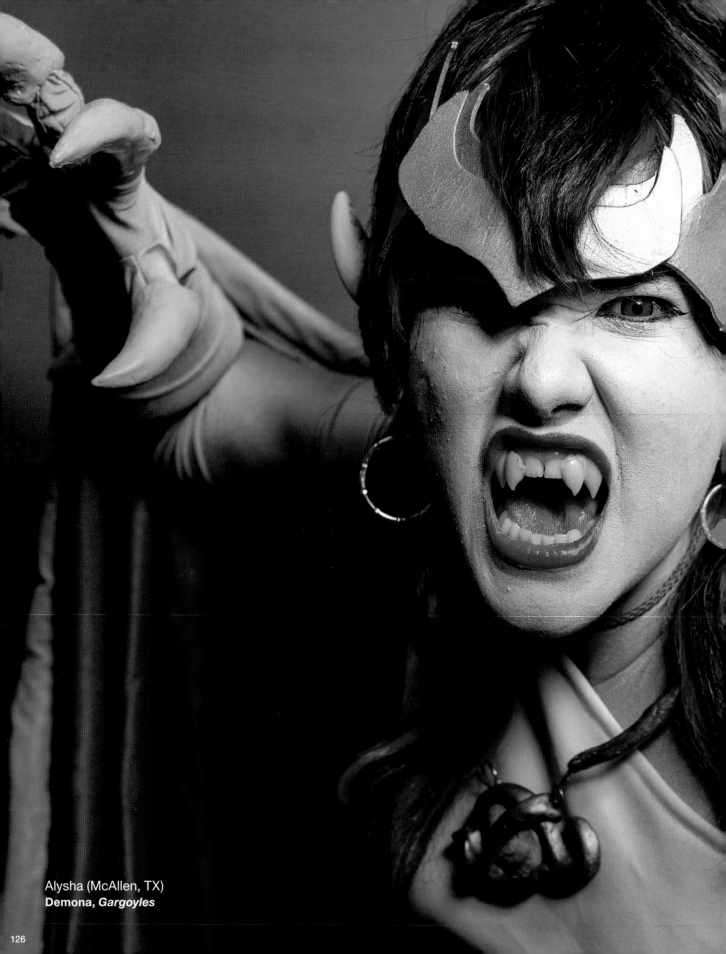

Alysha (McAllen, TX)
Demona, *Gargoyles*

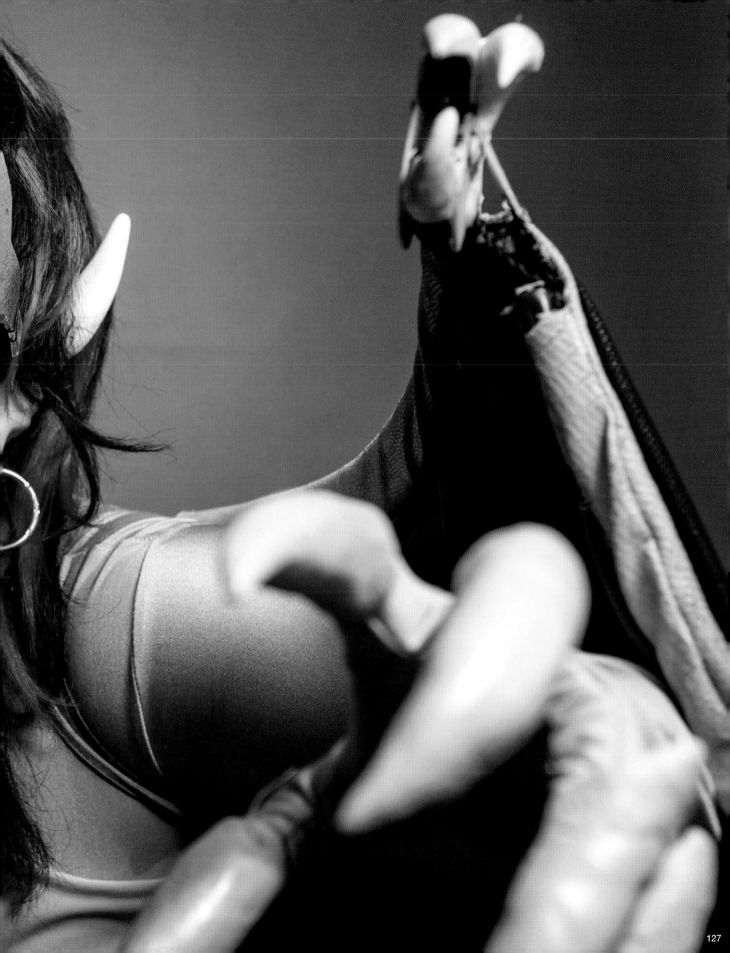

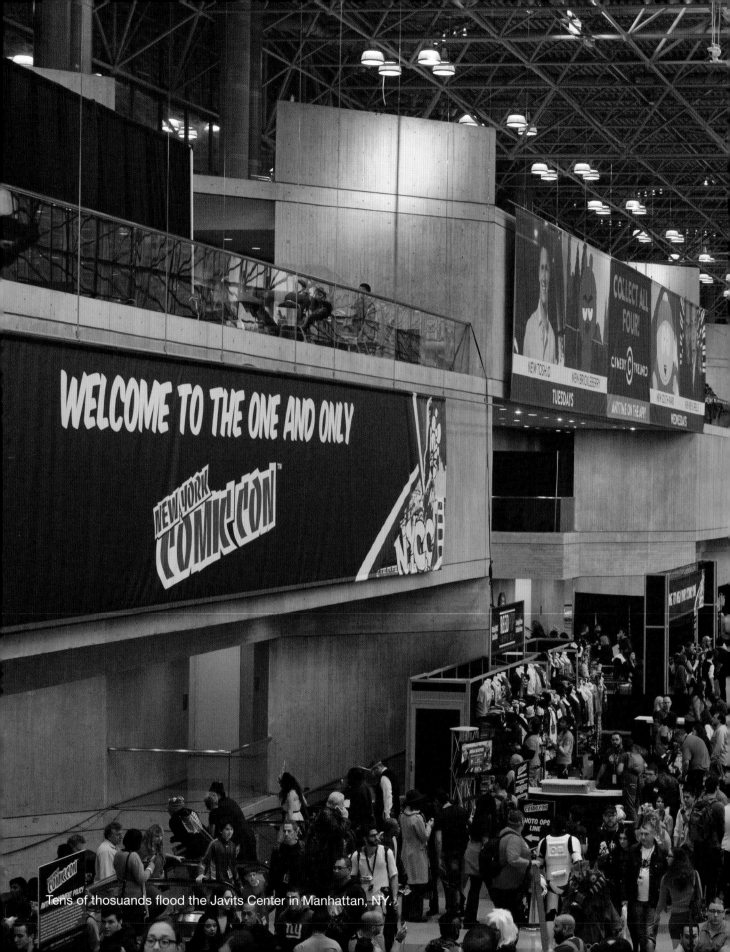

Tens of thosuands flood the Javits Center in Manhattan, NY.

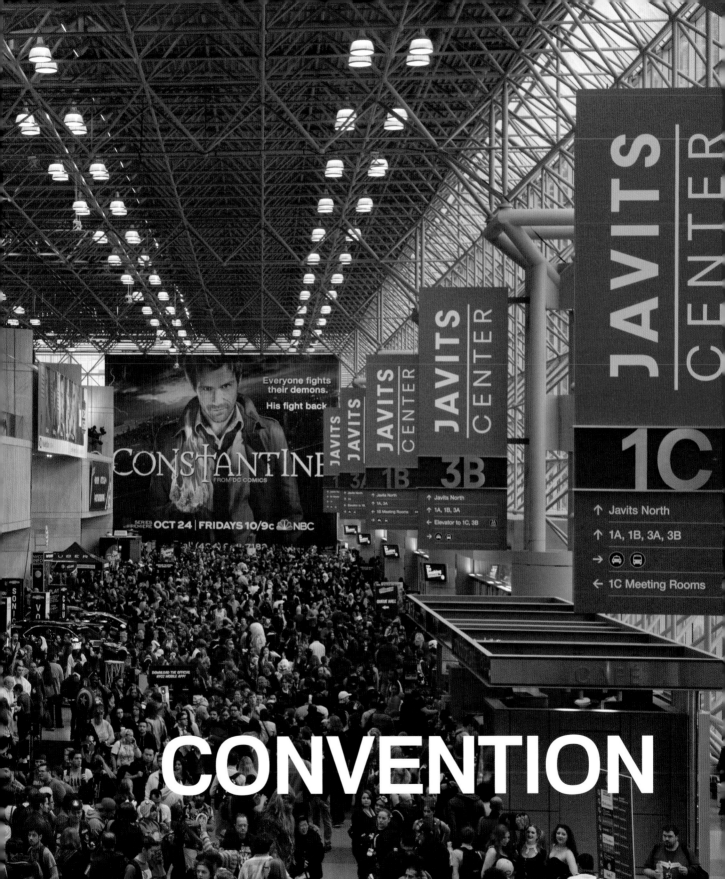

Everyone fights
their demons.

His fight back

CONSTANTINE
FROM DC COMICS

SERIES
PREMIERE OCT 24 | FRIDAYS 10/9c NBC

JAVITS CENTER
JAVITS CENTER
JAVITS CENTER
3A 1B 3B

↑ Javits North
↑ 1A, 3A
↑ 1B Meeting Rooms

↑ Javits North
↑ 1A, 1B, 3A
↓ Elevator to 1C, 3B

JAVITS CENTER

1C
↑ Javits North
↑ 1A, 1B, 3A, 3B
← 1C Meeting Rooms

DOWNLOAD THE OFFICIAL
NYCC MOBILE APP!

CONVENTION

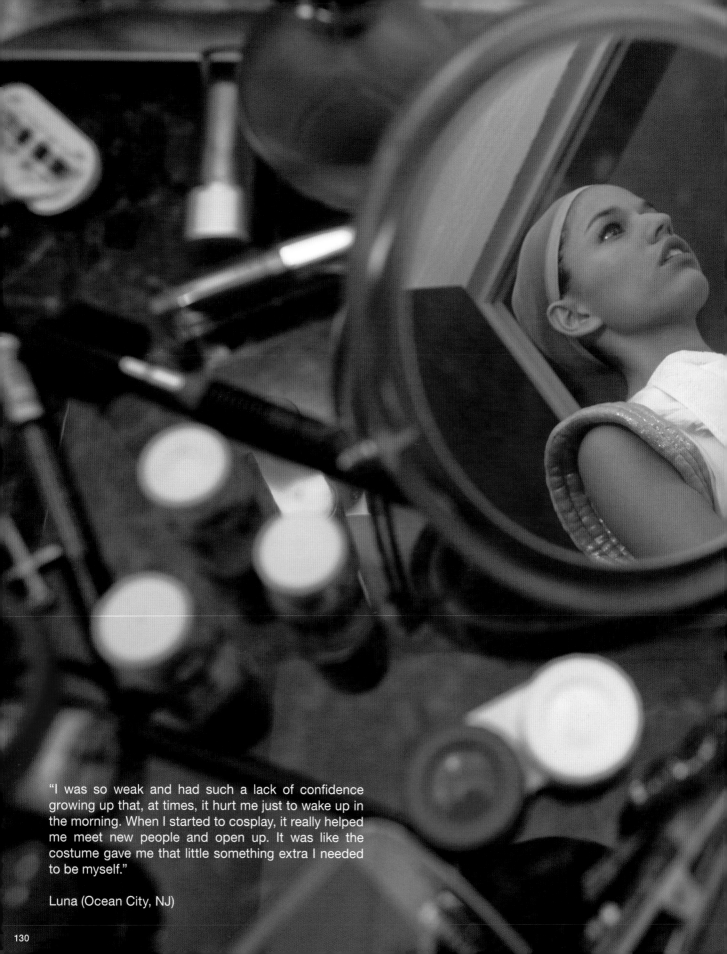

"I was so weak and had such a lack of confidence growing up that, at times, it hurt me just to wake up in the morning. When I started to cosplay, it really helped me meet new people and open up. It was like the costume gave me that little something extra I needed to be myself."

Luna (Ocean City, NJ)

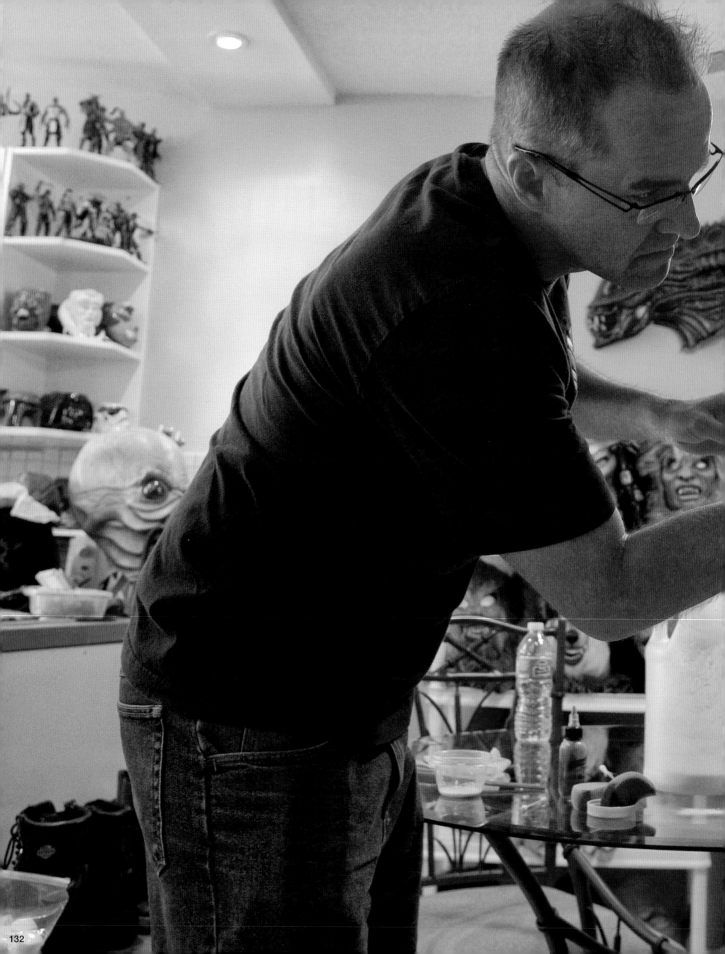

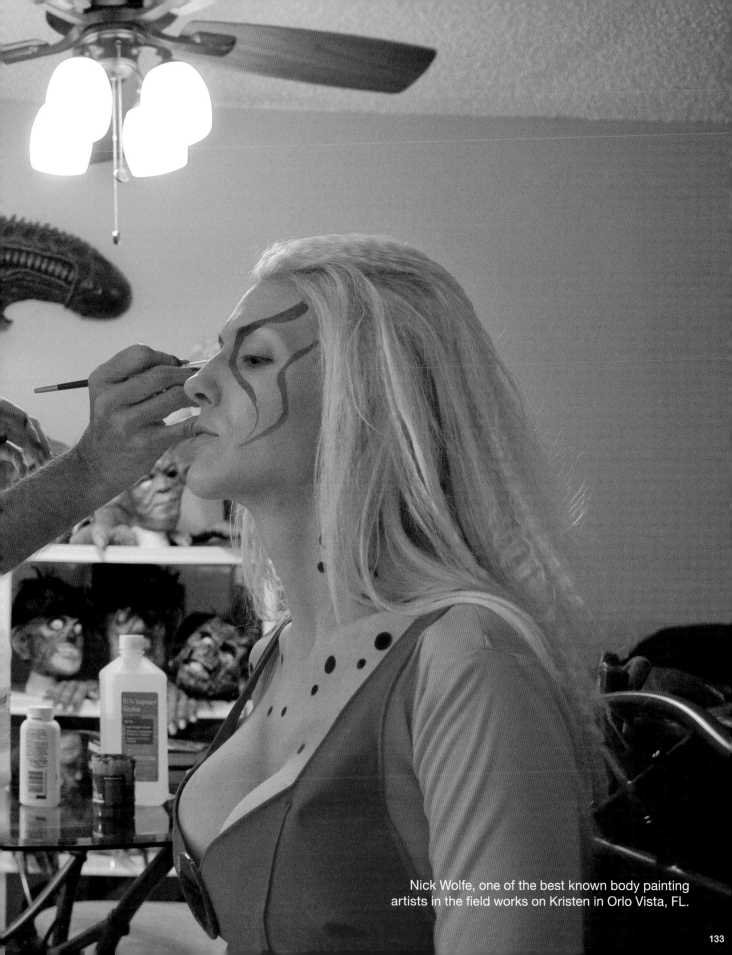

Nick Wolfe, one of the best known body painting
artists in the field works on Kristen in Orlo Vista, FL.

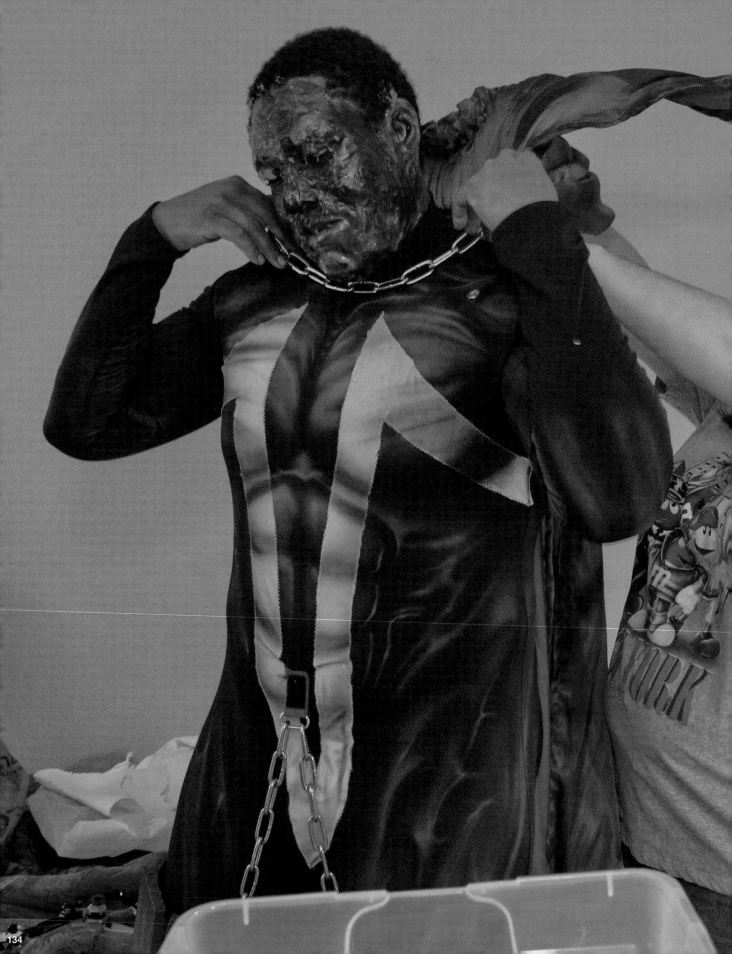

"I've always loved Spawn as a character but loved his design even more. It took me about 15 hours total to complete. It's also the first suit that I completely sewed myself, so I'm proud of that. For fans of the character it's always excitement. Not only do they get to see a rare Spawn cosplay, but no one does the burnt face. The best was when Todd McFarlane messaged me with how he loved it.

The charity work is something that words can't describe. The feeling is absolutely amazing. There really is nothing better than a little one running up with arms out wanting a hug from their favorite superhero. That's a lasting impression not just for them but for me too. I try to advertise a lot of what I do, not for recognition but, to try and inspire other cosplayers to get more involved. I don't think many really know the influence and power they have.

Cosplaying means something different to everyone; for me it's a multitude of things, mainly inspiration. I've found that you can really inspire others, young and old in a positive way through cosplay. It's also a form of escape; it's a chance to become someone else. You put a costume on and you often feel that you are that character."

Michael (Youngstown, OH)

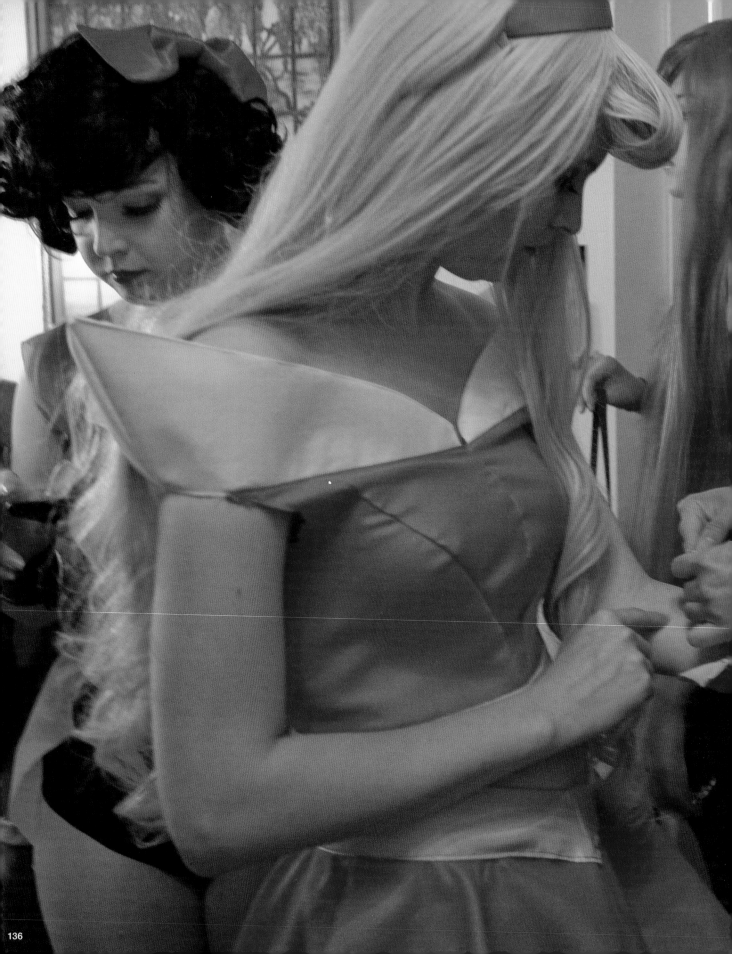

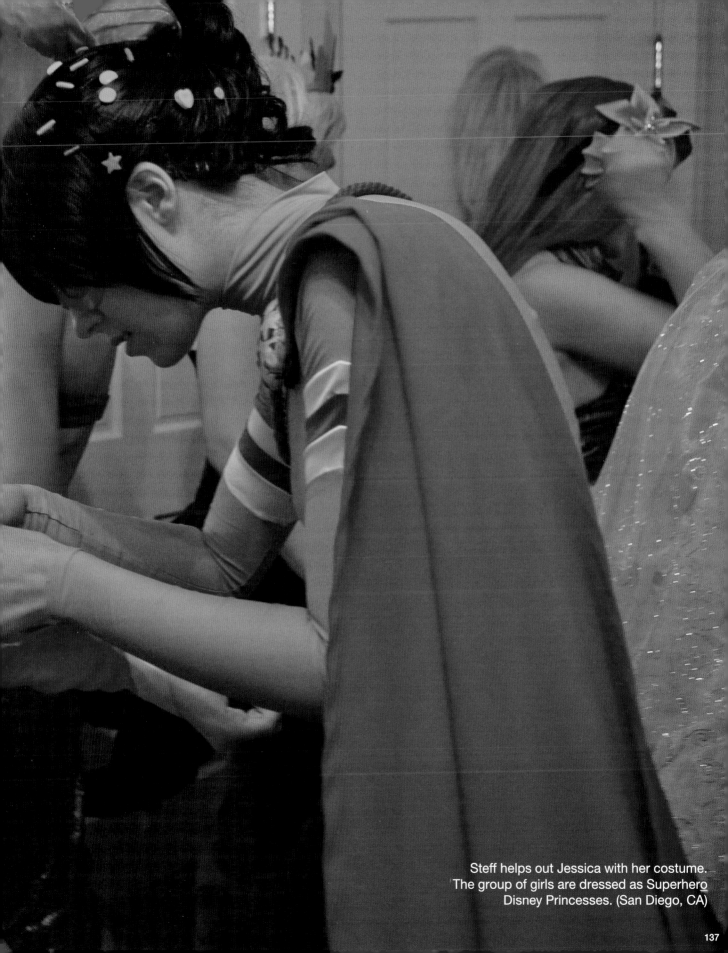

Steff helps out Jessica with her costume.
The group of girls are dressed as Superhero
Disney Princesses. (San Diego, CA)

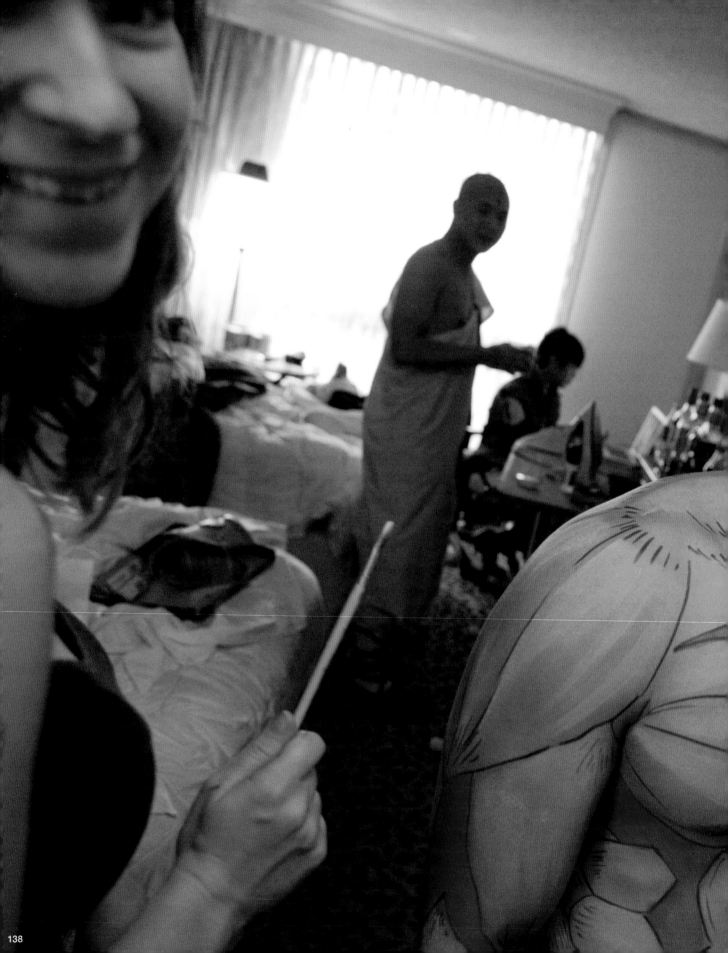

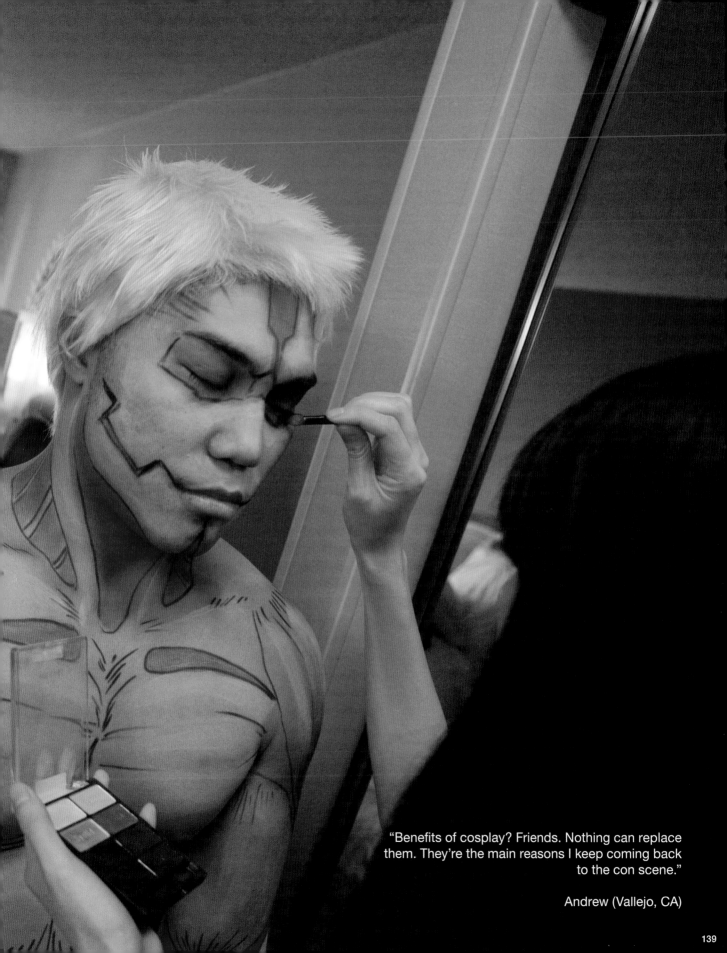

"Benefits of cosplay? Friends. Nothing can replace them. They're the main reasons I keep coming back to the con scene."

Andrew (Vallejo, CA)

"I researched for months, gathered materials and made everything from scratch. From the undergarments to the crown, it was all made by me--over 14,000 rhinestones and roughly 10,000 pearls all hand-sewn and placed by hand. Esther was, hands down, my most difficult piece – honestly something that probably shouldn't be done by someone who's only been sewing for three years and considered a novice.

Considering it took 10 months to completely fabricate (painting, hand-stitching, lighting, jewelry), I was extremely happy and excited to have it finished. If it weren't for my friends and family, she honestly wouldn't have gotten done."

Kelley (Ooltewah, TN)

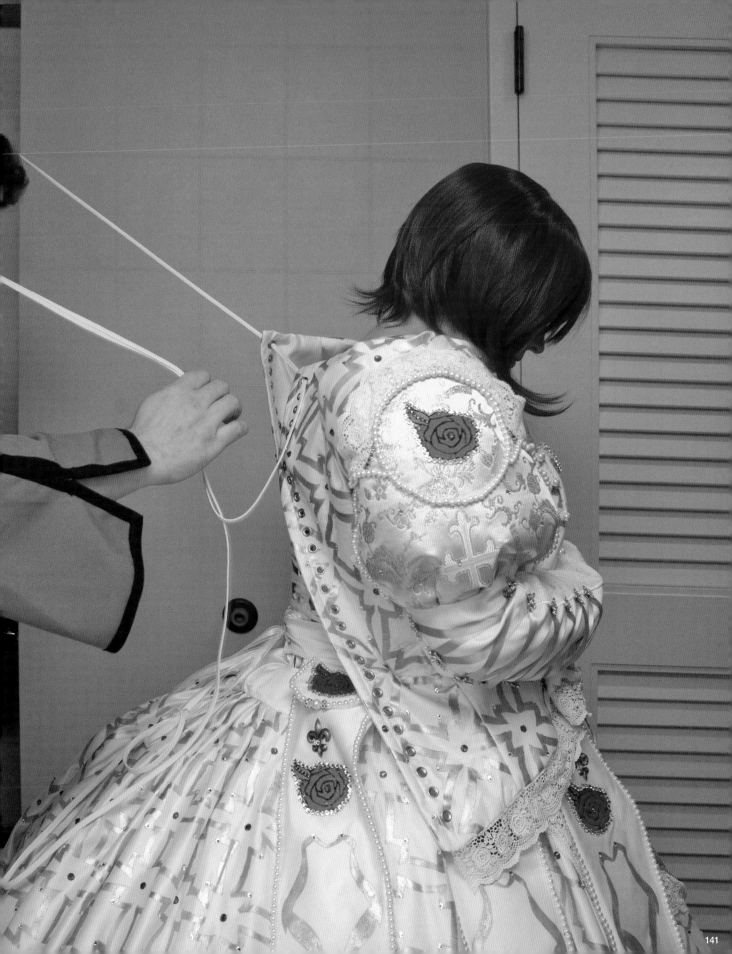

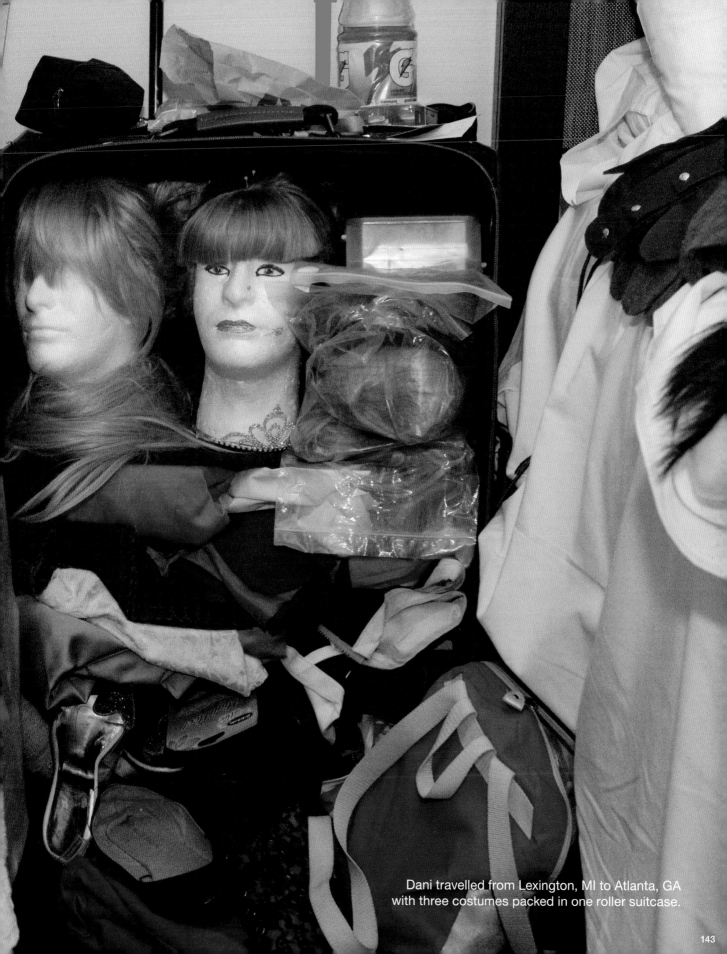

Dani travelled from Lexington, MI to Atlanta, GA
with three costumes packed in one roller suitcase.

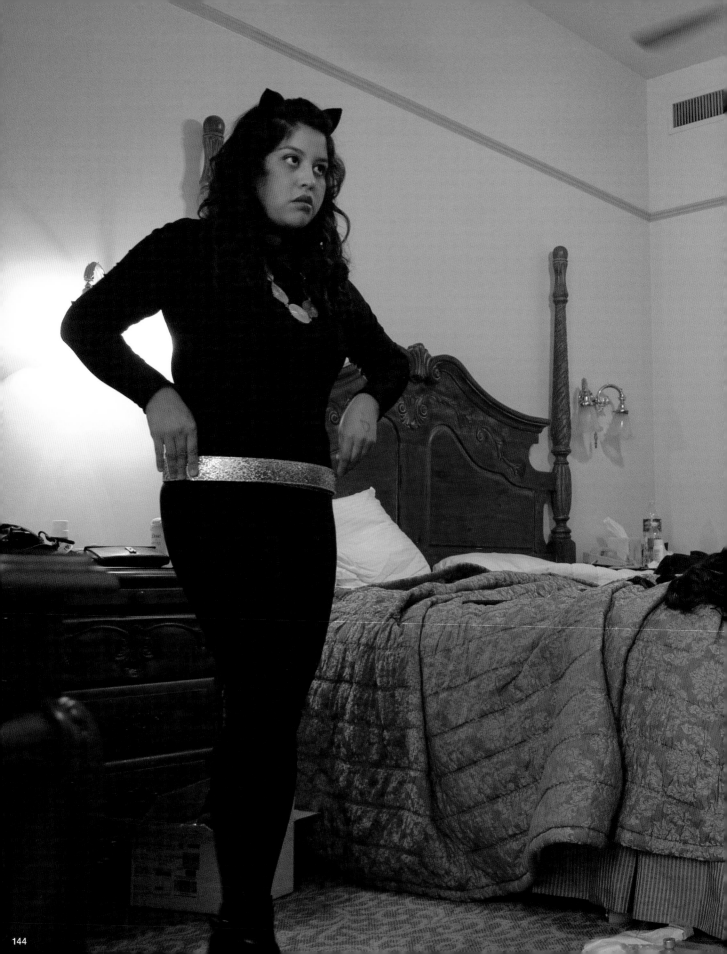

"San Diego is regarded as the best comic con in the world, so it's intimidating for a first-time cosplayer to be there amongst the talent the convention attracts. In 2013, I finally silenced that voice of doubt and realized that life's too short to deny myself the opportunity to cosplay for fear that I might be scrutinized by strangers. I contacted a cosplayer in Canada named Kristen Welker, who owns and runs *BadaBoom! Costumes*, and commissioned her to make the Classic Catwoman suit, claws and belt for me."

Sara (Houston, TX)

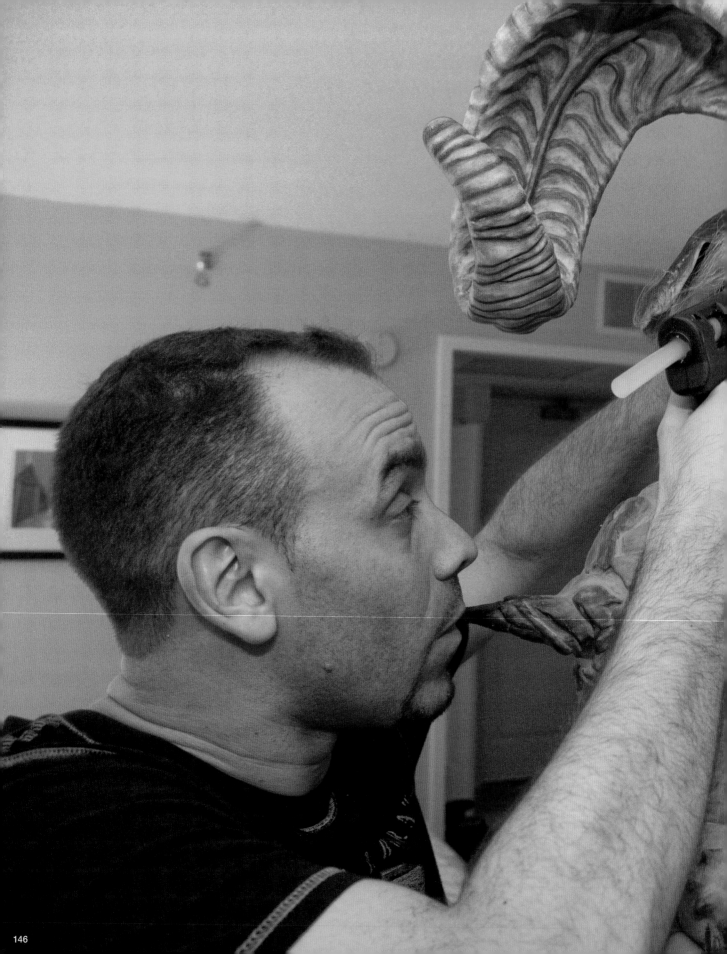

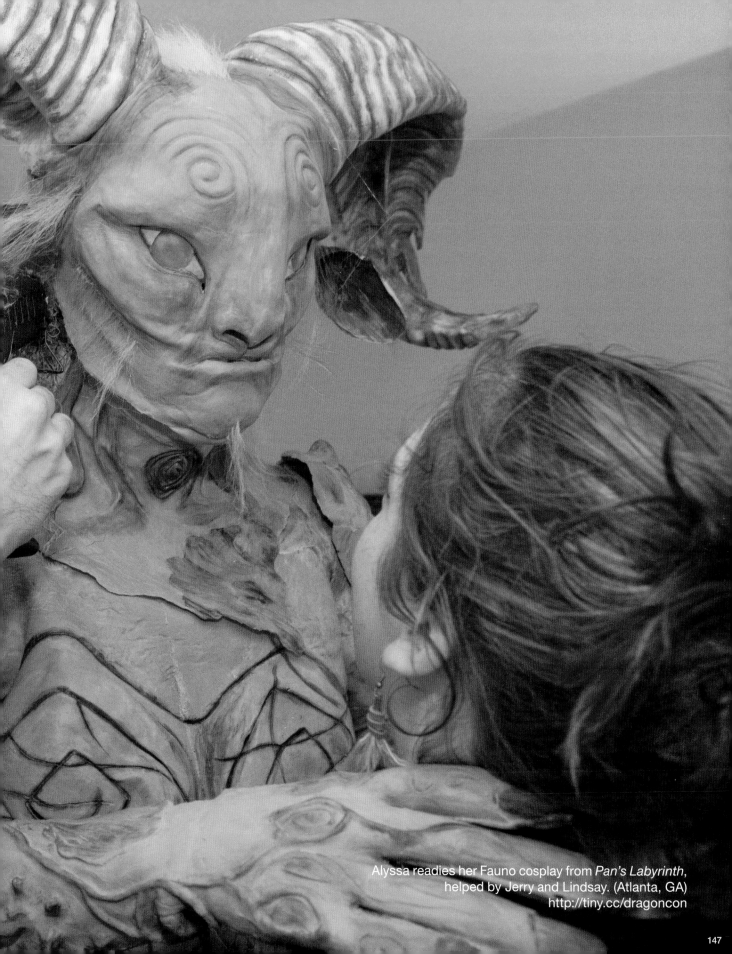

Alyssa readies her Fauno cosplay from *Pan's Labyrinth*,
helped by Jerry and Lindsay. (Atlanta, GA)
http://tiny.cc/dragoncon

"In 2009 we both attended *The Venture Bros.* panel in our costumes - Steven as The Monarch and me as Dr. Mrs.The Monarch. After the panel, I saw him down the hall and flagged him down because I wanted a photo with The Monarch! My mom actually took the photo for us, and that's the exact moment we met.

It was a pretty simple and quick meeting. I don't think we even talked much. I'm not sure I even got his name! He was there with two of his friends, but I didn't get a photo with them or talk to them I was shy and he was really tall and I don't think he cared to talk to much to me.

We didn't exchange info and I did the creep on *DeviantArt* and stumbled across his profile! He now tells me how lucky I was he saw it because, apparently, he never went on there and just happened to catch my message. I hit him up the next year on *DeviantArt* and asked what day he was wearing the Monarch and if he wanted to join forces and our relationship grew from there!"

Kit and Steven (Los Angeles, CA)

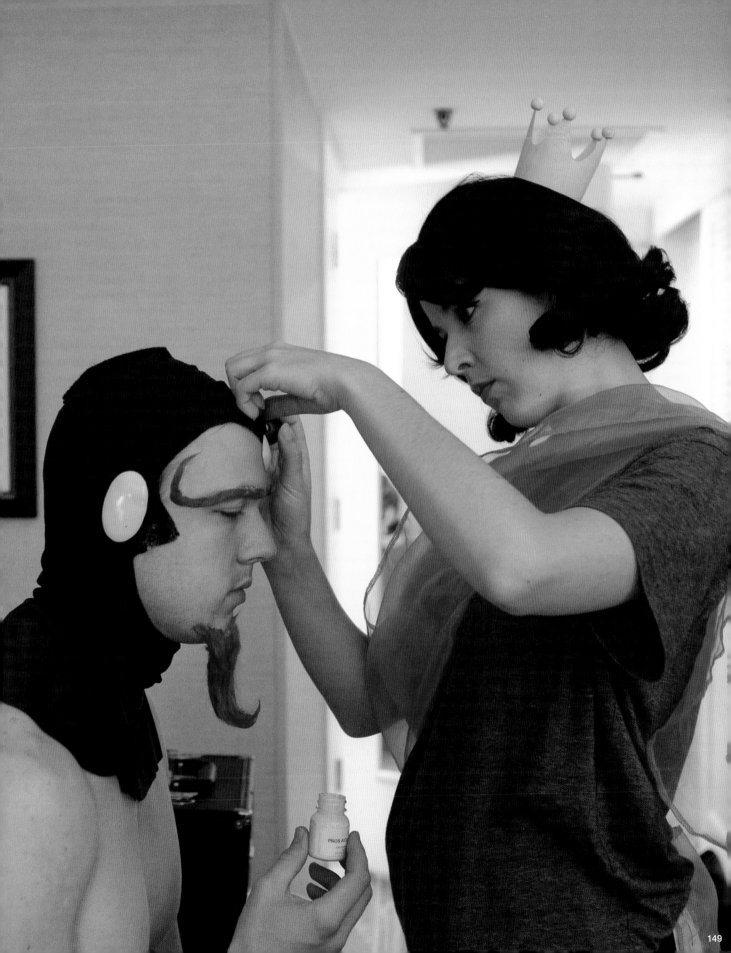

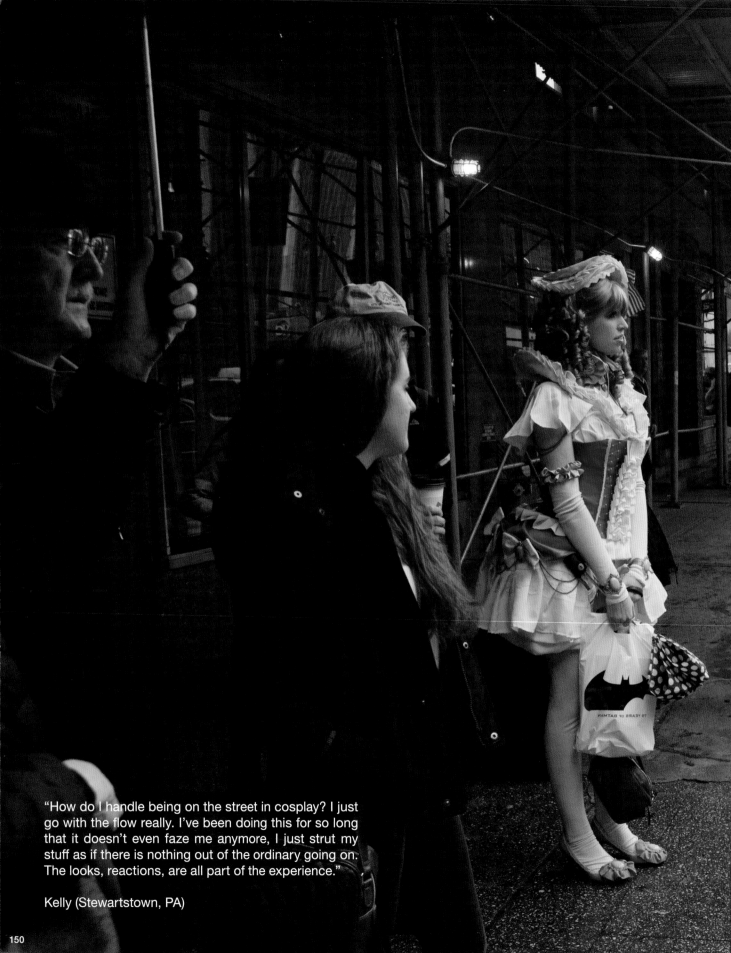

"How do I handle being on the street in cosplay? I just go with the flow really. I've been doing this for so long that it doesn't even faze me anymore, I just strut my stuff as if there is nothing out of the ordinary going on. The looks, reactions, are all part of the experience."

Kelly (Stewartstown, PA)

150

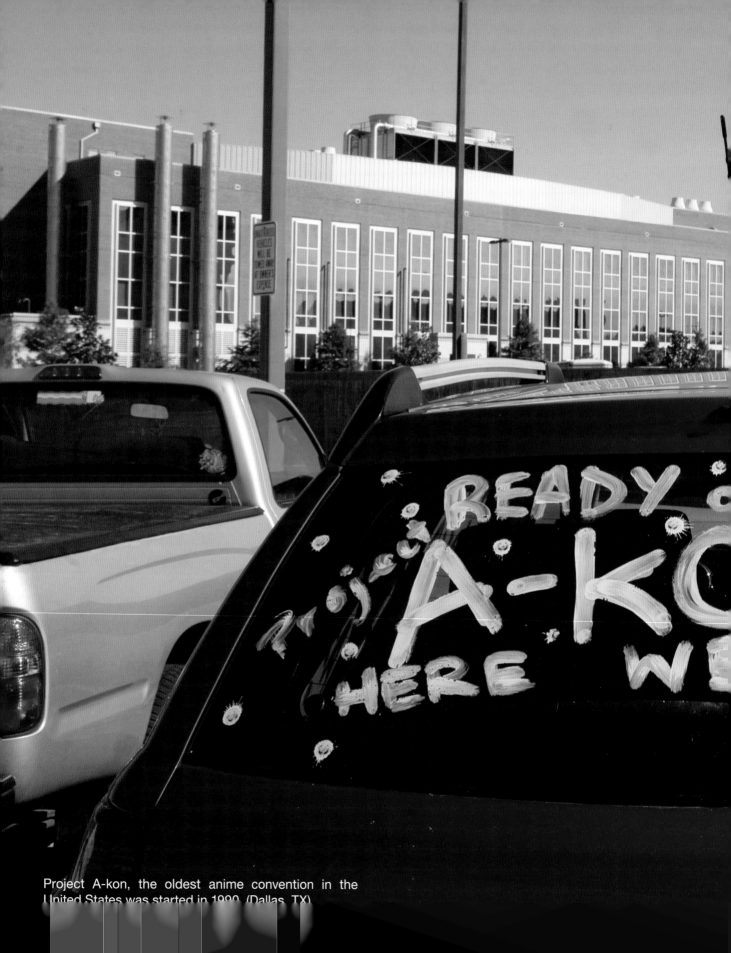

Project A-kon, the oldest anime convention in the
United States was started in 1990. (Dallas, TX)

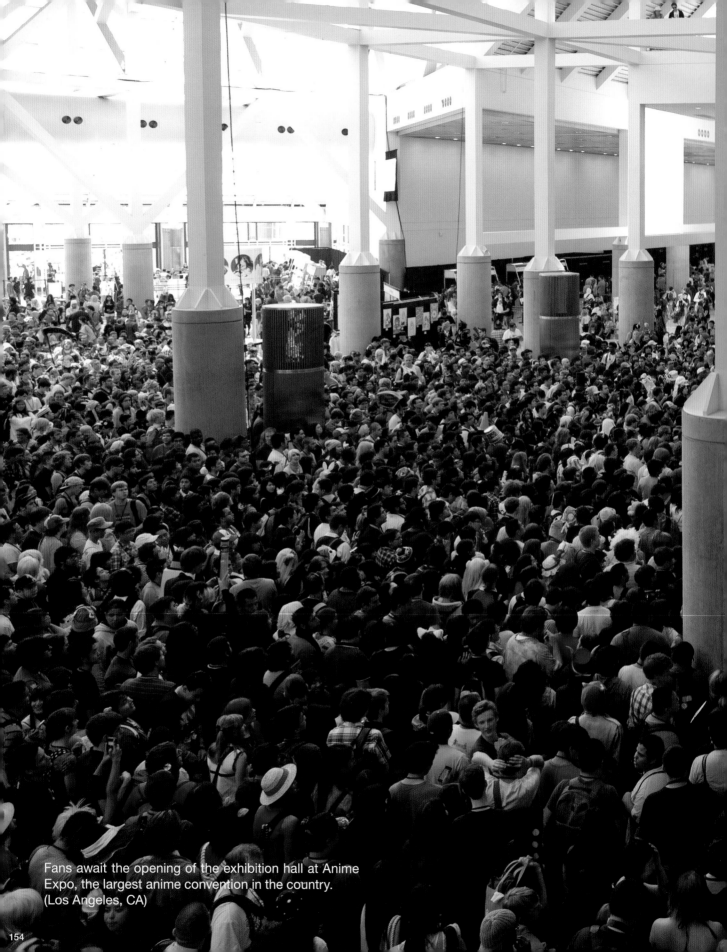

Fans await the opening of the exhibition hall at Anime
Expo, the largest anime convention in the country.
(Los Angeles, CA)

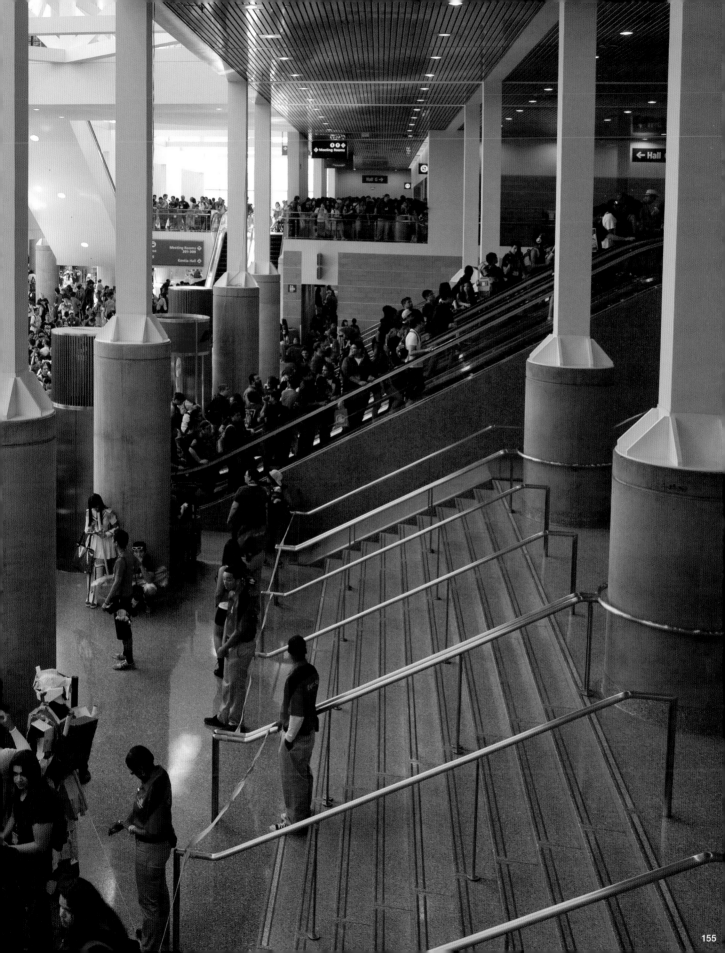

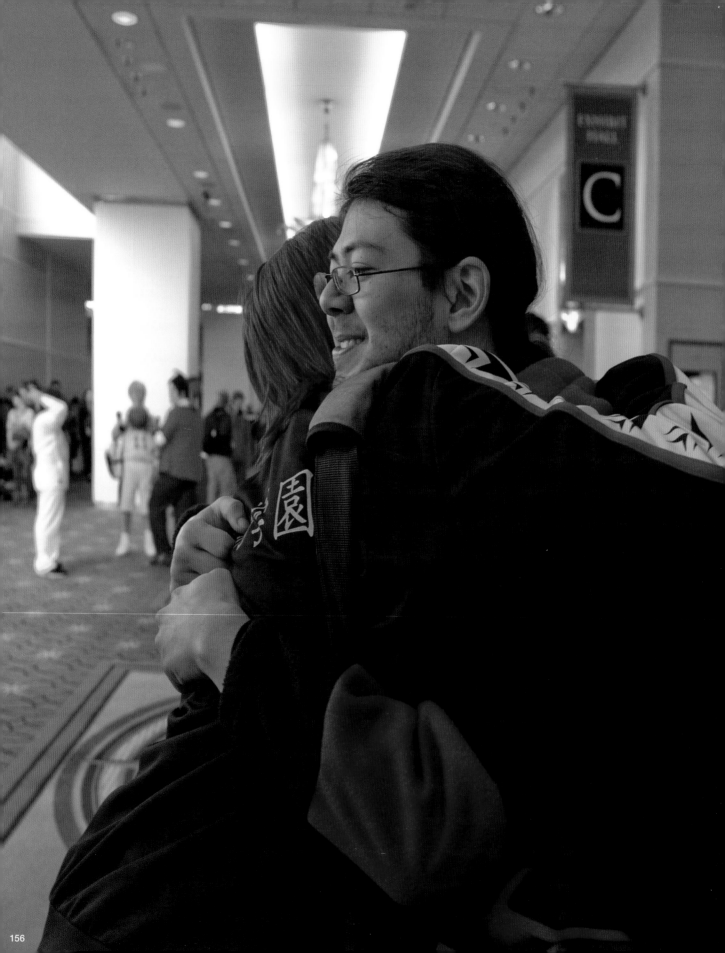

"Conventions are a place where someone who works minimum wage and someone who gets a five-figure paycheck are equal and get just as excited discussing, fanboy/fangirling out or watching a series together."

Richard (Fairfax Station, VA)

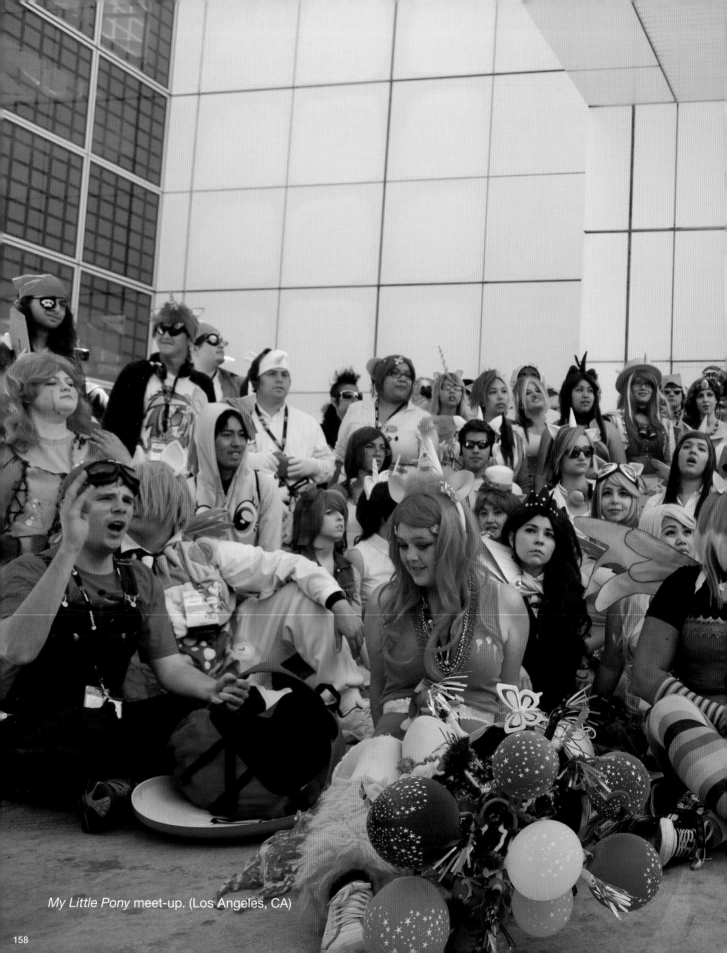

My Little Pony meet-up. (Los Angeles, CA)

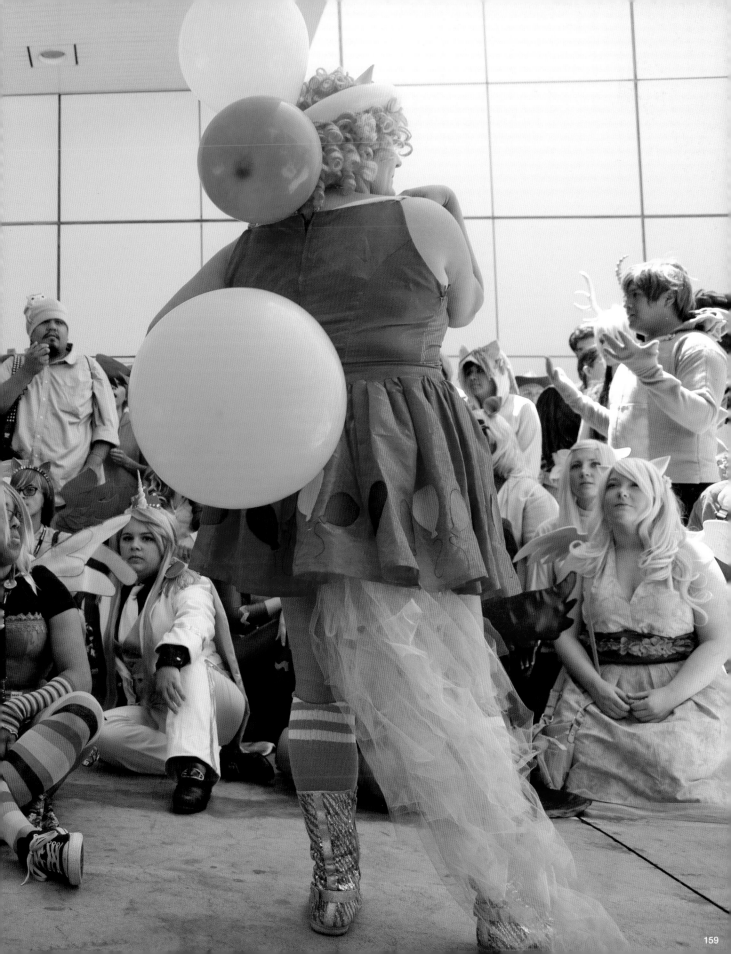

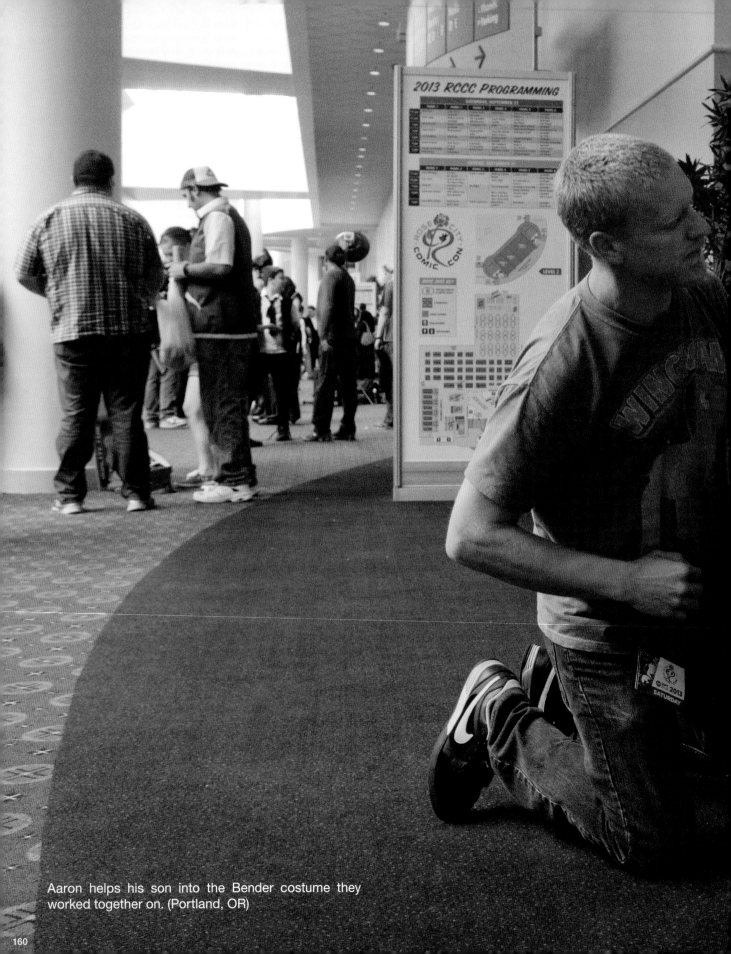

Aaron helps his son into the Bender costume they worked together on. (Portland, OR)

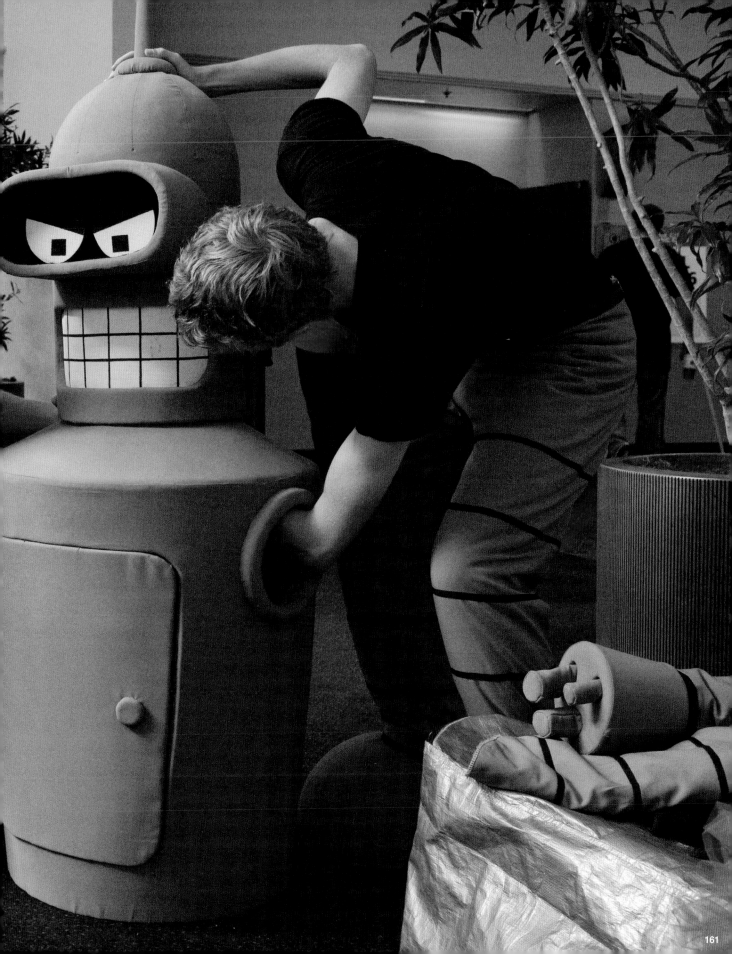

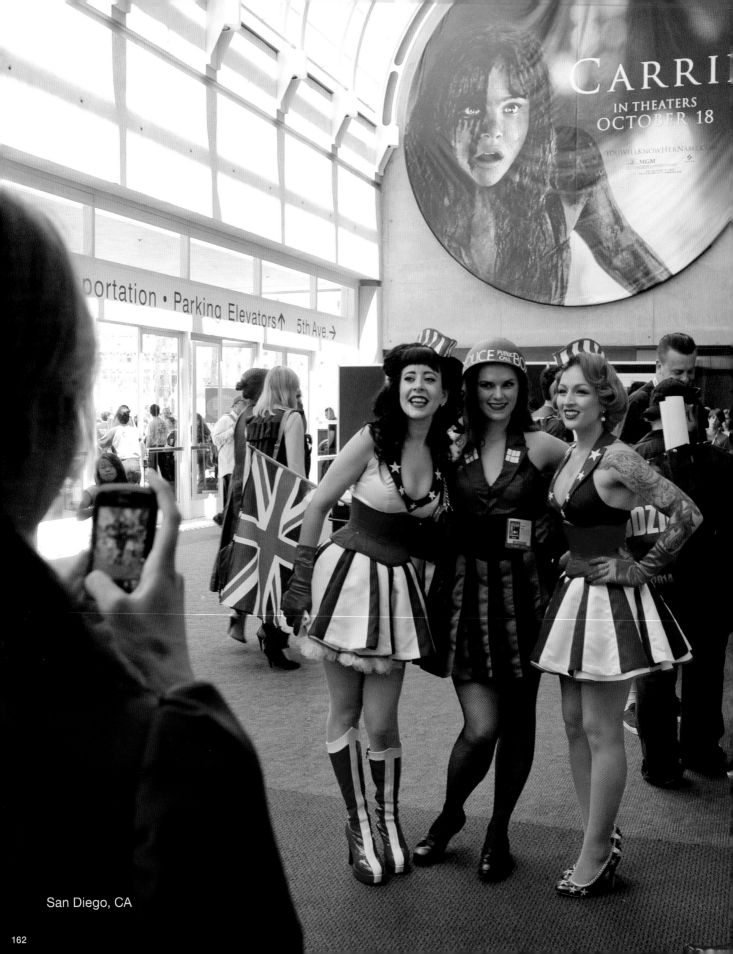

CARRIE

IN THEATERS
OCTOBER 18

YOUWILLKNOWHERNAME.COM

MGM

...portation • Parking Elevators ↑ 5th Ave. →

San Diego, CA

162

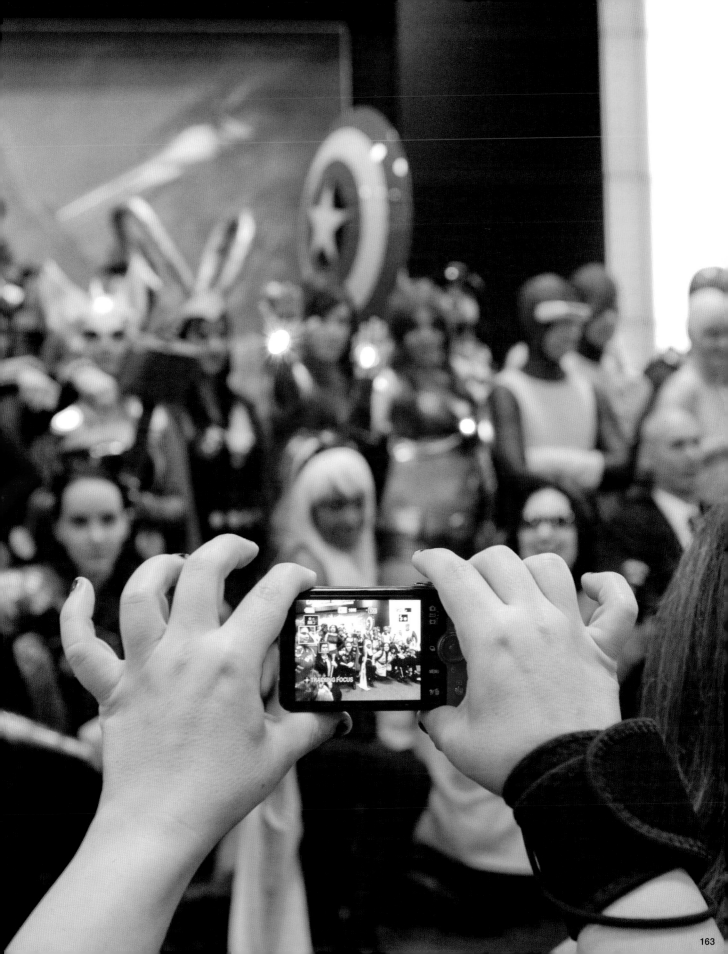

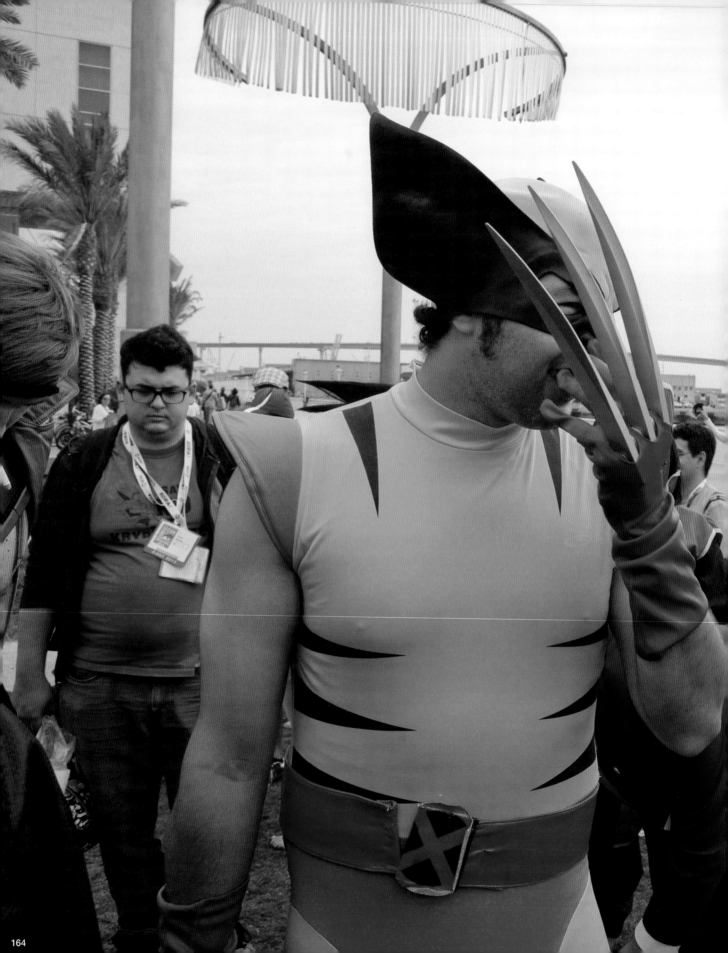

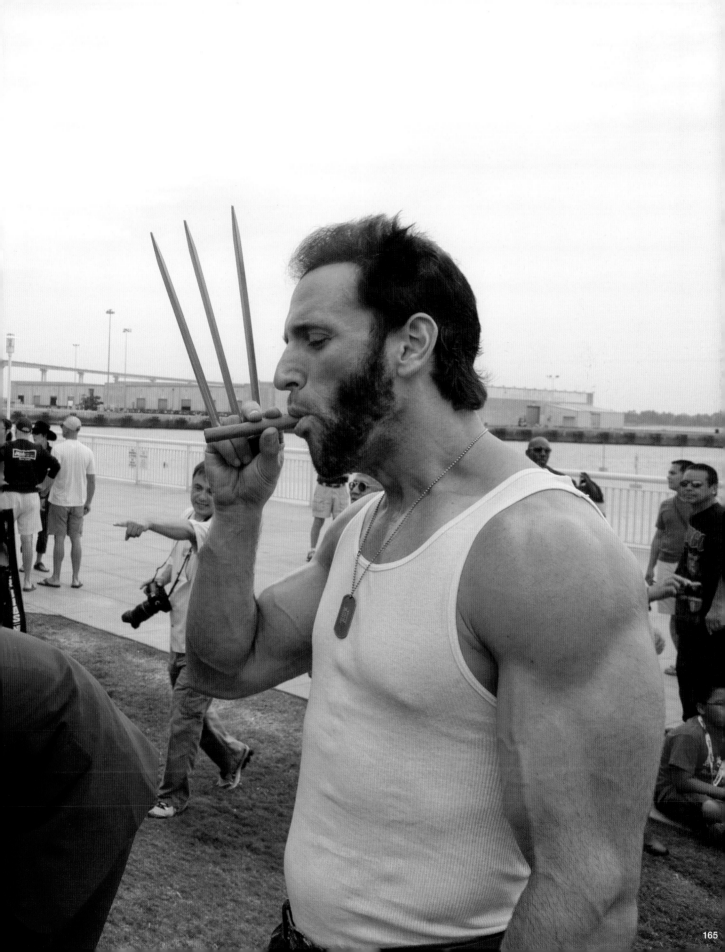

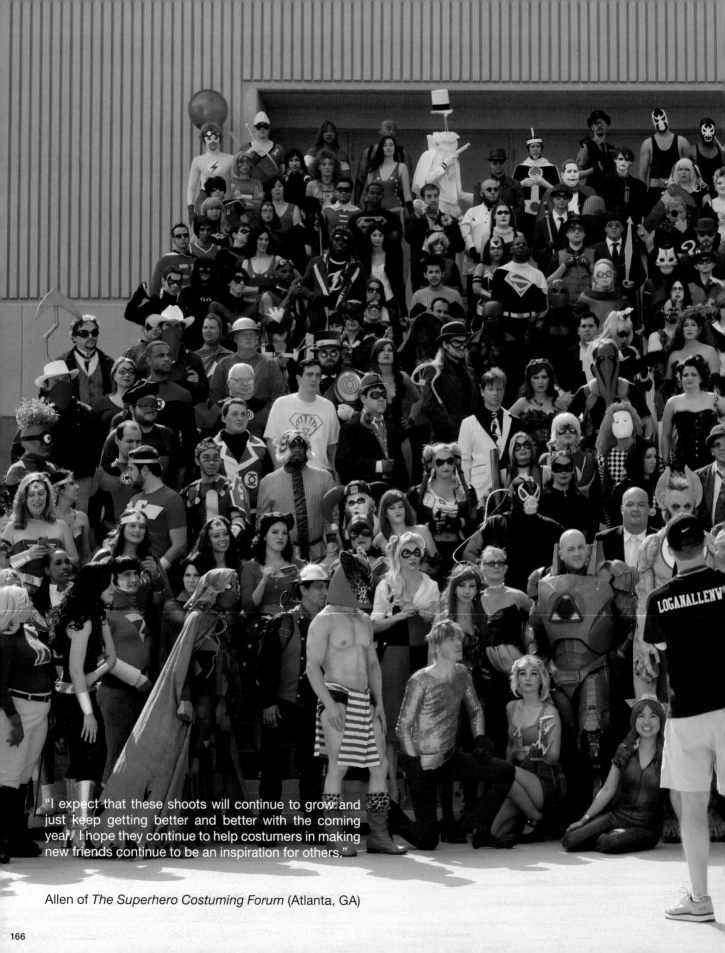

"I expect that these shoots will continue to grow and just keep getting better and better with the coming year. I hope they continue to help costumers in making new friends continue to be an inspiration for others."

Allen of *The Superhero Costuming Forum* (Atlanta, GA)

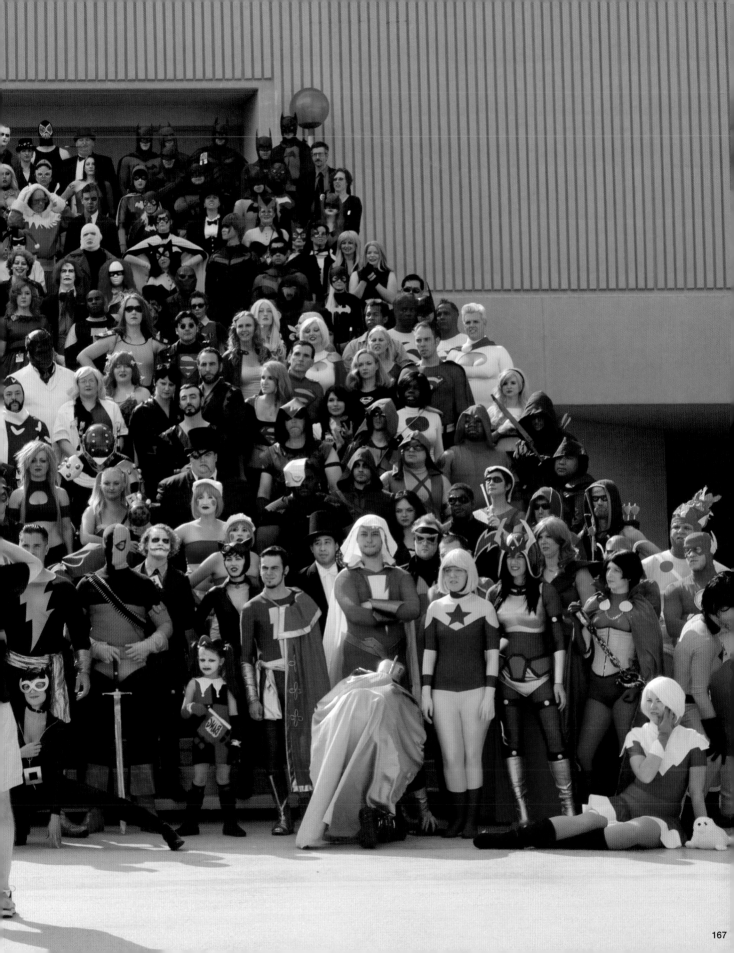

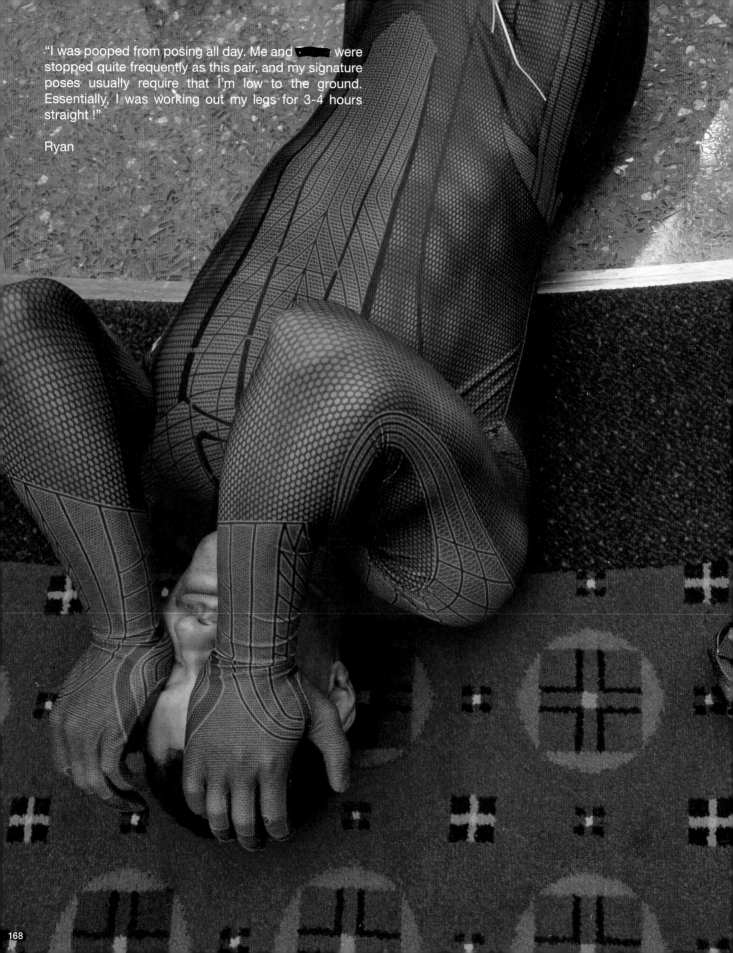

"I was pooped from posing all day. Me and ▮▮▮▮▮ were stopped quite frequently as this pair, and my signature poses usually require that I'm low to the ground. Essentially, I was working out my legs for 3-4 hours straight !"

Ryan

168

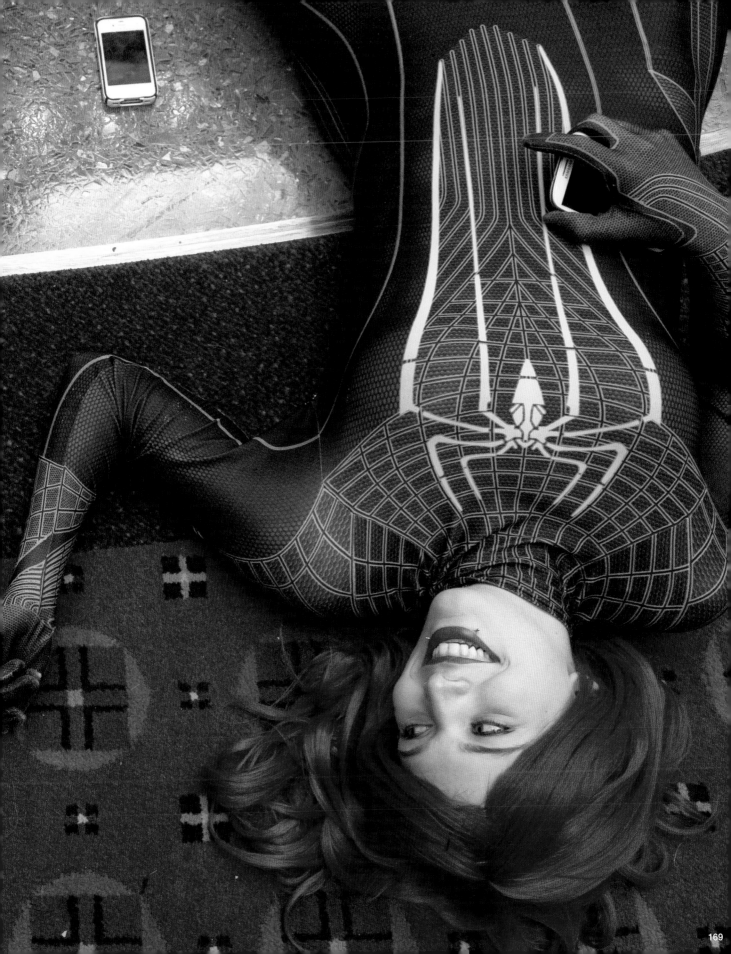

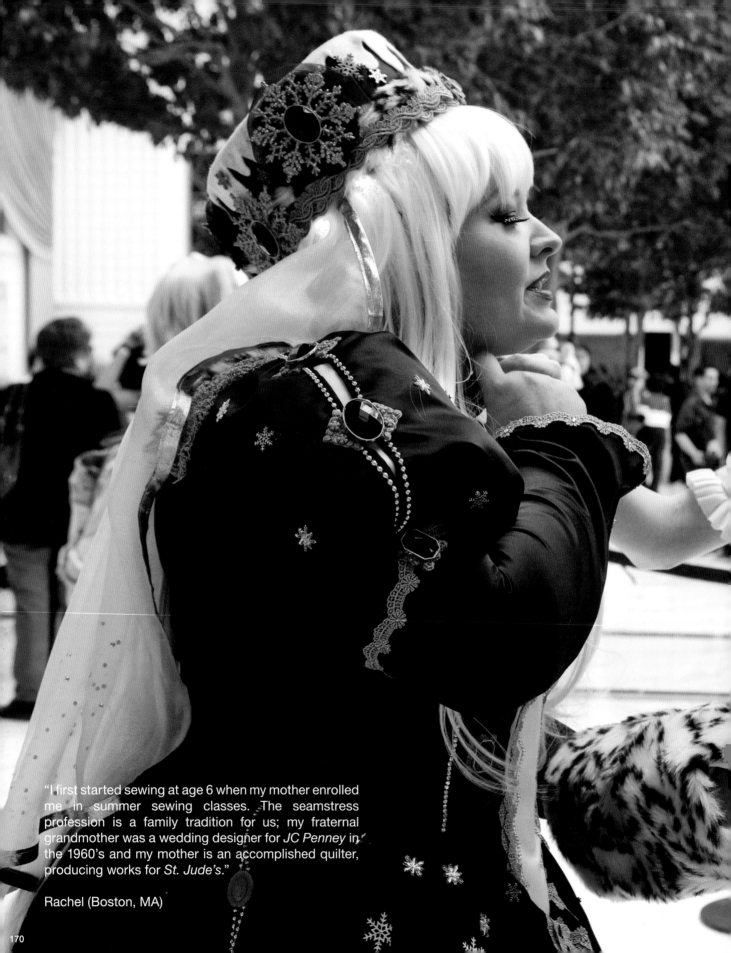

"I first started sewing at age 6 when my mother enrolled me in summer sewing classes. The seamstress profession is a family tradition for us; my fraternal grandmother was a wedding designer for *JC Penney* in the 1960's and my mother is an accomplished quilter, producing works for *St. Jude's*."

Rachel (Boston, MA)

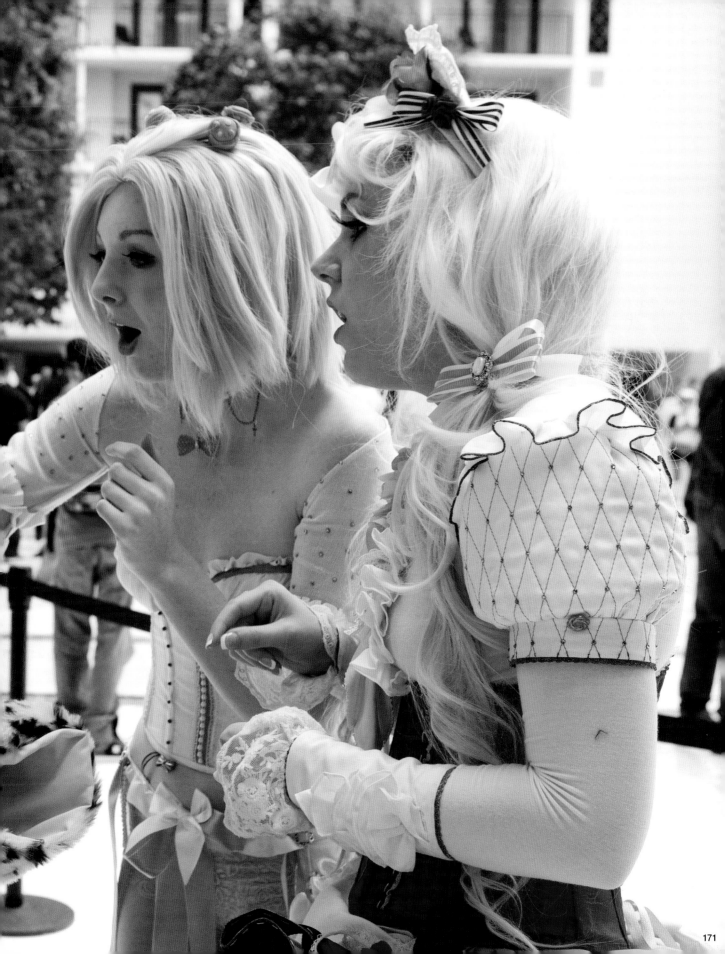

Danielle (Roanoke, VA)

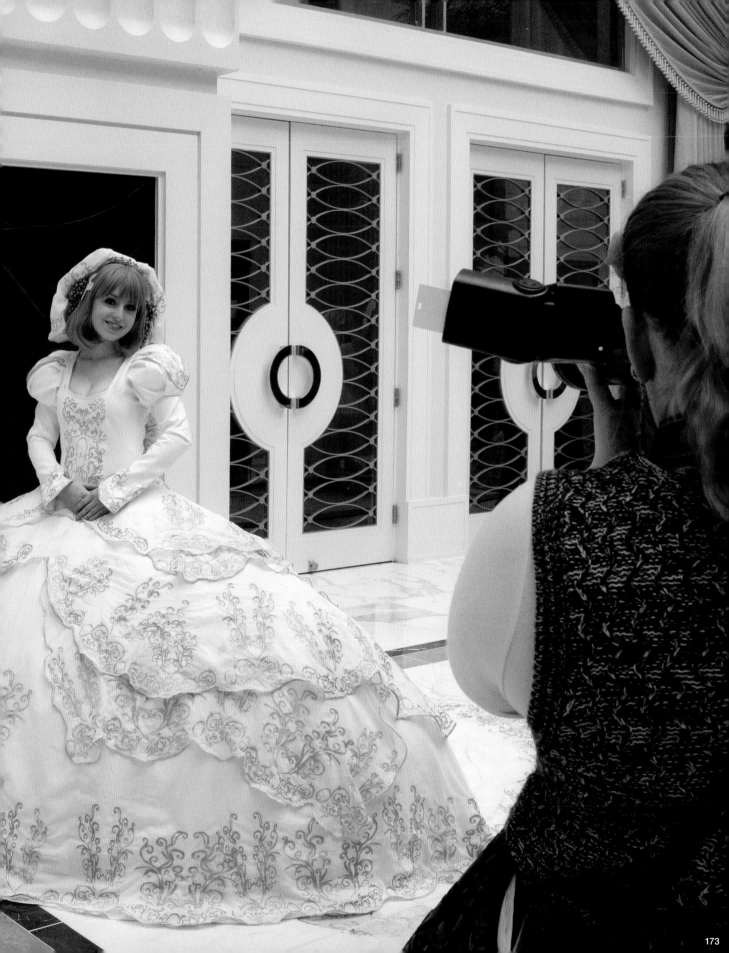

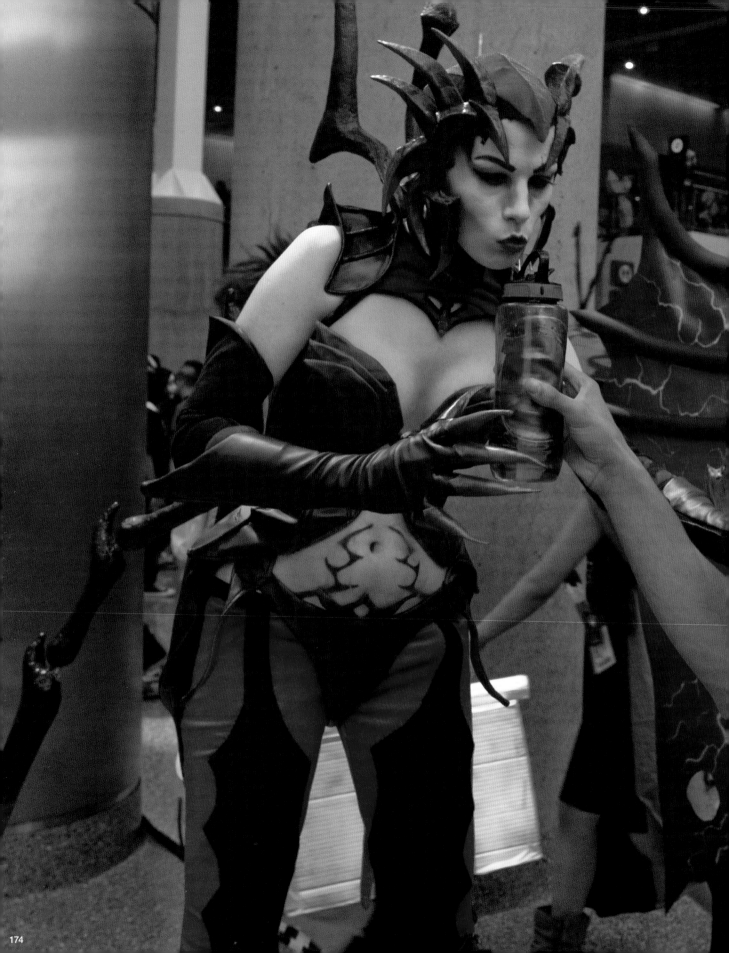

"I think our dynamic is different from most couples who cosplay because there's a very sharp delineation in our roles. Britt does all of the crafting and usually all of the wearing of costumes, and I handle all of the logistics and provide an outsider's perspective. When she's in a stressful costume like Orianna or Elise, I can focus 100% on what she needs without having to worry about my own costume.

When we both dress up, we either both go in simpler costumes, so neither of us needs a handler (like Bastion), or whoever is wearing the less stressful costume is the designated handler (like Sejuani). The way each of us approaches cosplay is so different that we balance each other out and provide perspective to each other."

Ian (Seattle, WA)

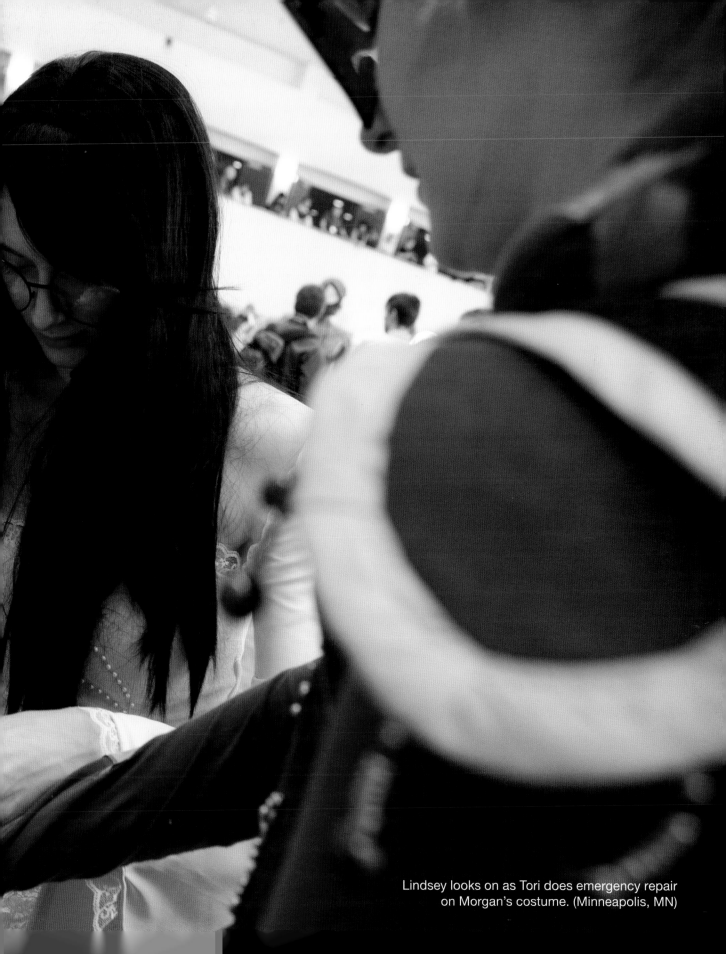

Lindsey looks on as Tori does emergency repair on Morgan's costume. (Minneapolis, MN)

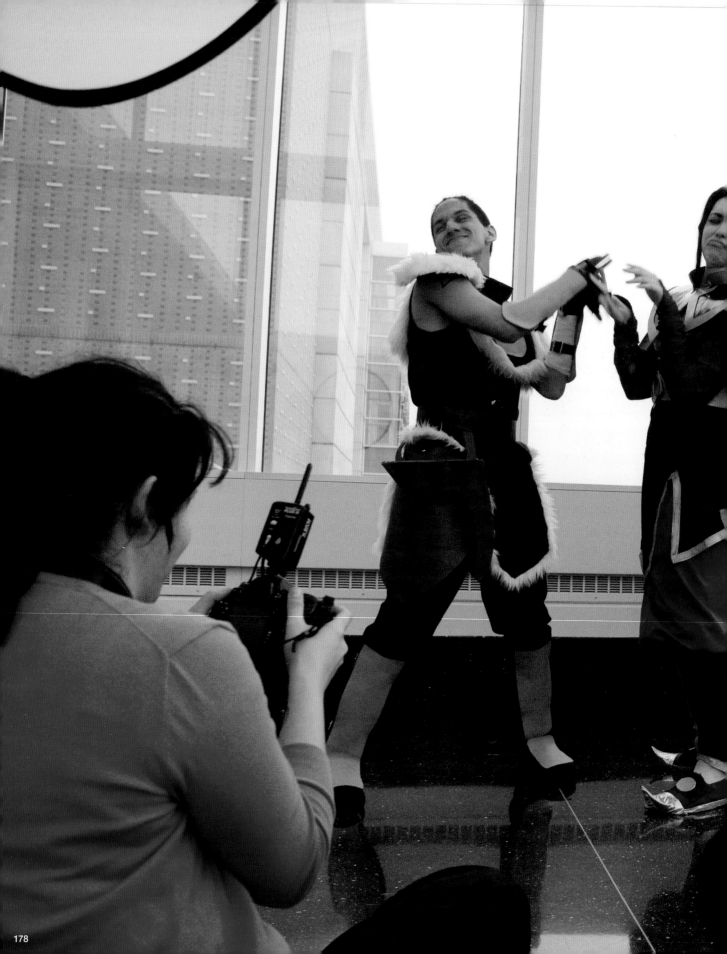

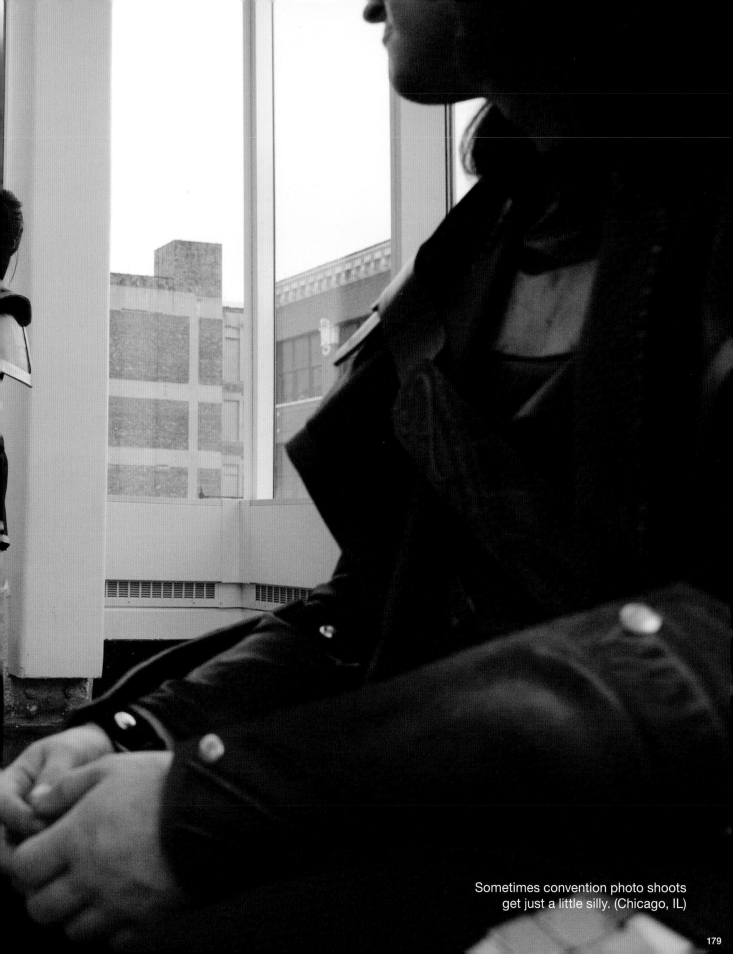

Sometimes convention photo shoots
get just a little silly. (Chicago, IL)

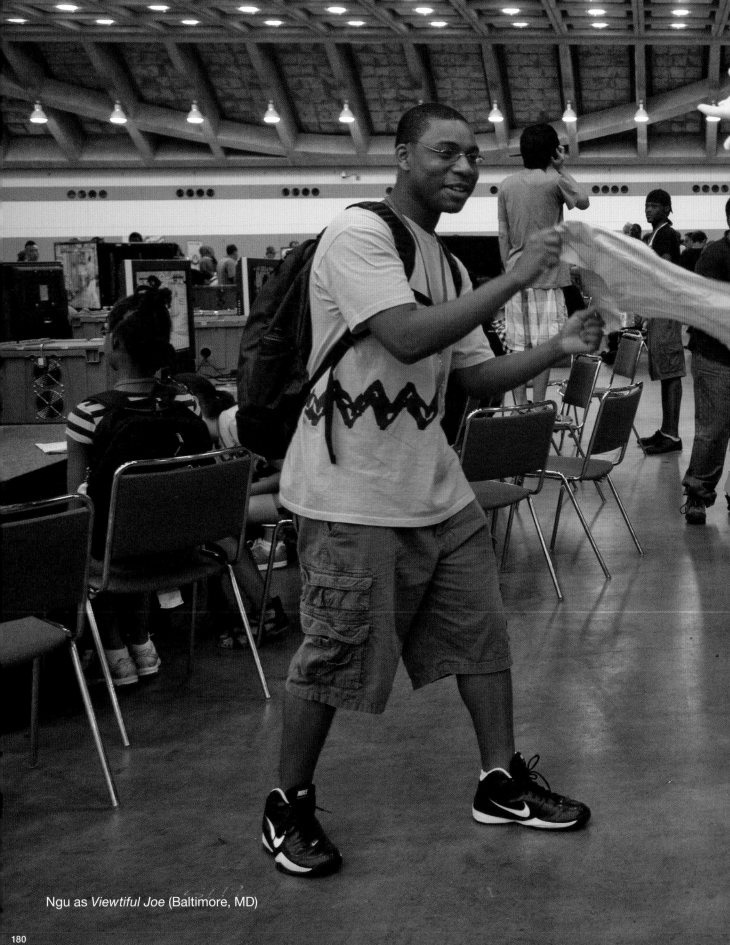

Ngu as *Viewtiful Joe* (Baltimore, MD)

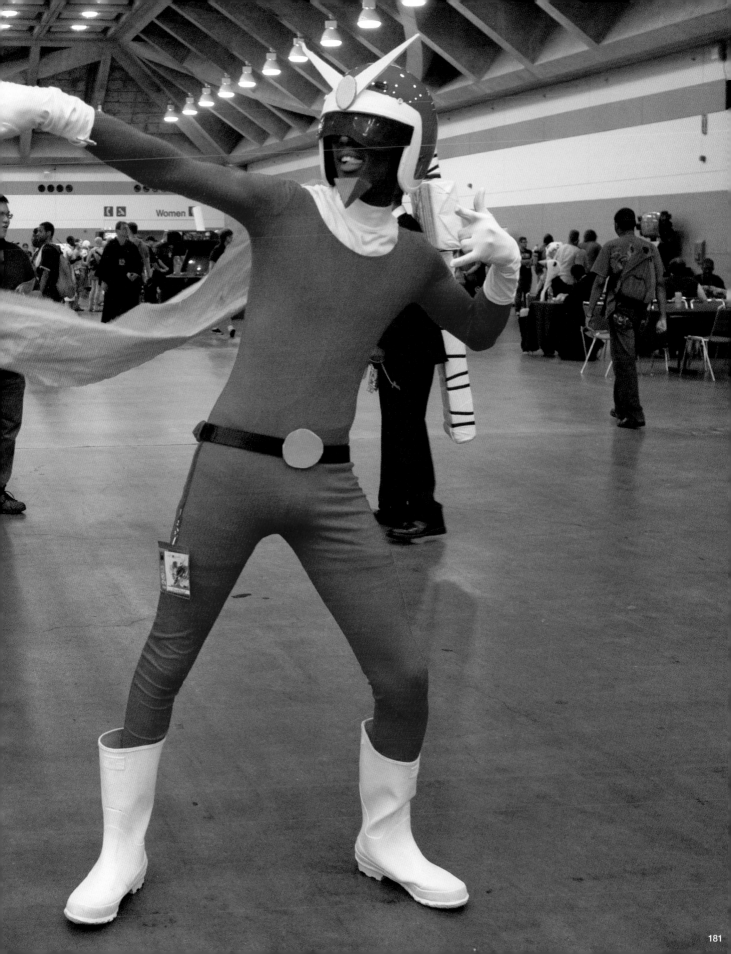

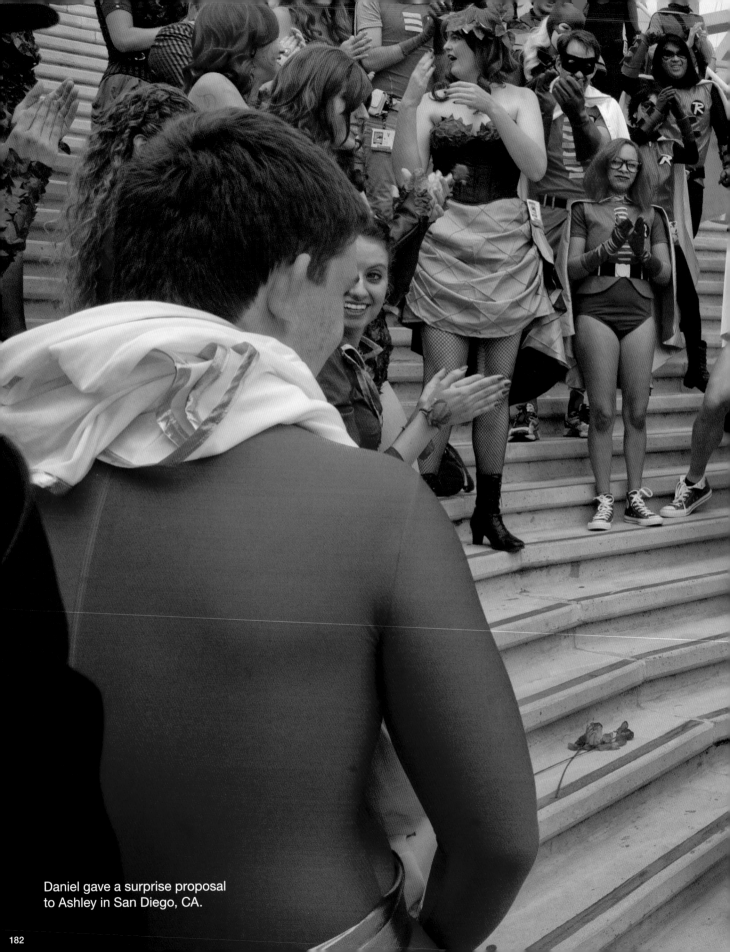

Daniel gave a surprise proposal
to Ashley in San Diego, CA.

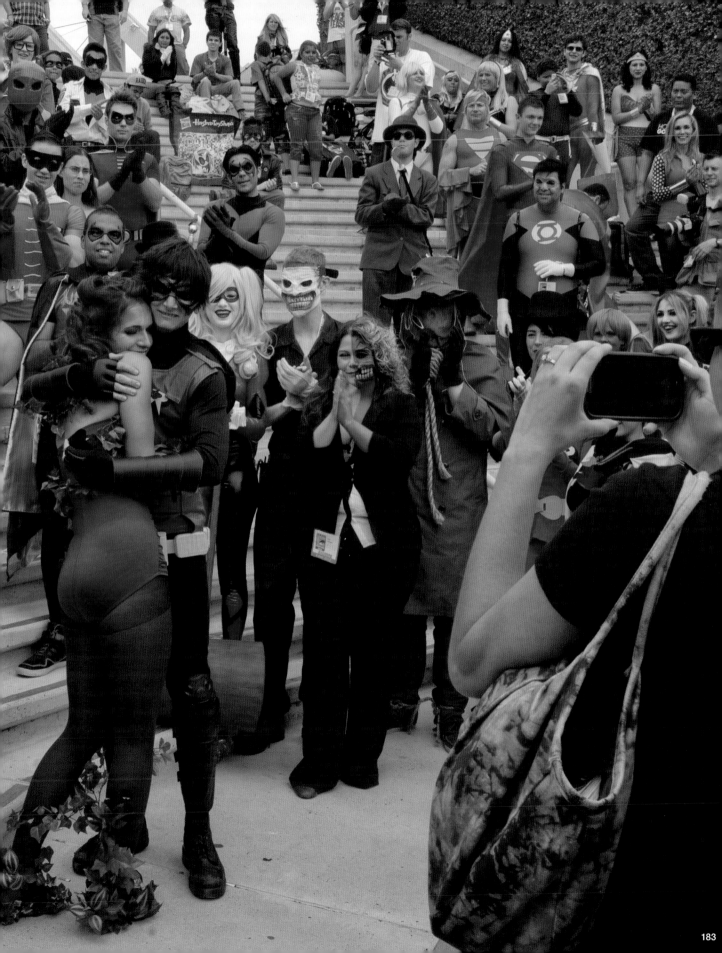

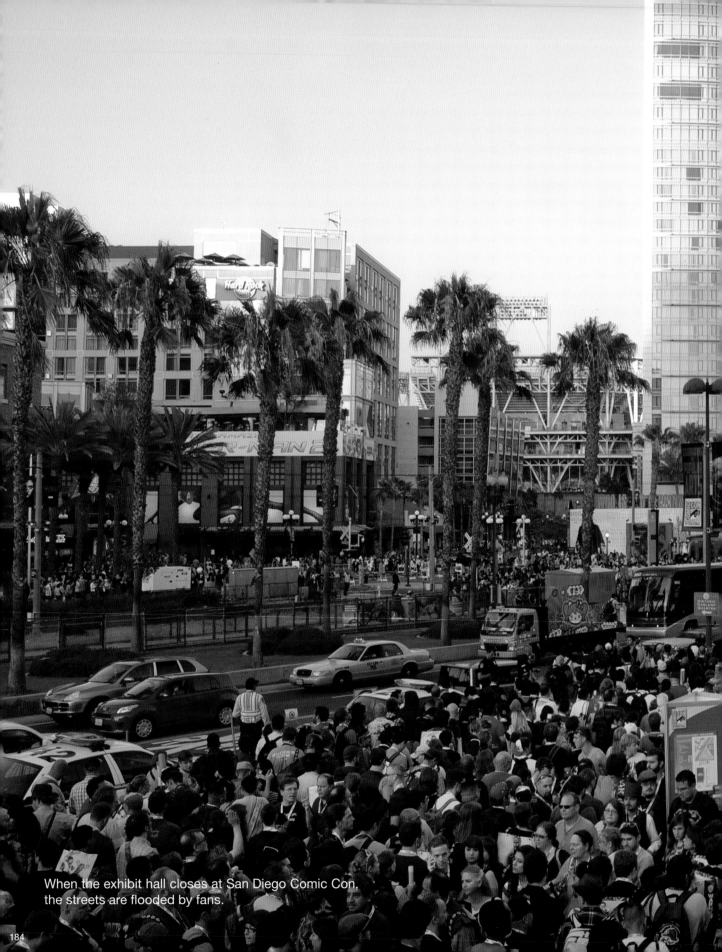

When the exhibit hall closes at San Diego Comic Con, the streets are flooded by fans.

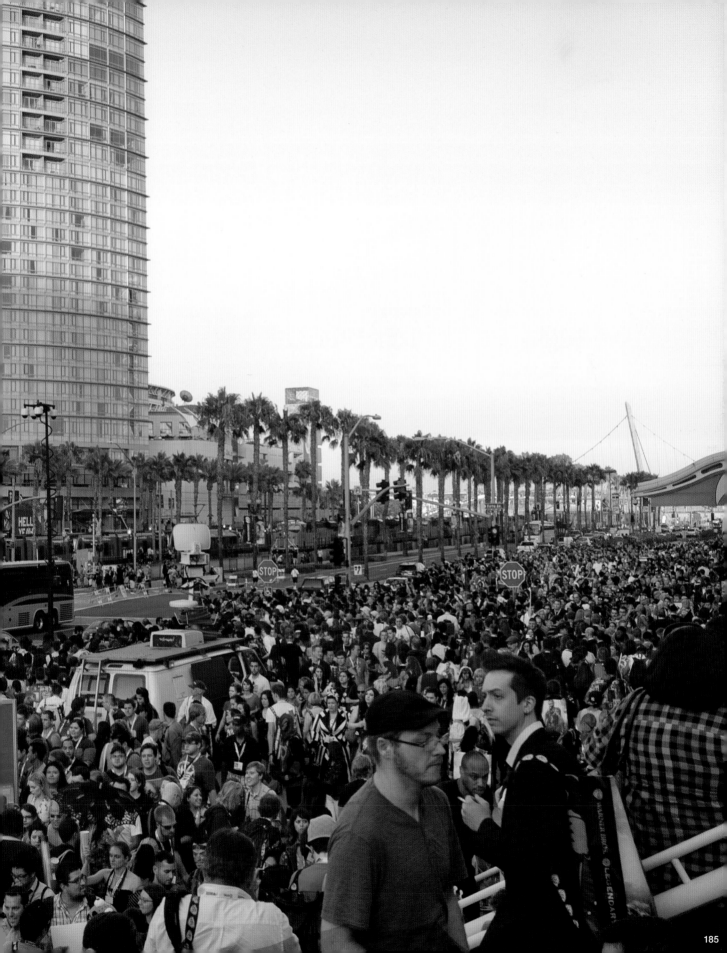

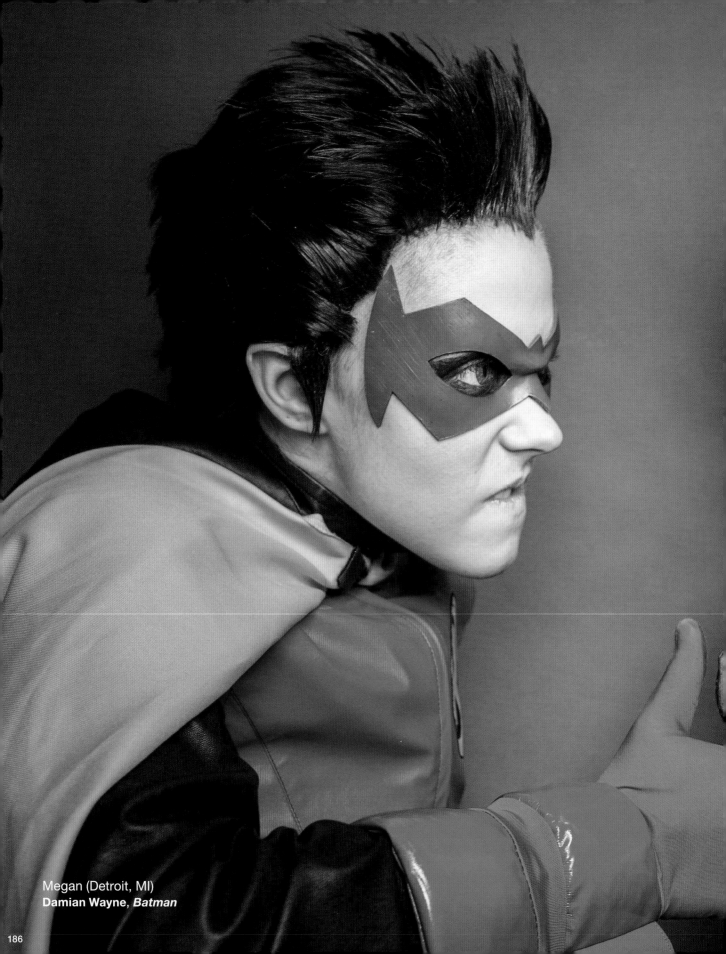

Megan (Detroit, MI)
Damian Wayne, *Batman*

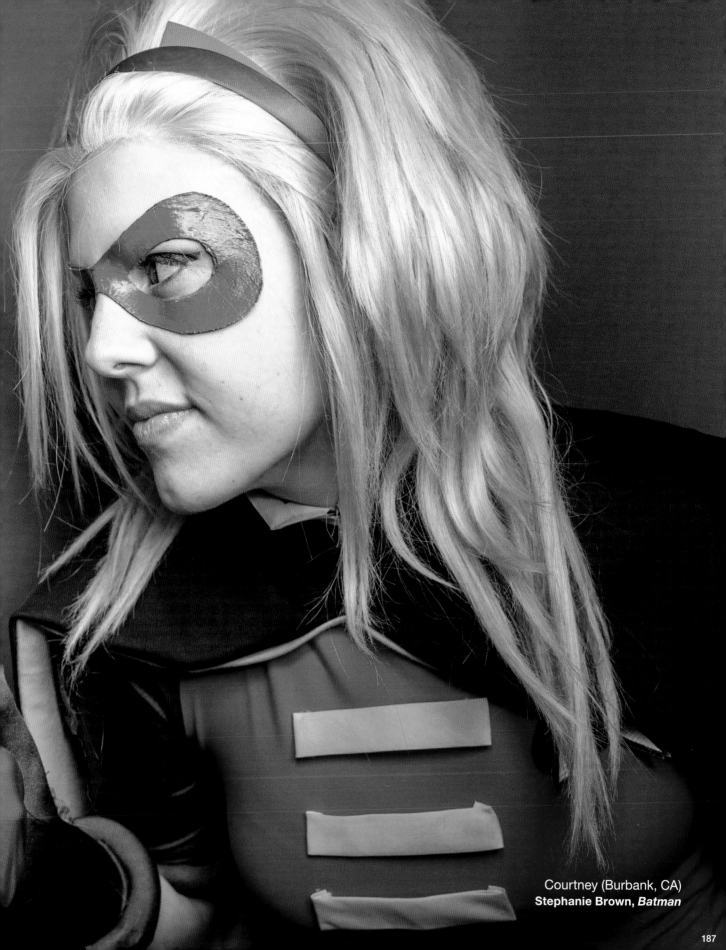

Courtney (Burbank, CA)
Stephanie Brown, *Batman*

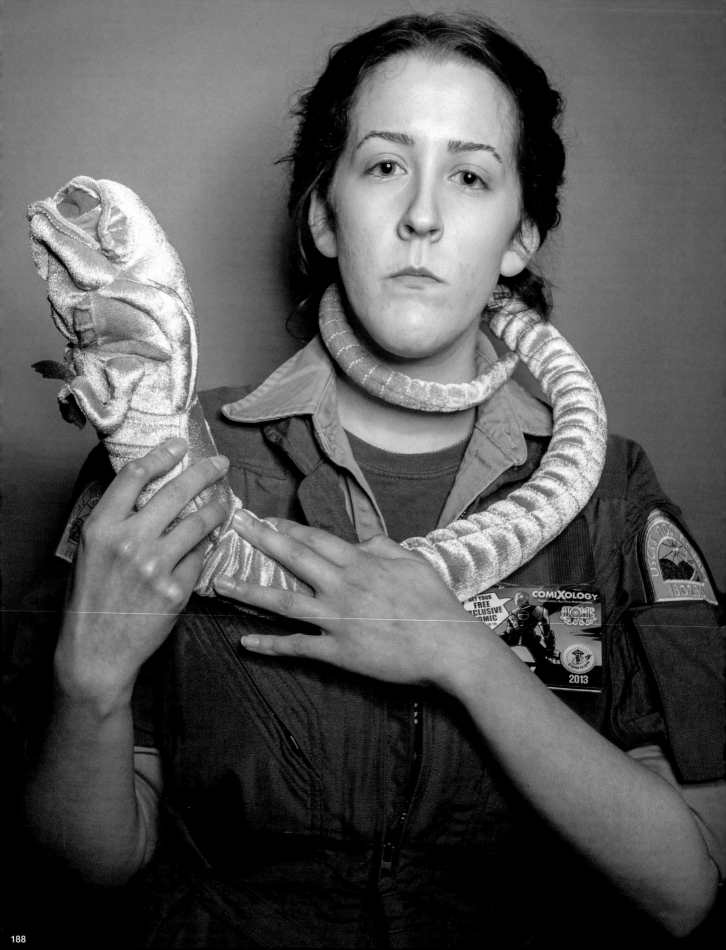

Katie (Seattle, WA)
Ripley, *Alien*

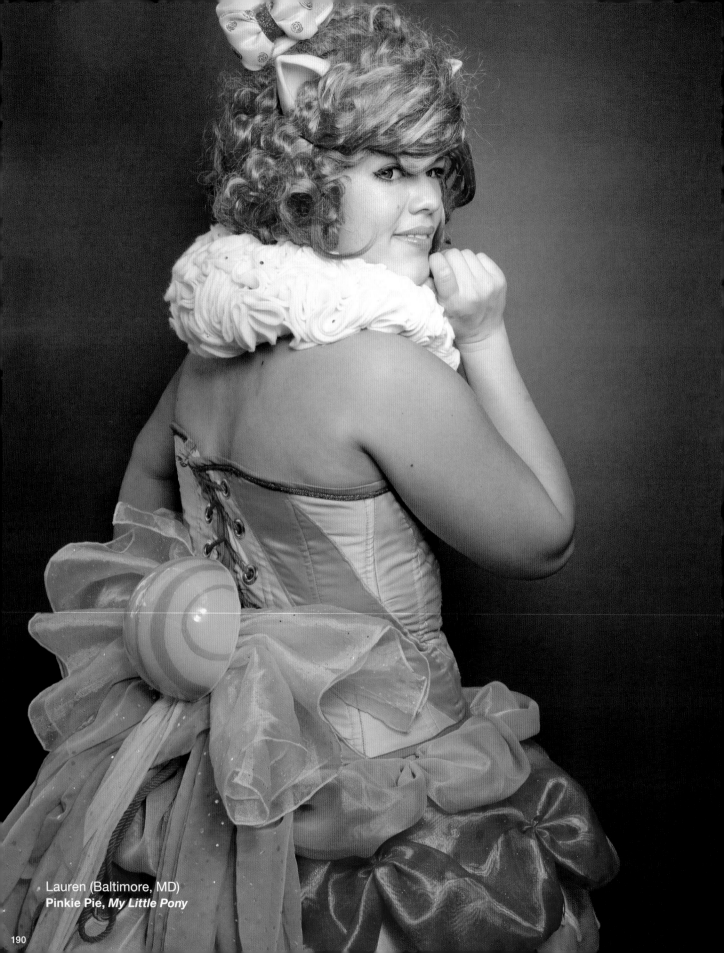

Lauren (Baltimore, MD)
Pinkie Pie, *My Little Pony*

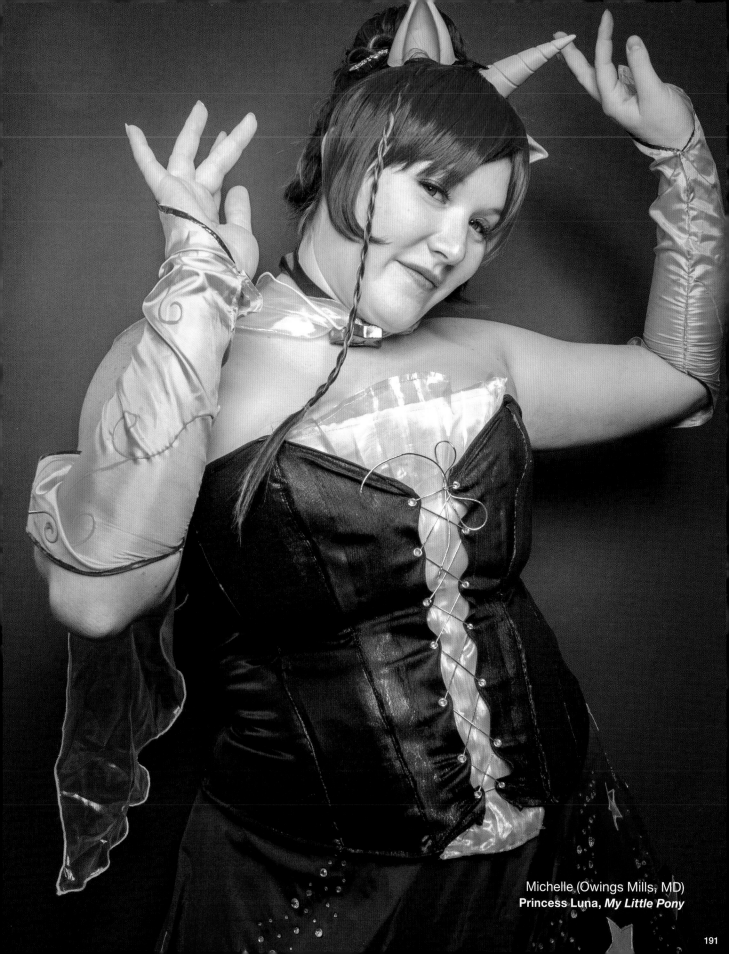

Michelle (Owings Mills, MD)
Princess Luna, *My Little Pony*

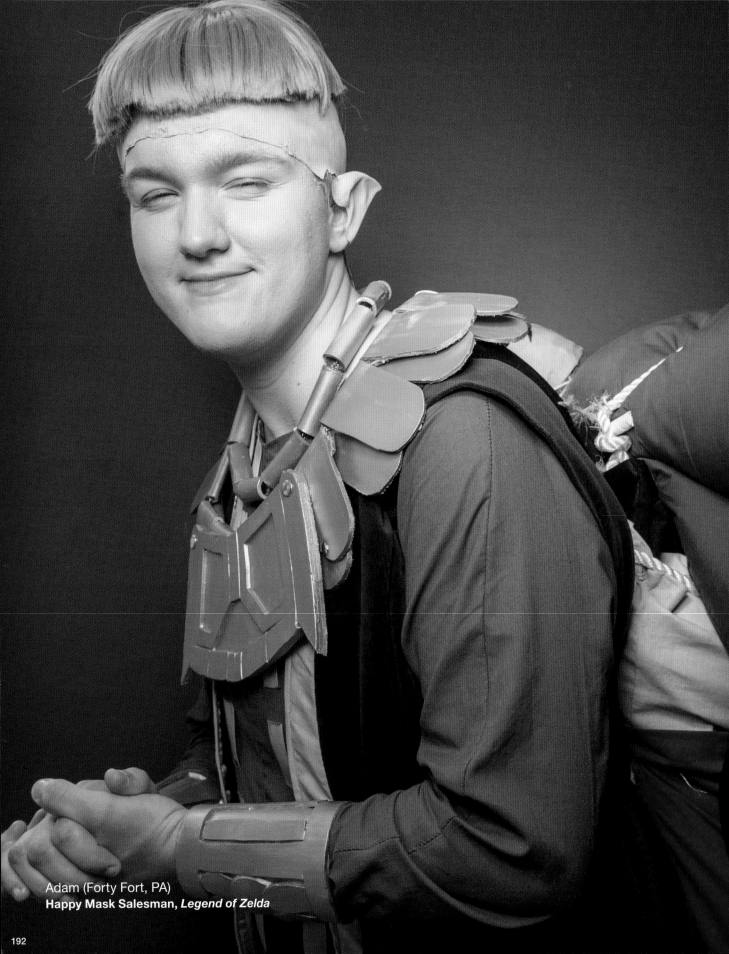

Adam (Forty Fort, PA)
Happy Mask Salesman, *Legend of Zelda*

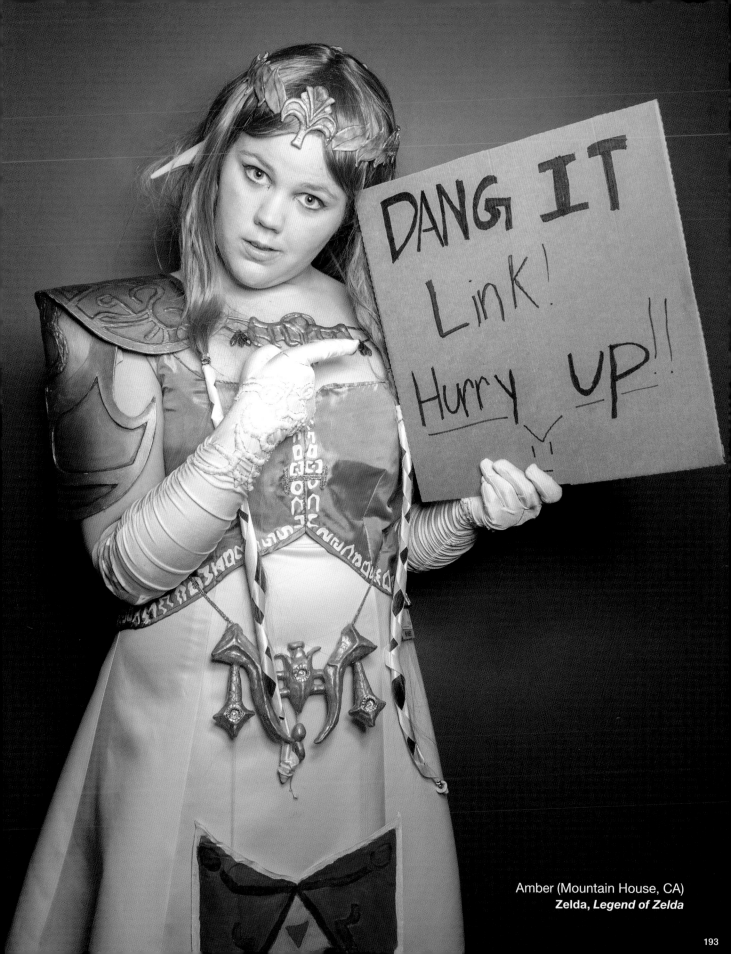

DANG IT LINK! Hurry UP!!

Amber (Mountain House, CA)
Zelda, Legend of Zelda

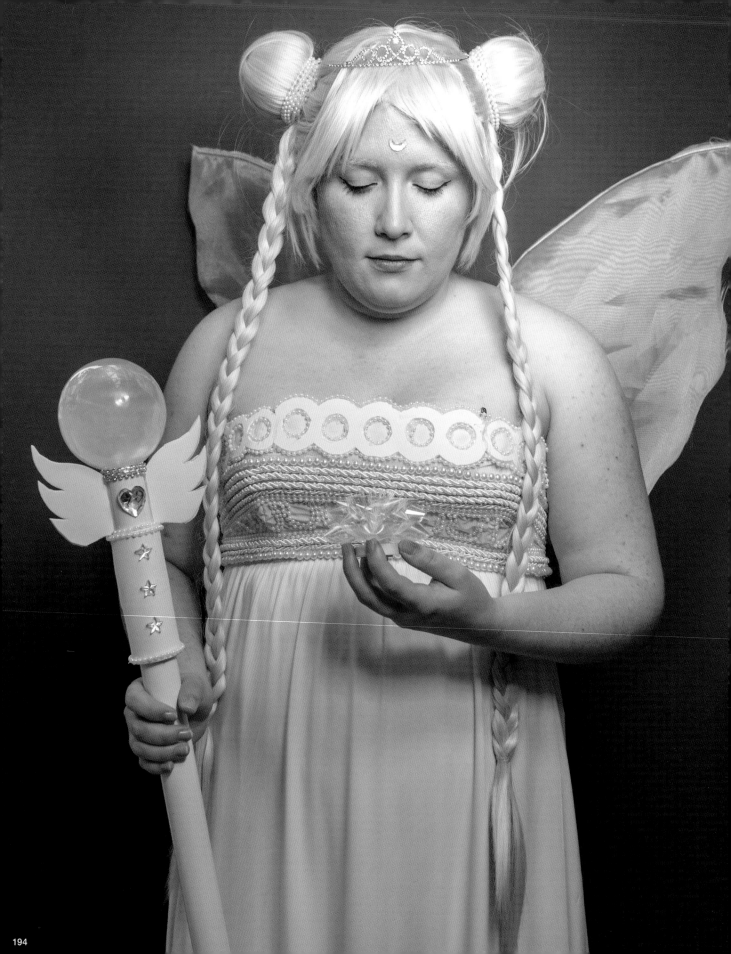

"Cosplay has taught me to not be afraid-- to not be afraid to try something new, to cosplay something outside my comfort zone, to try new designs to a character or something original, to ask for help from other cosplayers or to ask how they made something."

Kara (Billerica, MA)

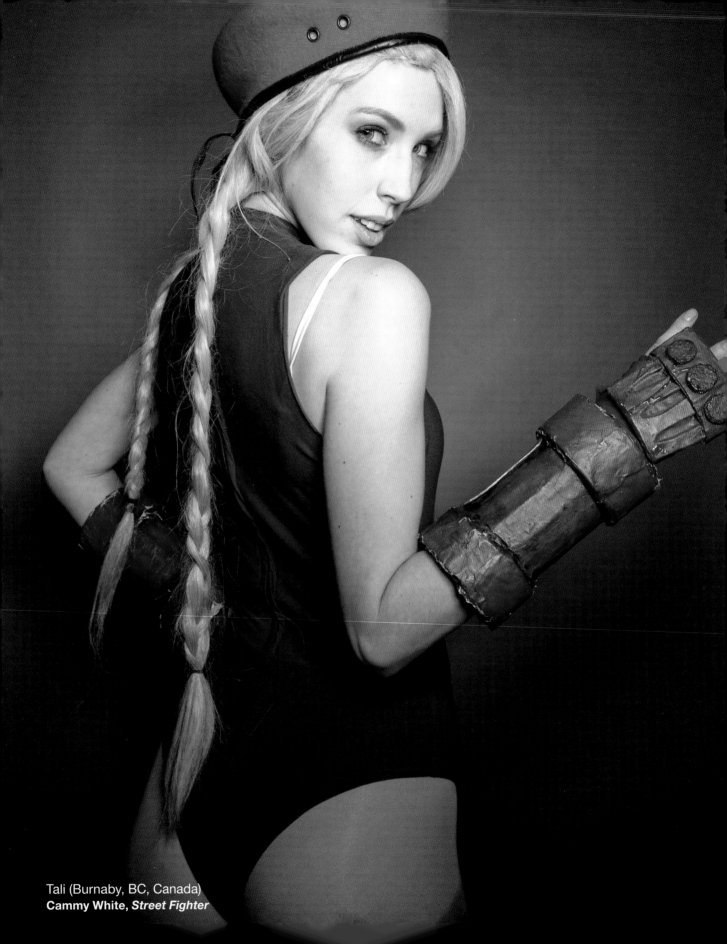

Tali (Burnaby, BC, Canada)
Cammy White, *Street Fighter*

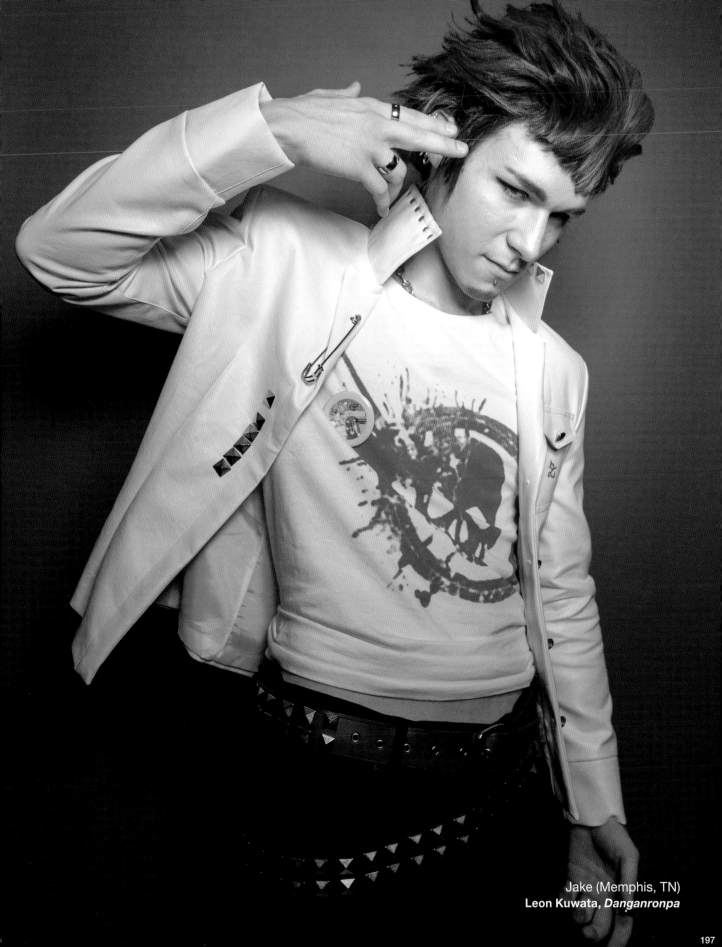

Jake (Memphis, TN)
Leon Kuwata, *Danganronpa*

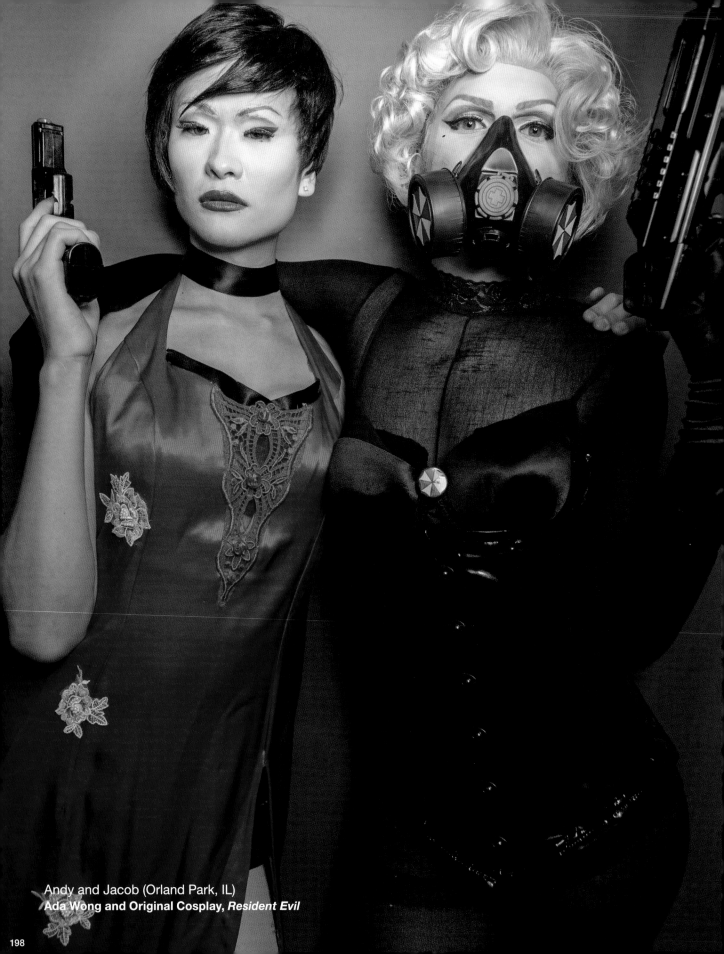

Andy and Jacob (Orland Park, IL)
Ada Wong and Original Cosplay, *Resident Evil*

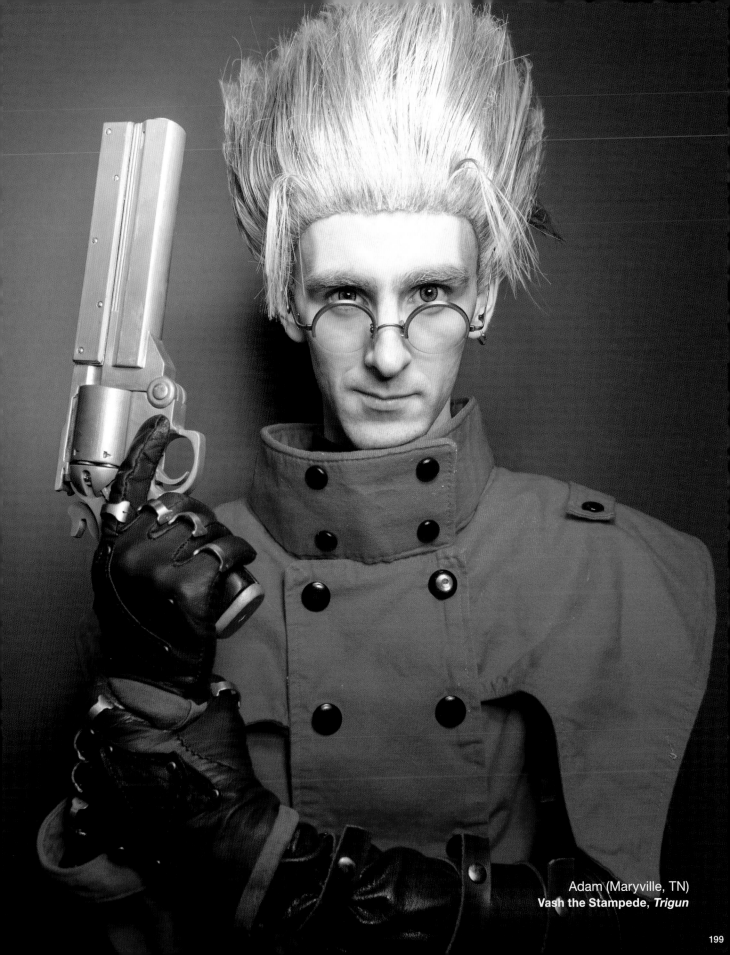

Adam (Maryville, TN)
Vash the Stampede, *Trigun*

Michael (St. Cloud, MN)
Captain Harlock

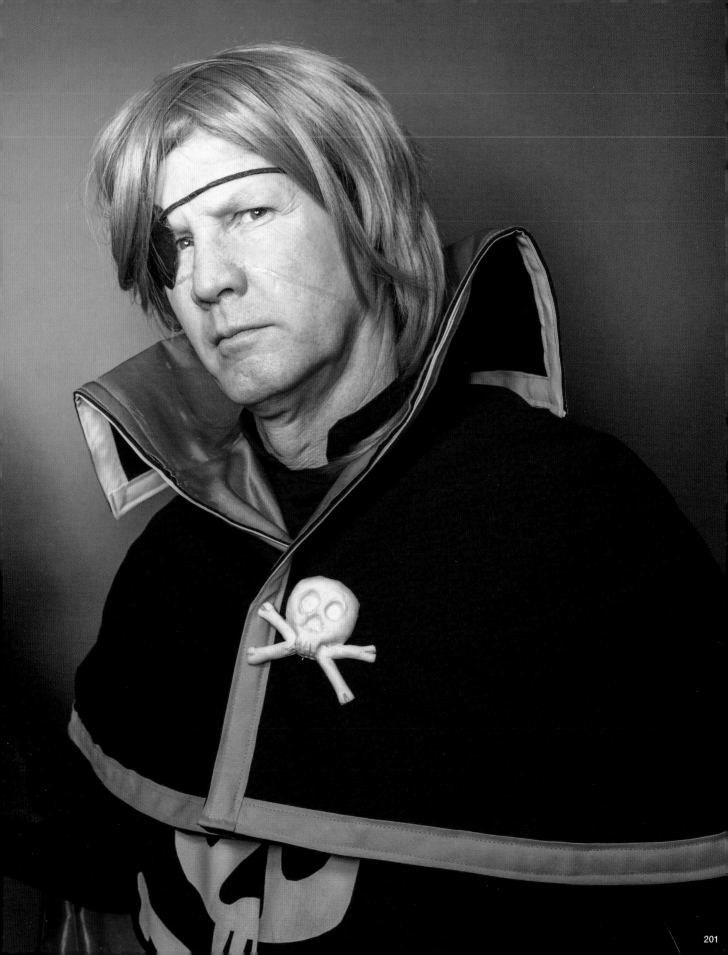

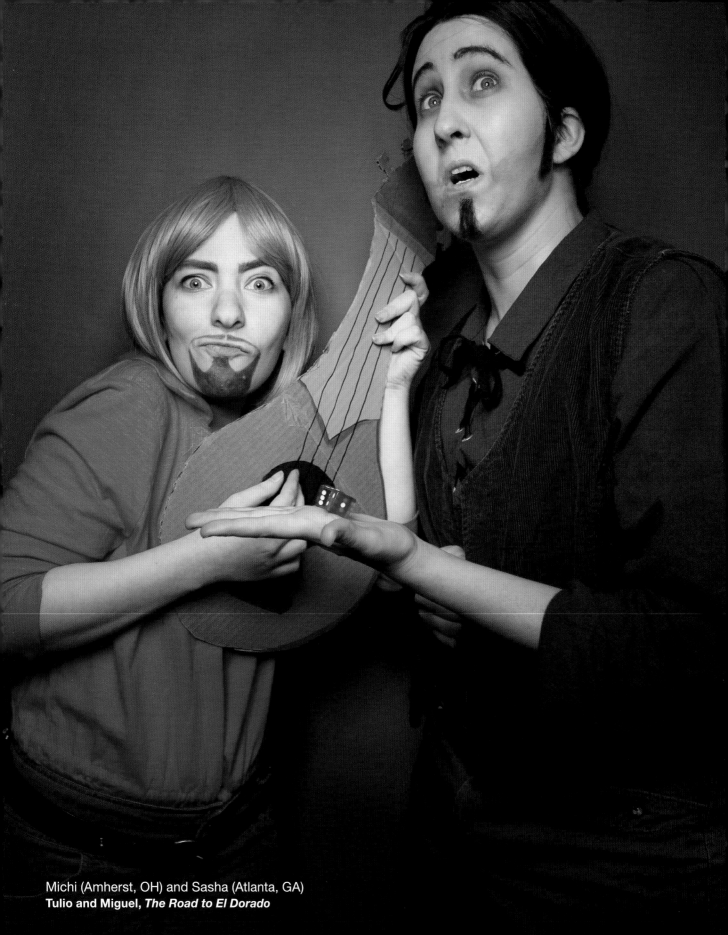

Michi (Amherst, OH) and Sasha (Atlanta, GA)
Tulio and Miguel, *The Road to El Dorado*

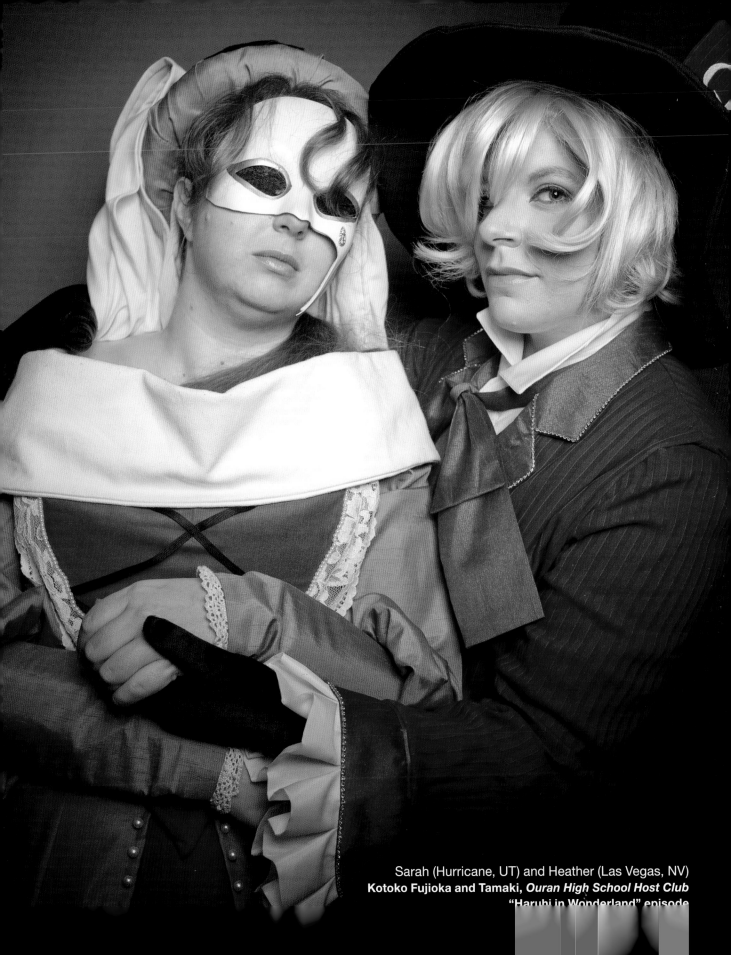

Sarah (Hurricane, UT) and Heather (Las Vegas, NV)
Kotoko Fujioka and Tamaki, *Ouran High School Host Club*
"Haruhi in Wonderland" episode

Desiree (Forest Park, IL)
Naruto Uzumaki

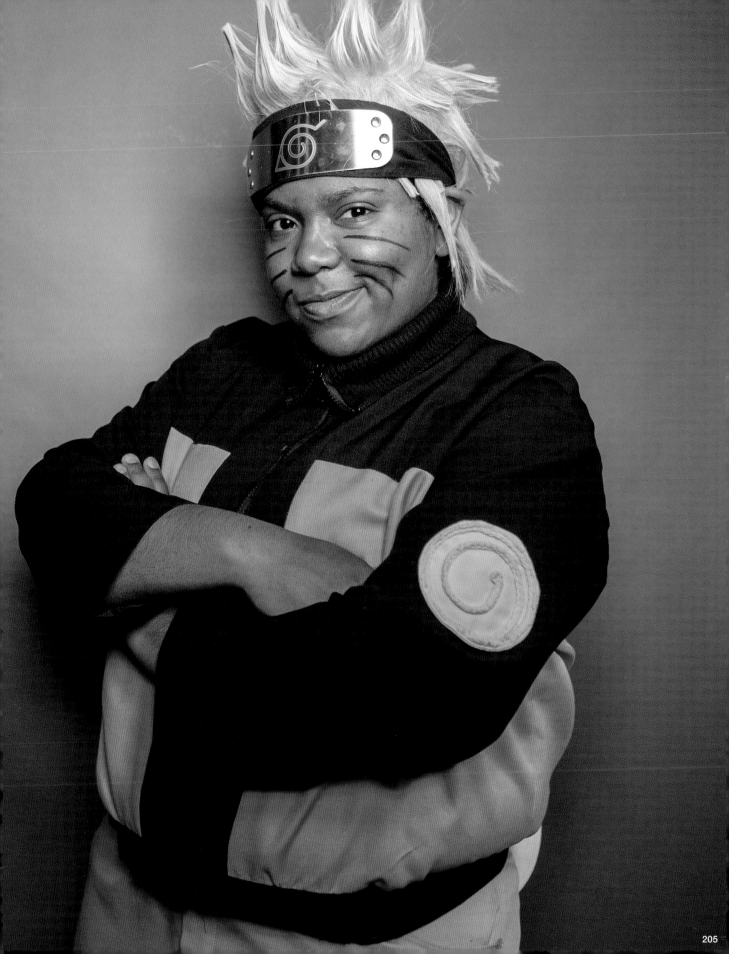

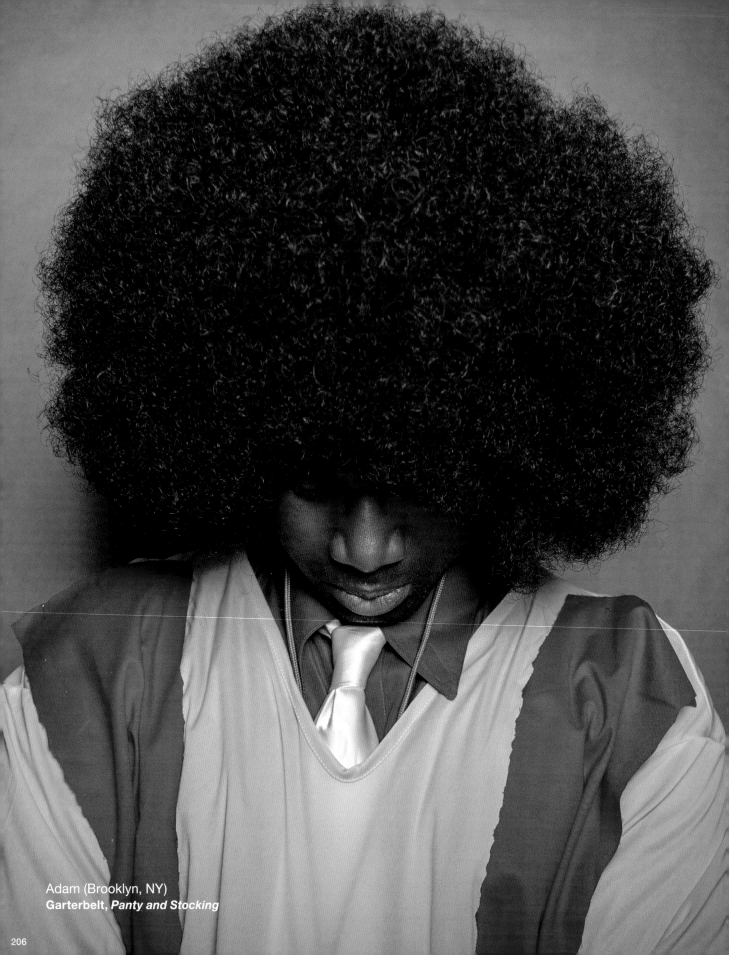

Adam (Brooklyn, NY)
Garterbelt, *Panty and Stocking*

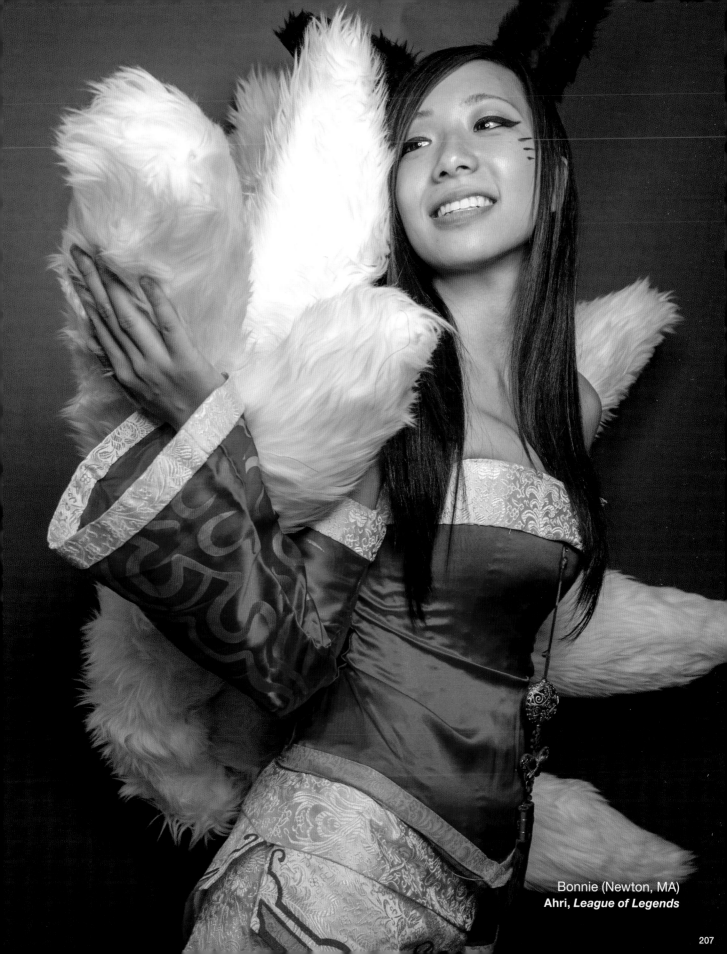

Bonnie (Newton, MA)
Ahri, *League of Legends*

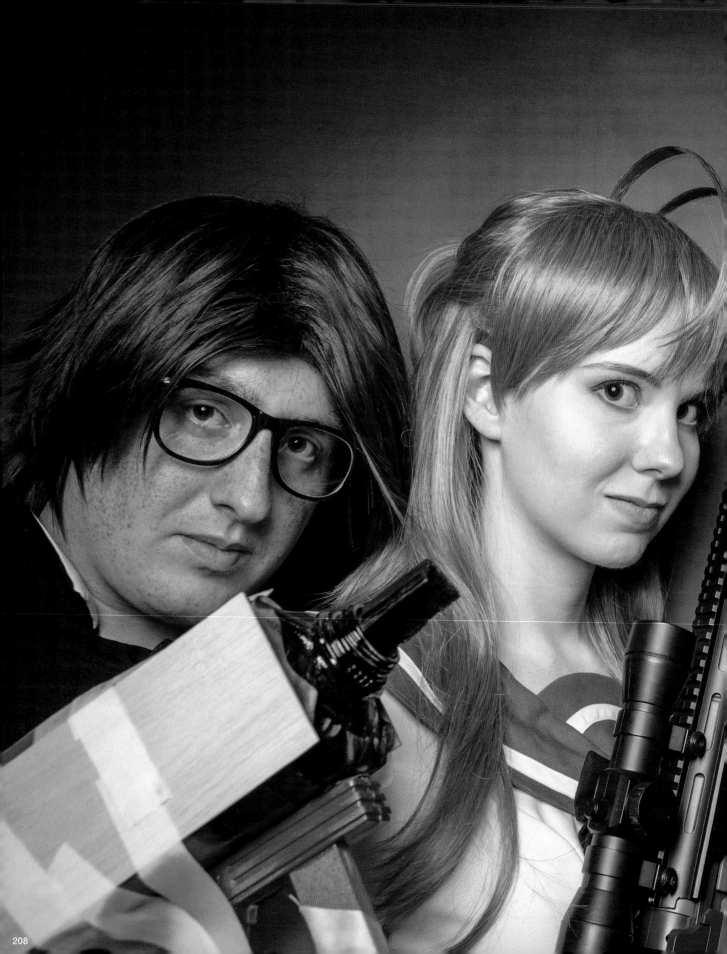

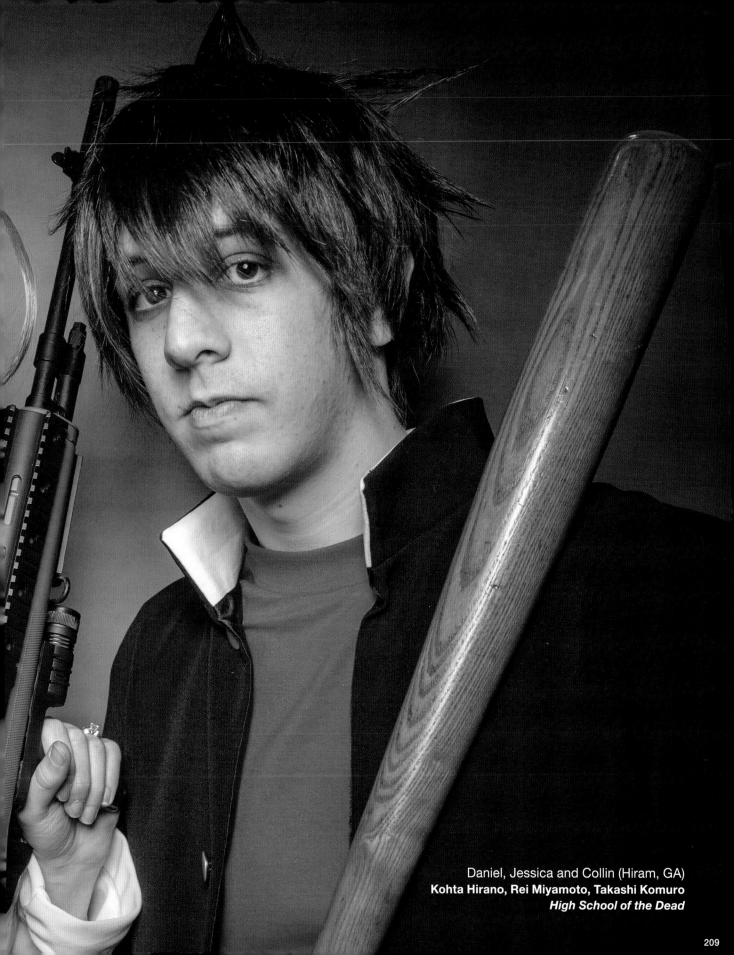

Daniel, Jessica and Collin (Hiram, GA)
Kohta Hirano, Rei Miyamoto, Takashi Komuro
High School of the Dead

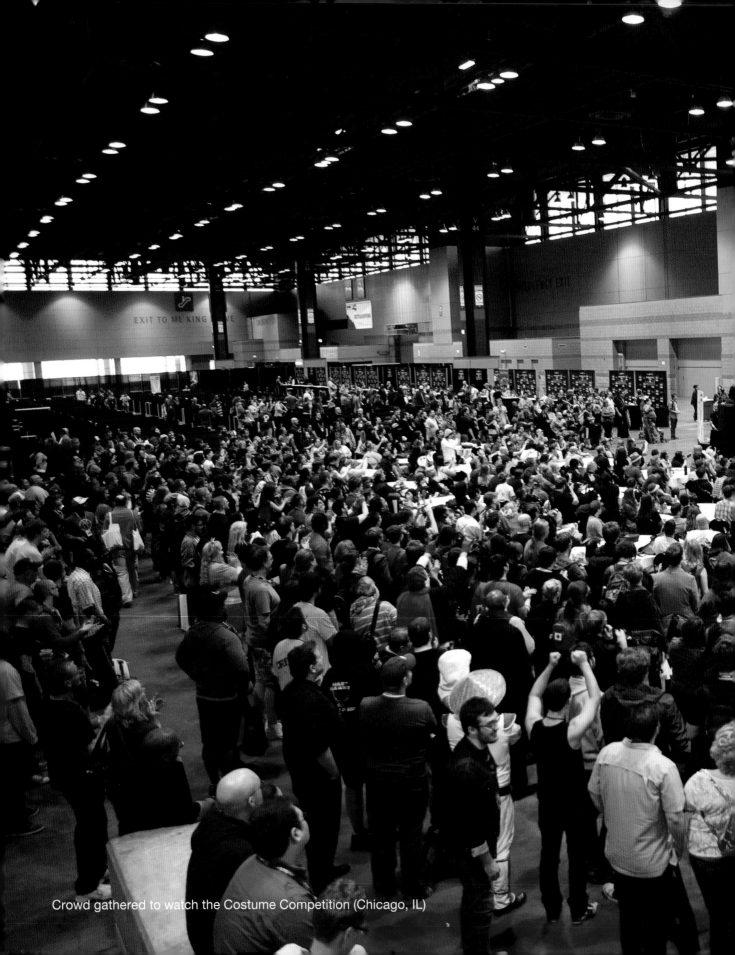

Crowd gathered to watch the Costume Competition (Chicago, IL)

COMPETITION

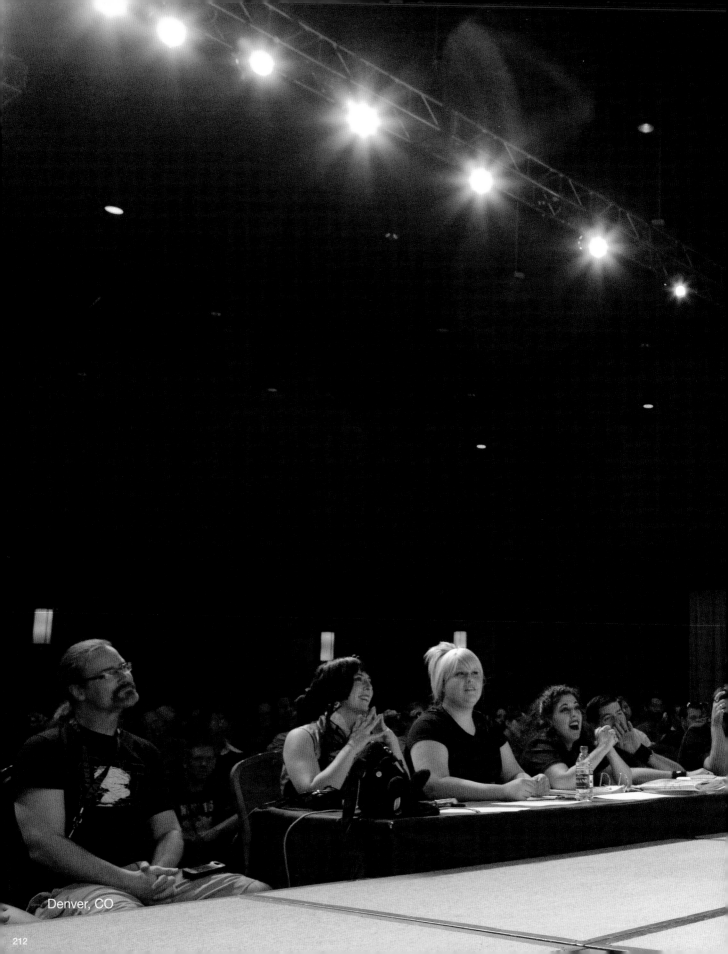

Denver, CO

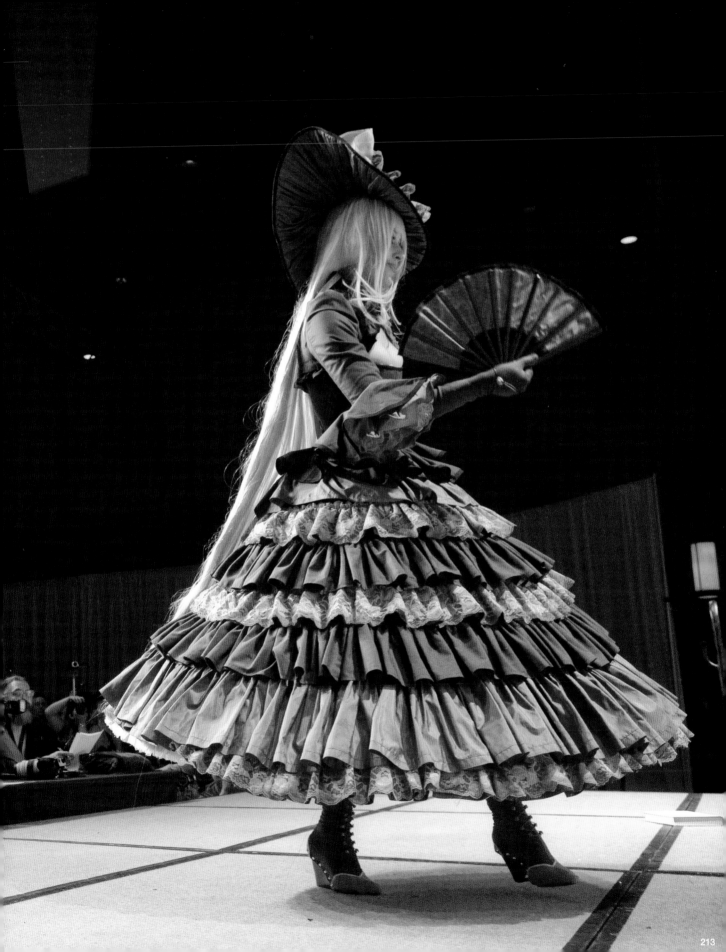

Minneapolis, MN

A Note on Cosplay Competitions from a Ten Year Vet

SHIKARIUS

I've been actively competing for over 10 years and I've been in all sorts of competitions. I love it. I wouldn't give it up for anything. The people I've met backstage and the experiences I've had have been nothing short of incredible, and they really make a convention for me.

I think the biggest differences between anime and comic con competitions really comes down to who's judging it. Anime-focused conventions usually have cosplayer judges while judges at comic cons are sometimes celebrity judges. You can certainly get the feeling that it's more geared towards audience entertainment than the cosplayers themselves.

As soon as I walk in the judging room, I'm met with four very excited faces (one of the judges actually squee'd) and I immediately delve into explaining everything I possibly can. When you cosplay, you put so much time and effort into something you very rarely get a chance to really go in-depth about anything but those four people know precisely what I had to do and I could tell they appreciated it. I was nervous, but these were people who had done the same things I had done and had probably definitely hot-glued some seams together in their own time. They're usually cosplayers and they're always fellow geeks. We all started somewhere!

The best part for me, though, is greenroom/backstage. If you ever wanted to meet every cosplay tutorial given human shape in one room, enter a contest. I have never met a single contestant who didn't want to gush about how they made something or how something moves. I think it all comes back to the idea that, if you treat it like a hardcore "competition", you're not going to have the best time. You'll be nervous and you probably won't talk to many people. Instead, I highly suggest that you look at it as "a large gathering of people who care about craftsmanship and presentation just like you do" and then suddenly it's a lot more fun! I can look around and say "I want to cosplay with you sometimes !"

Competitions are only full of drama if people bring it. Otherwise, these are people who haveforgone sunlight for just as long as you have in order to put some sort of geeky costume together just to prance across a stage in front of thousands of other geeks.

In ending, I just gotta say: do it. Enter a contest. Talk to people. Ask how they did things. In 99% of cases they will be overjoyed to explain something to you. Meet new friends. Plan cosplays with them. This is the best environment to do so. Just take a breath and do it!

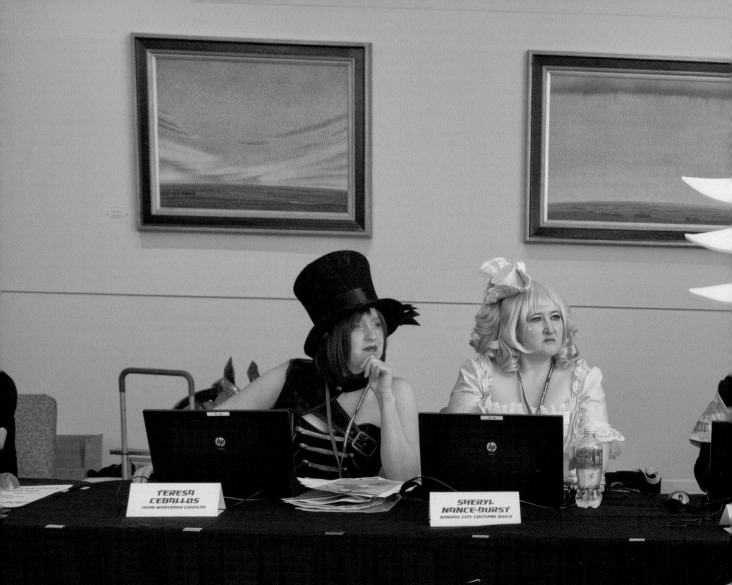

Costume contest judges Teresa, Sheryl and Lisi interview contestants during the pre-judging segment. (Overland Park, KS)

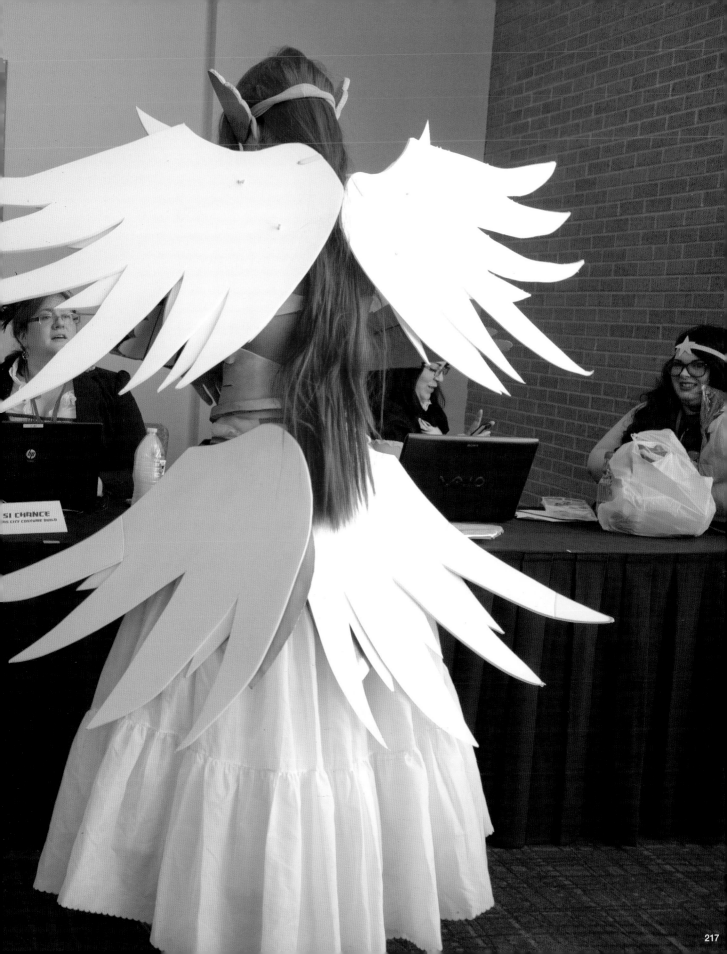

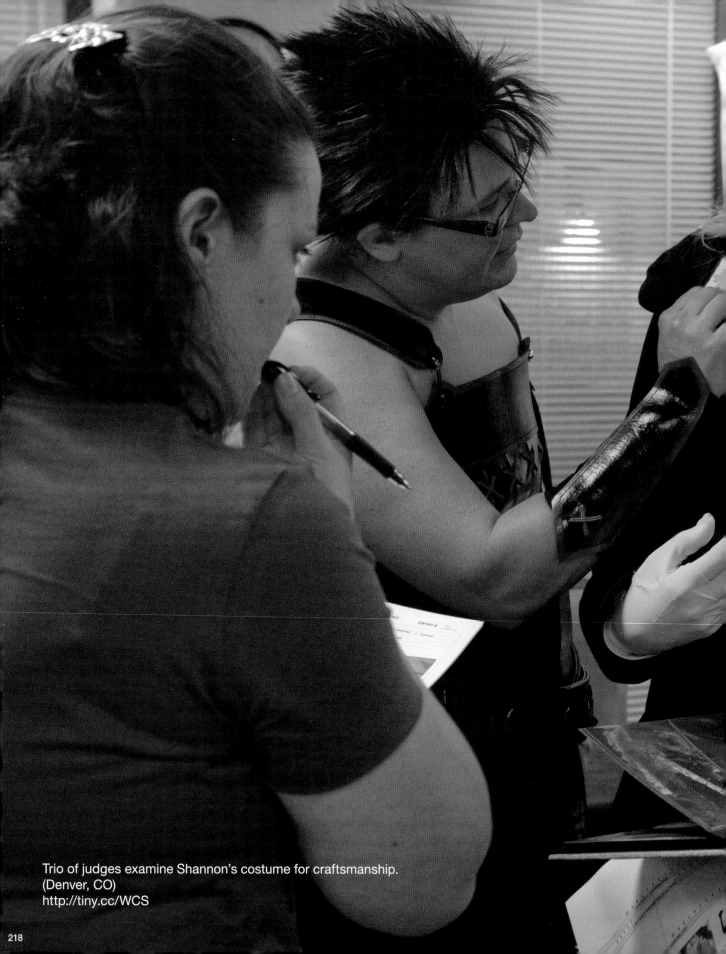

Trio of judges examine Shannon's costume for craftsmanship.
(Denver, CO)
http://tiny.cc/WCS

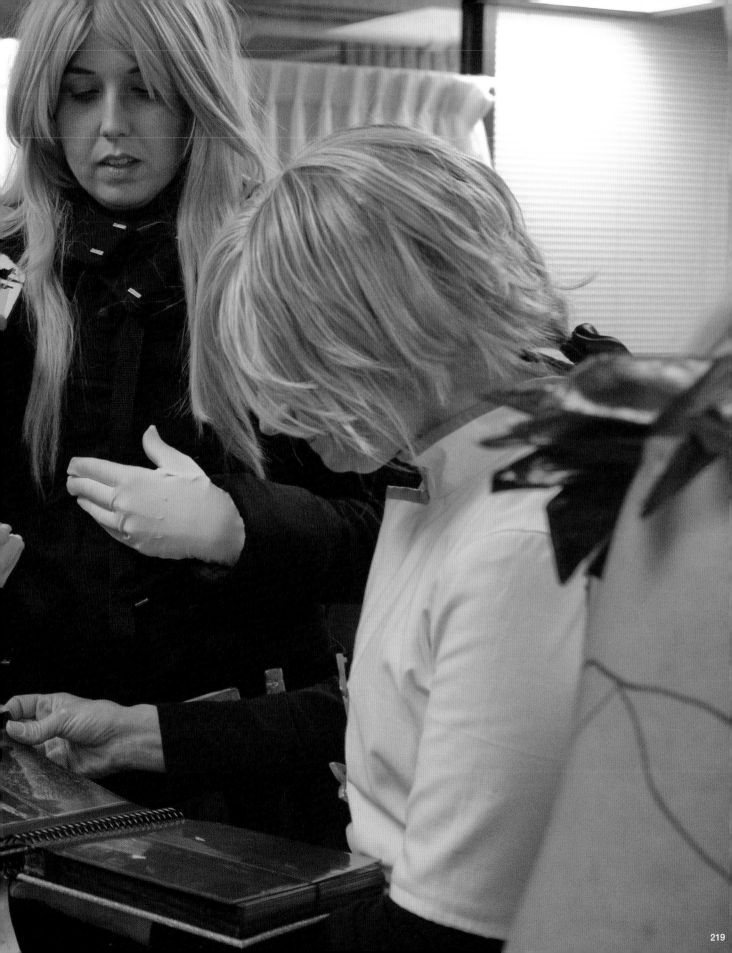

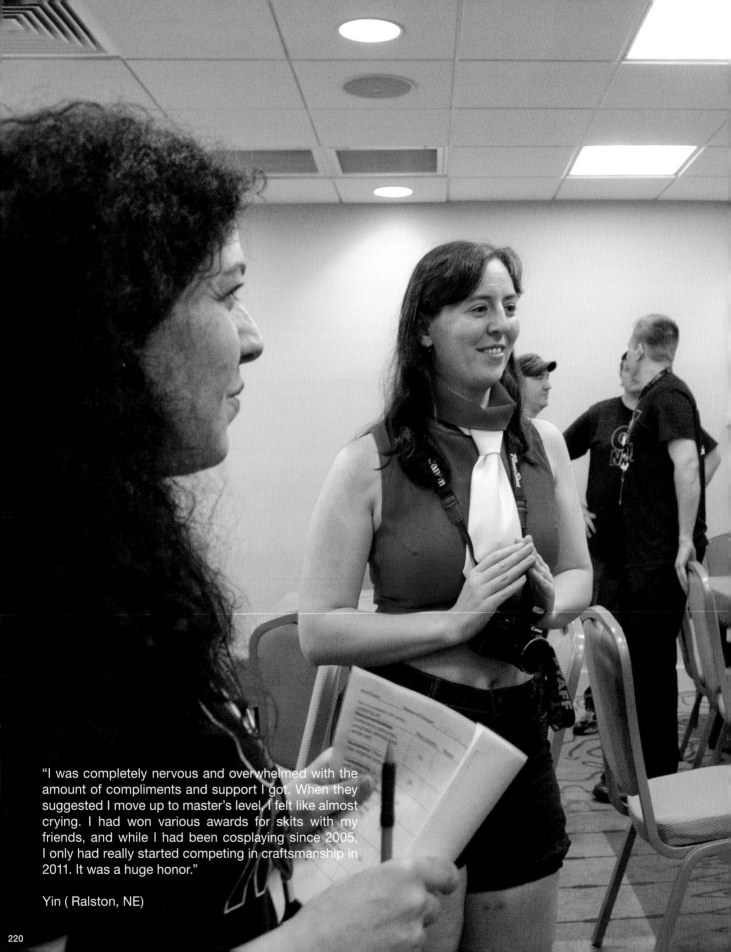

"I was completely nervous and overwhelmed with the amount of compliments and support I got. When they suggested I move up to master's level, I felt like almost crying. I had won various awards for skits with my friends, and while I had been cosplaying since 2005, I only had really started competing in craftsmanship in 2011. It was a huge honor."

Yin (Ralston, NE)

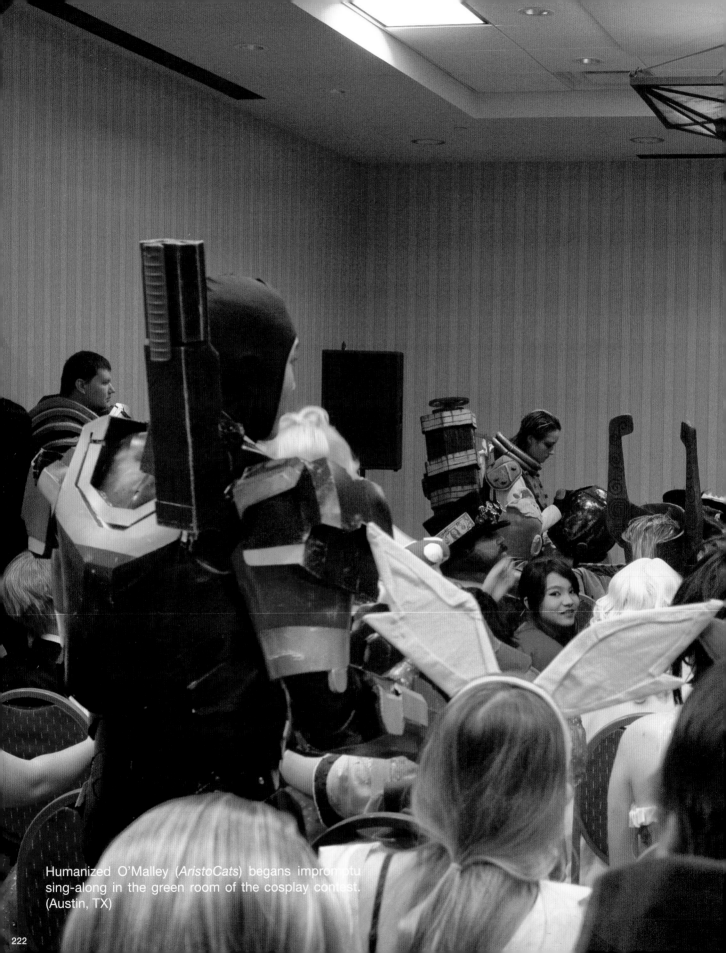

Humanized O'Malley (*AristoCats*) begans impromptu sing-along in the green room of the cosplay contest. (Austin, TX)

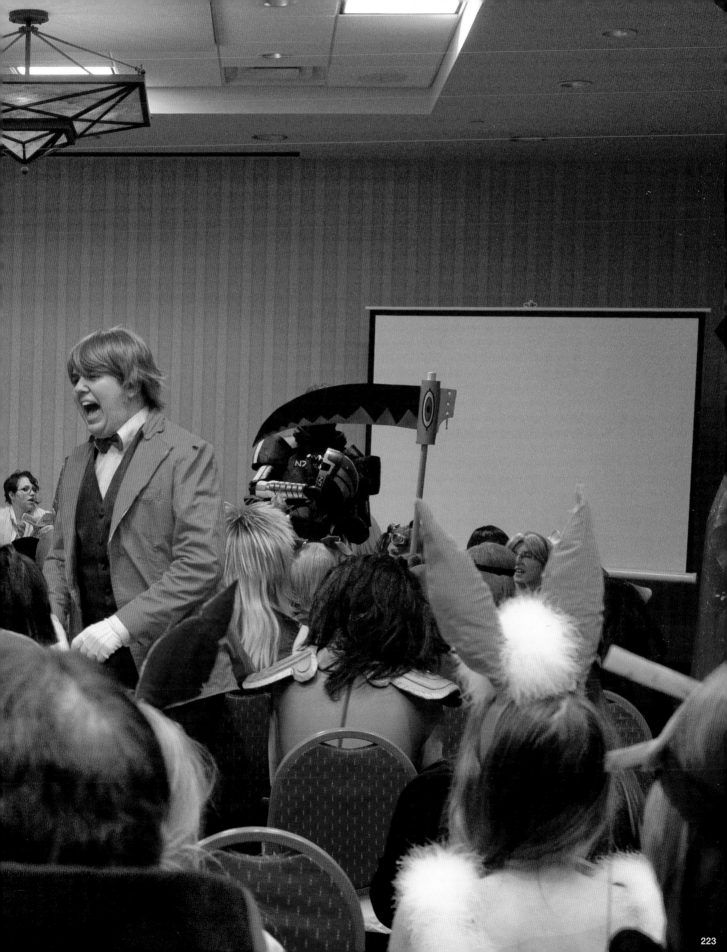

Denver, CO

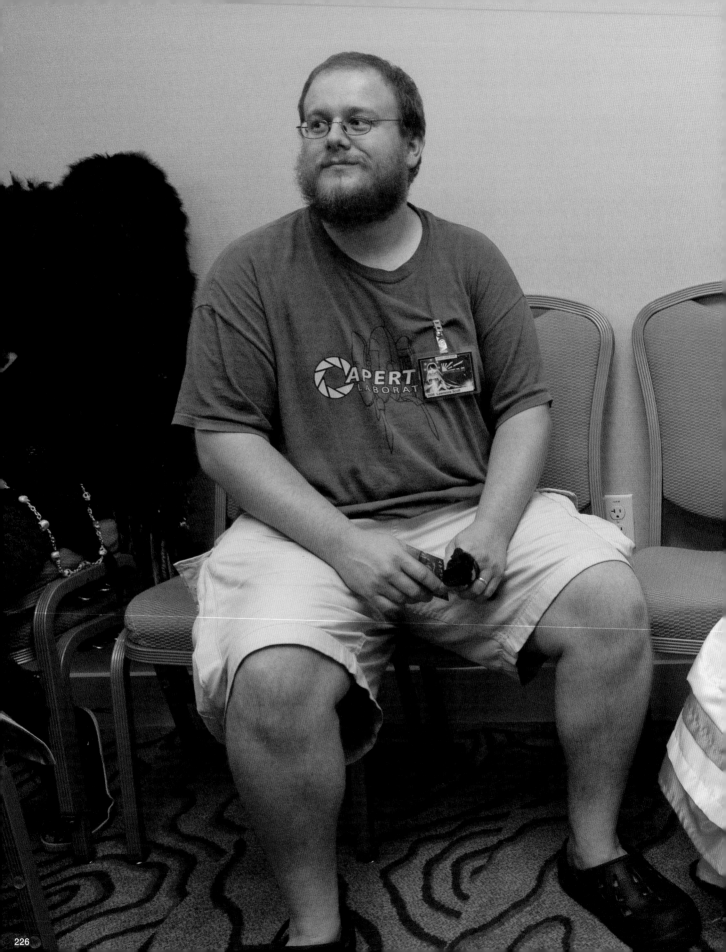

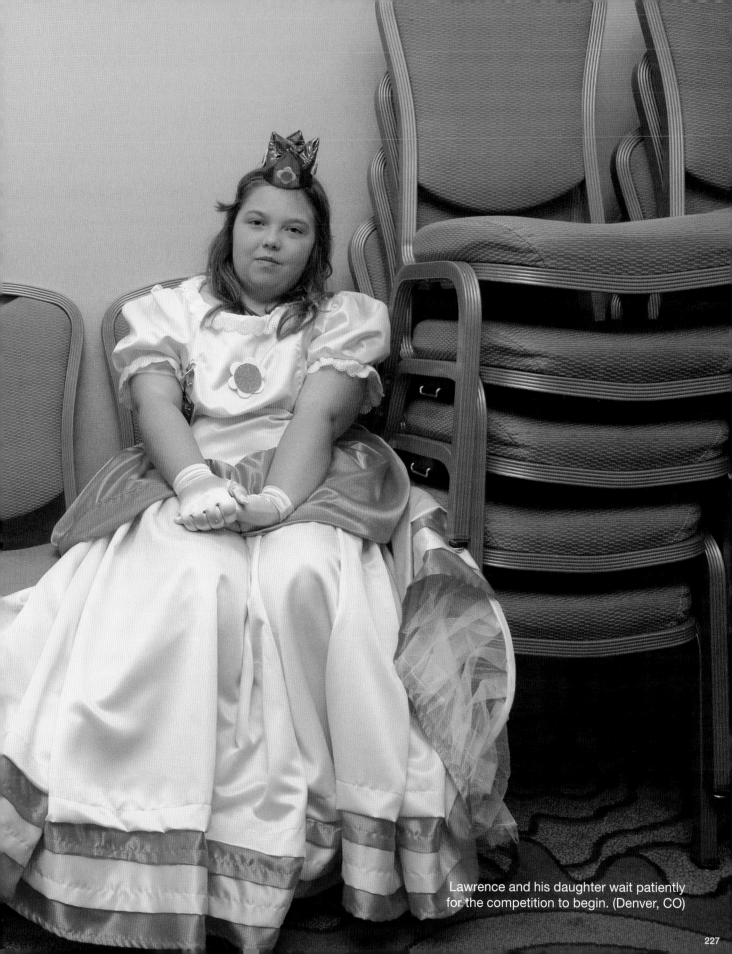

Lawrence and his daughter wait patiently
for the competition to begin. (Denver, CO)

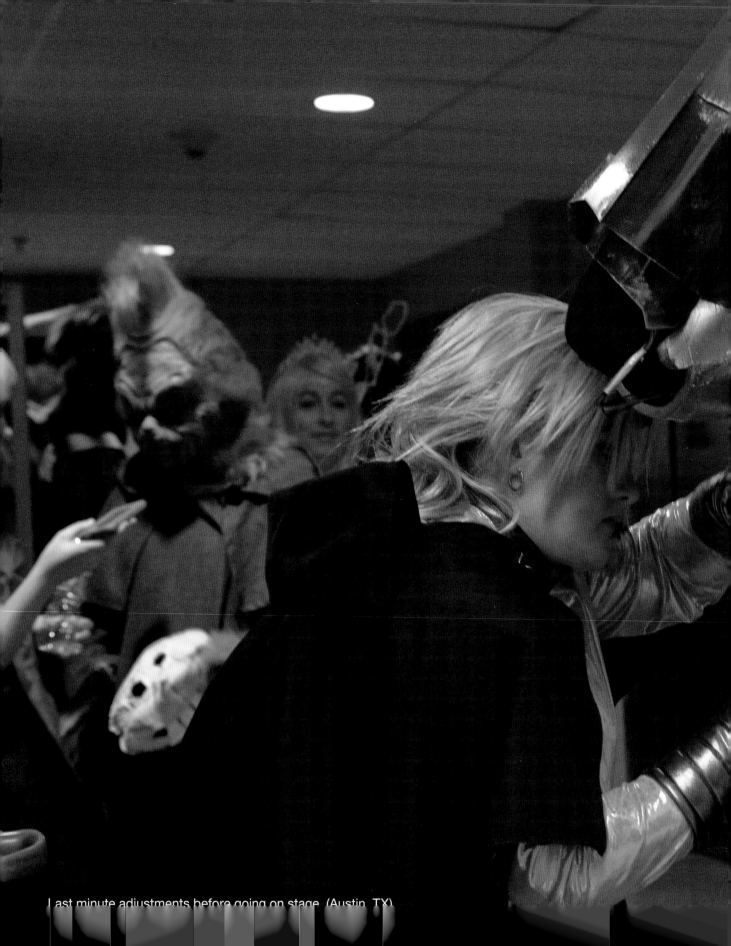

Last minute adjustments before going on stage. (Austin, TX)

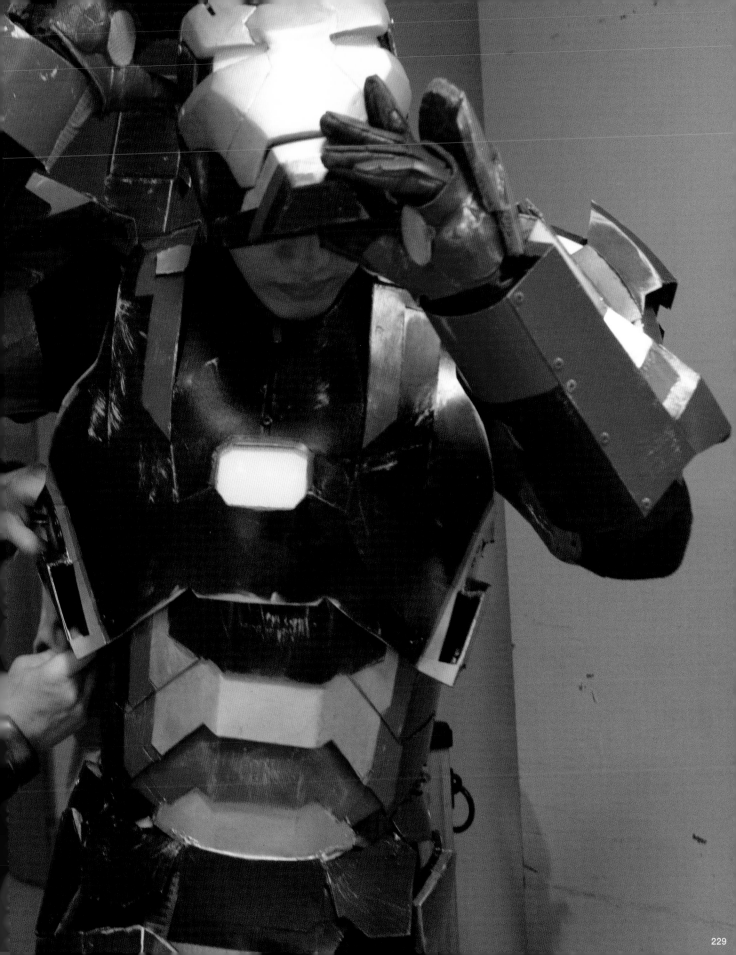

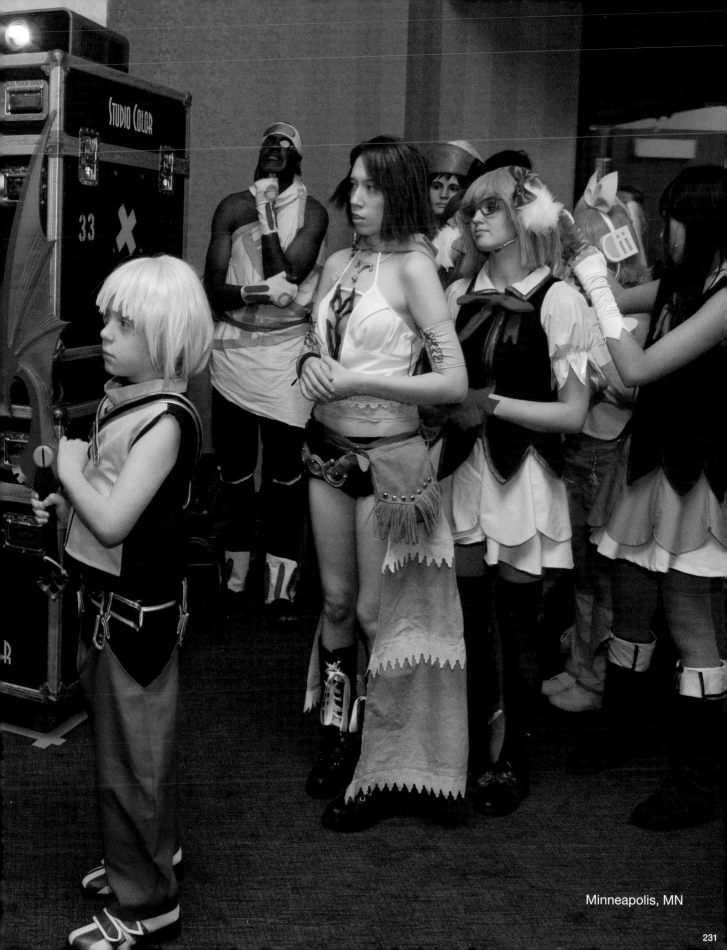

Minneapolis, MN

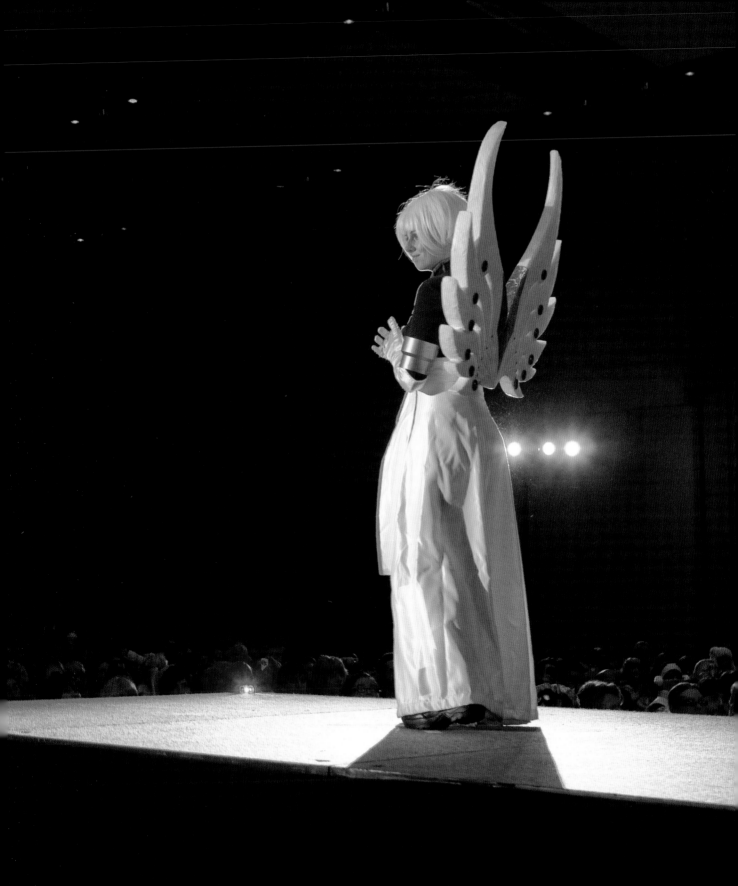

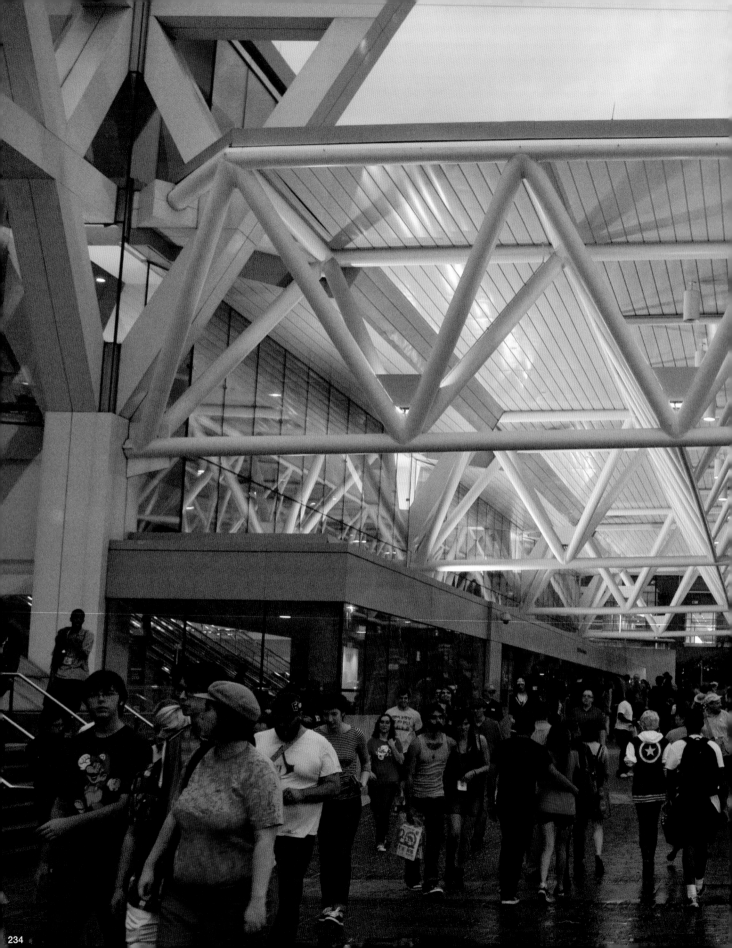

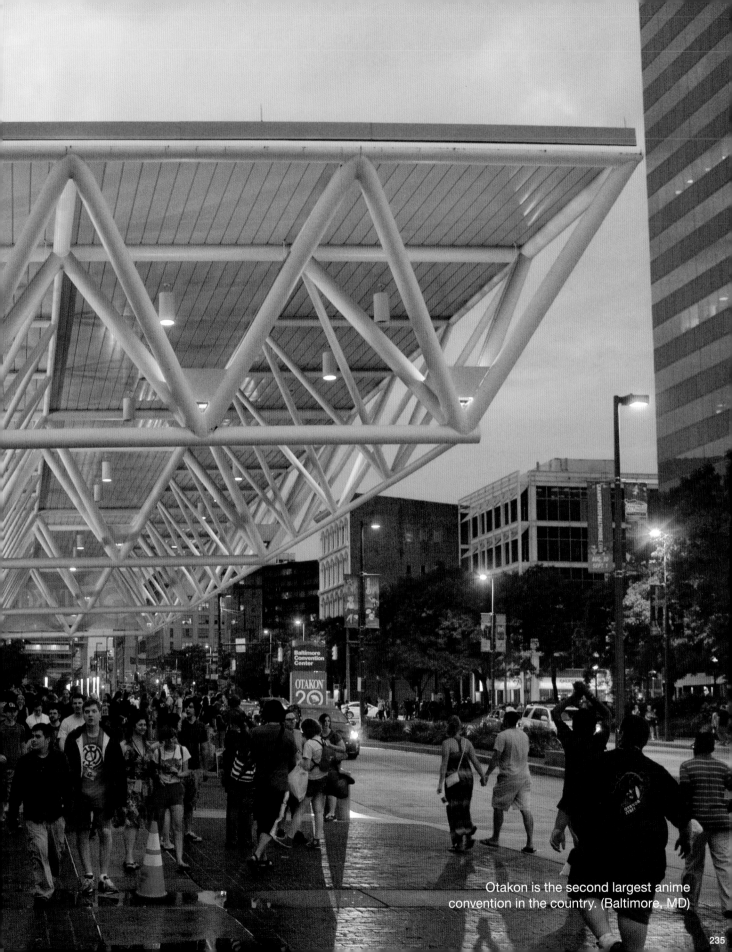

Otakon is the second largest anime convention in the country. (Baltimore, MD)

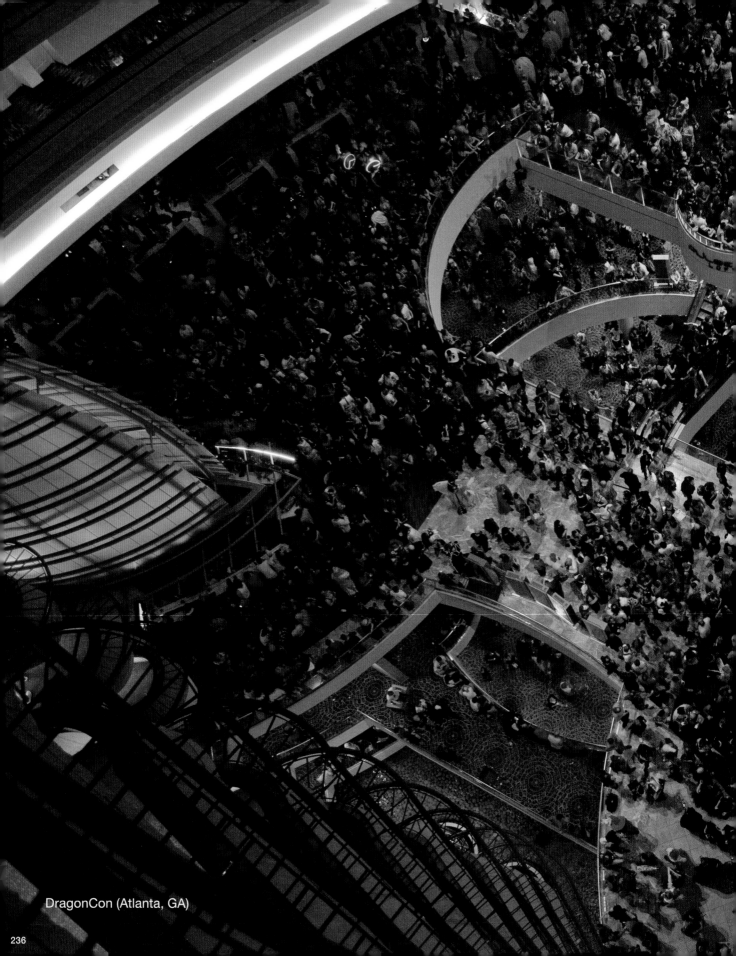

DragonCon (Atlanta, GA)

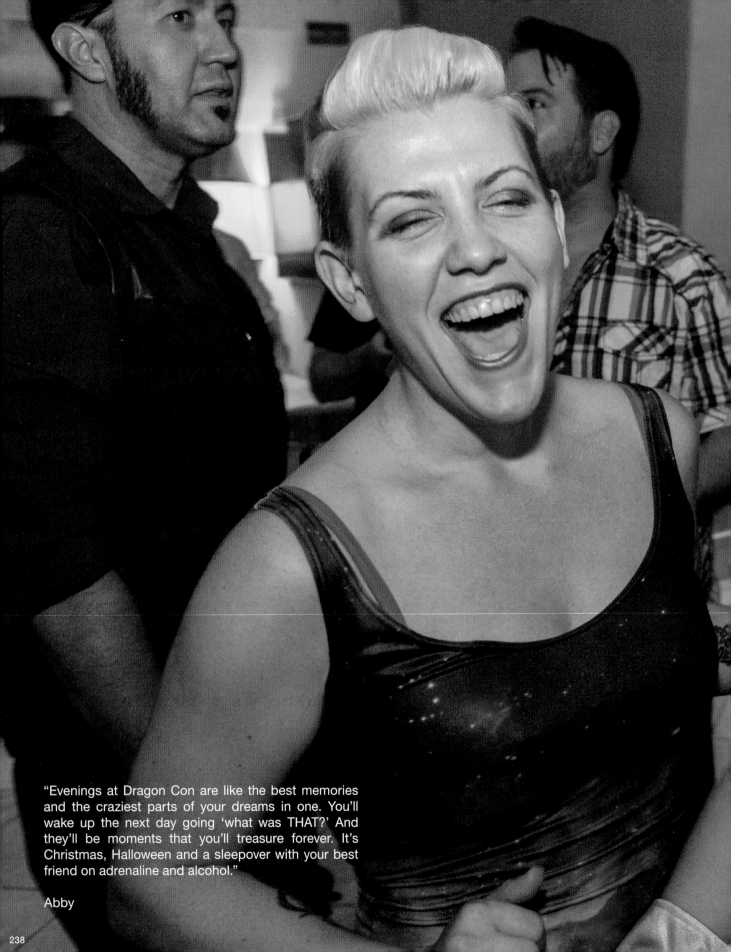

"Evenings at Dragon Con are like the best memories and the craziest parts of your dreams in one. You'll wake up the next day going 'what was THAT?' And they'll be moments that you'll treasure forever. It's Christmas, Halloween and a sleepover with your best friend on adrenaline and alcohol."

Abby

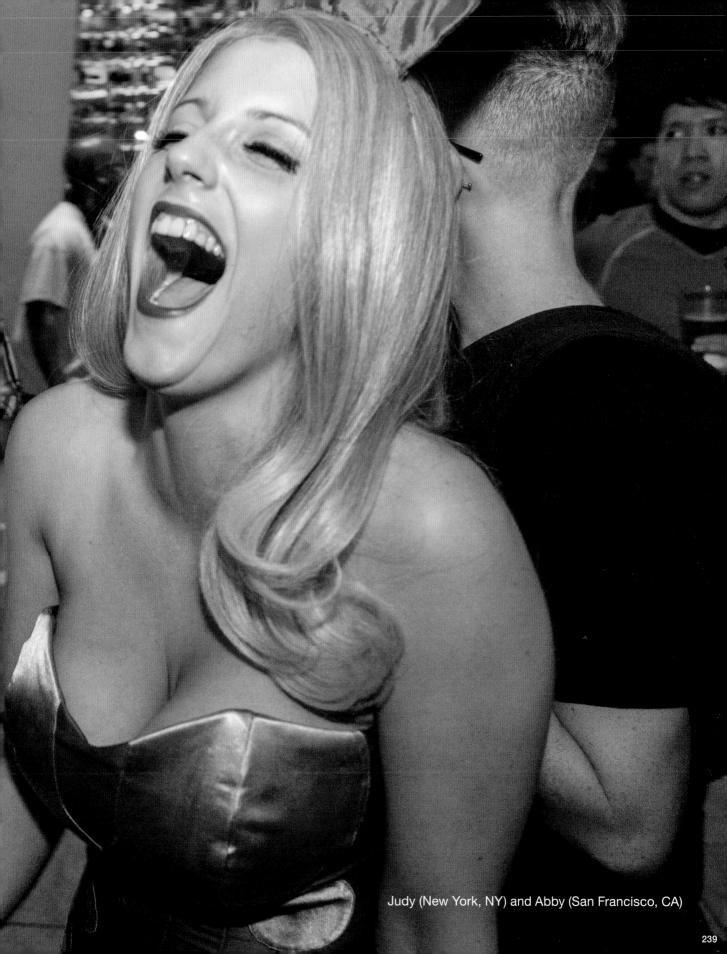

Judy (New York, NY) and Abby (San Francisco, CA)

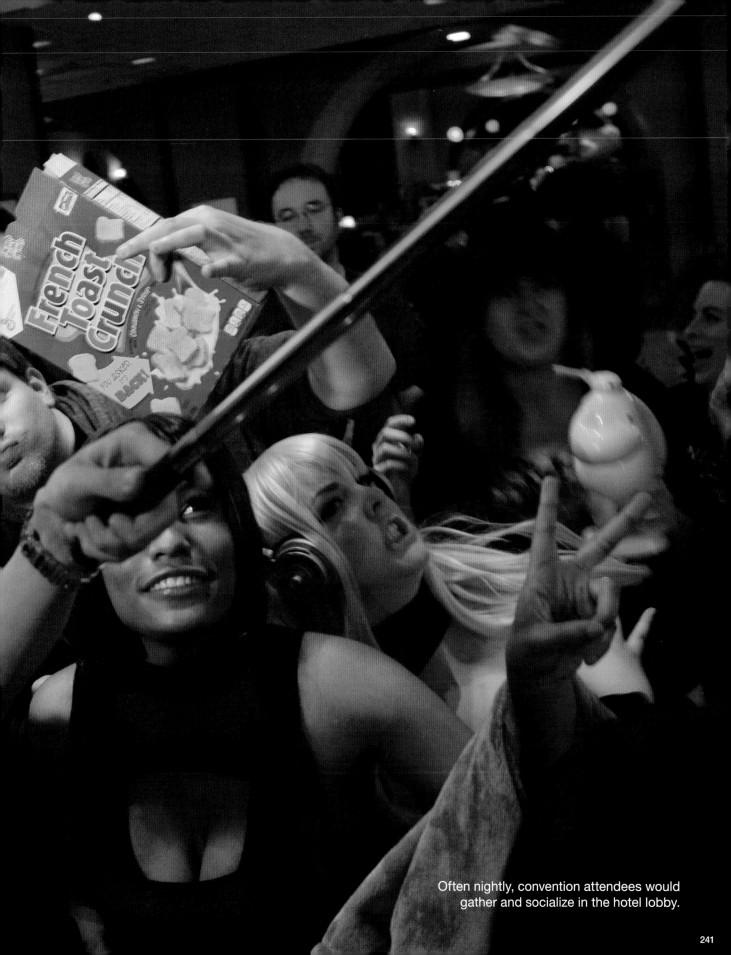

Often nightly, convention attendees would gather and socialize in the hotel lobby.

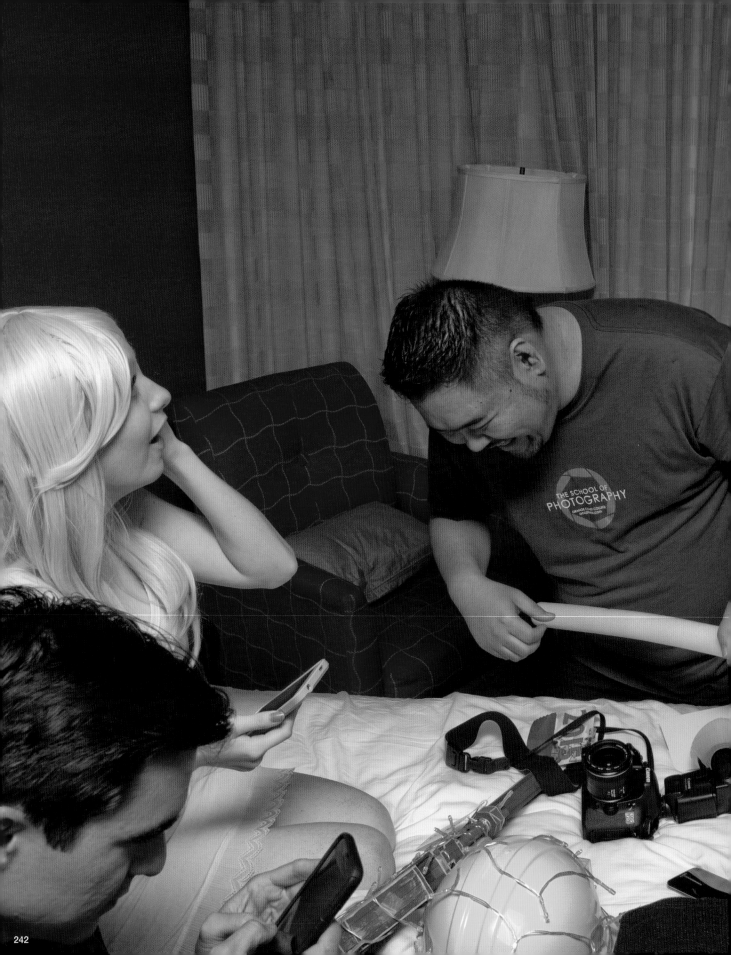

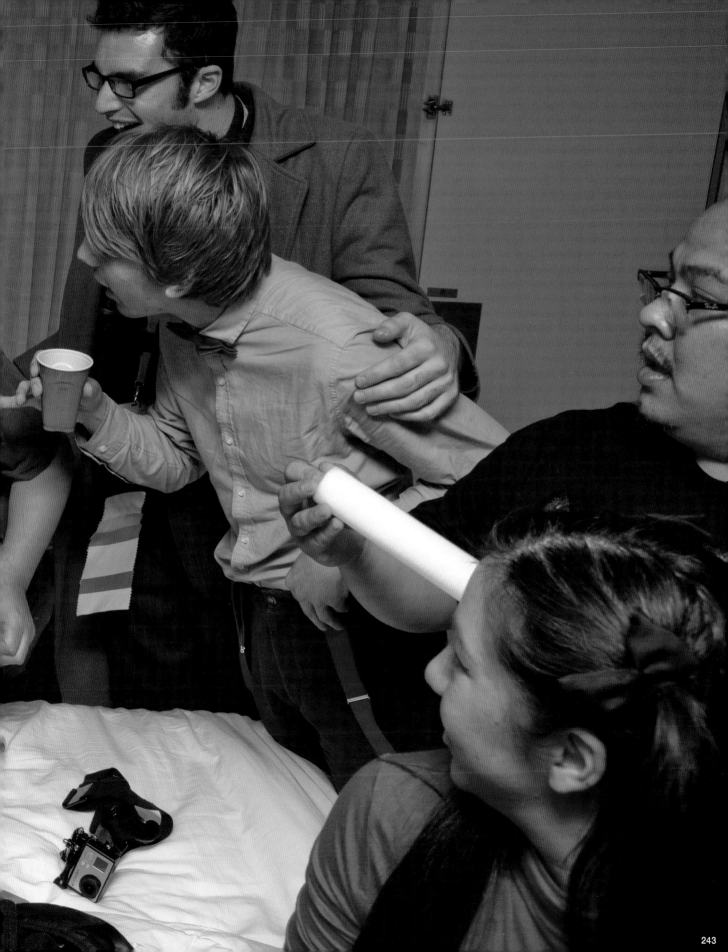

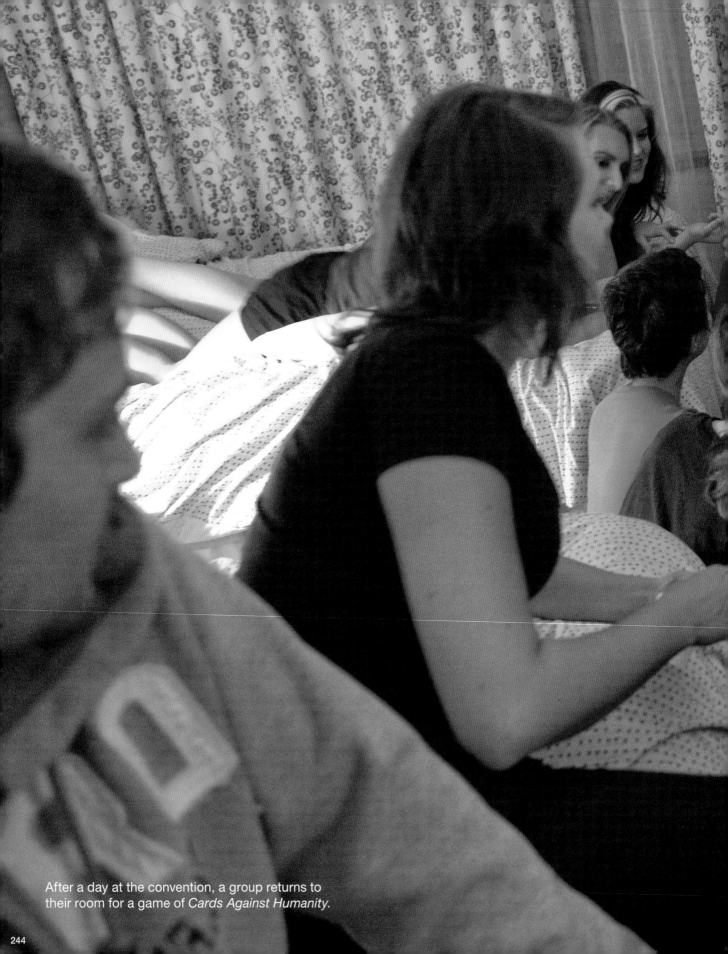

After a day at the convention, a group returns to their room for a game of *Cards Against Humanity*.

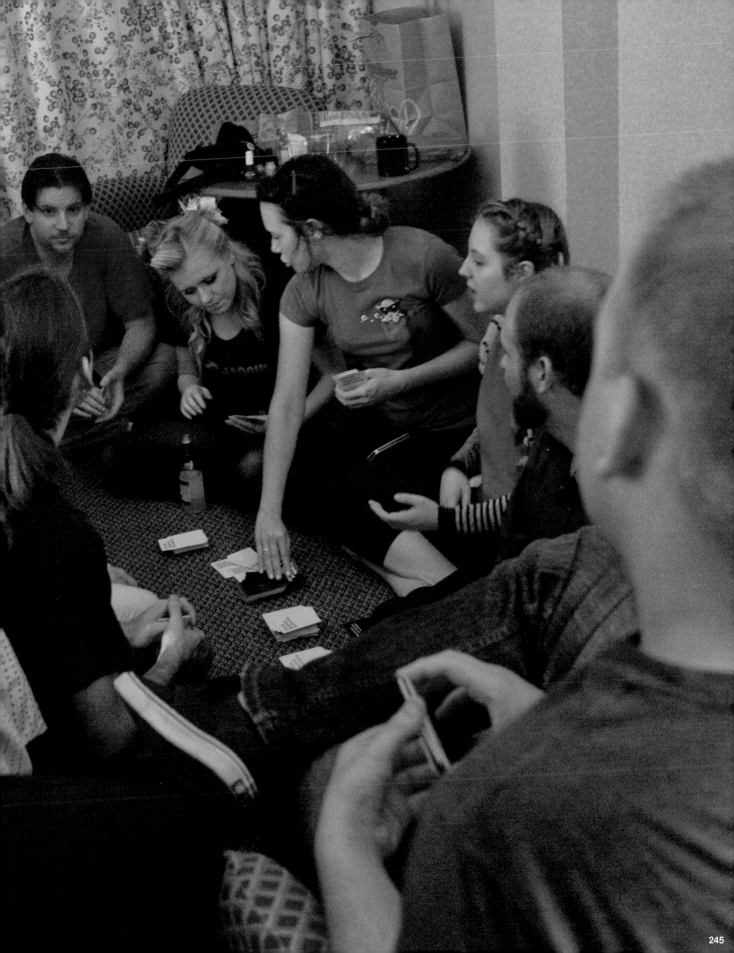

Most anime conventions offer night time programming
such as panels, gaming and dances.

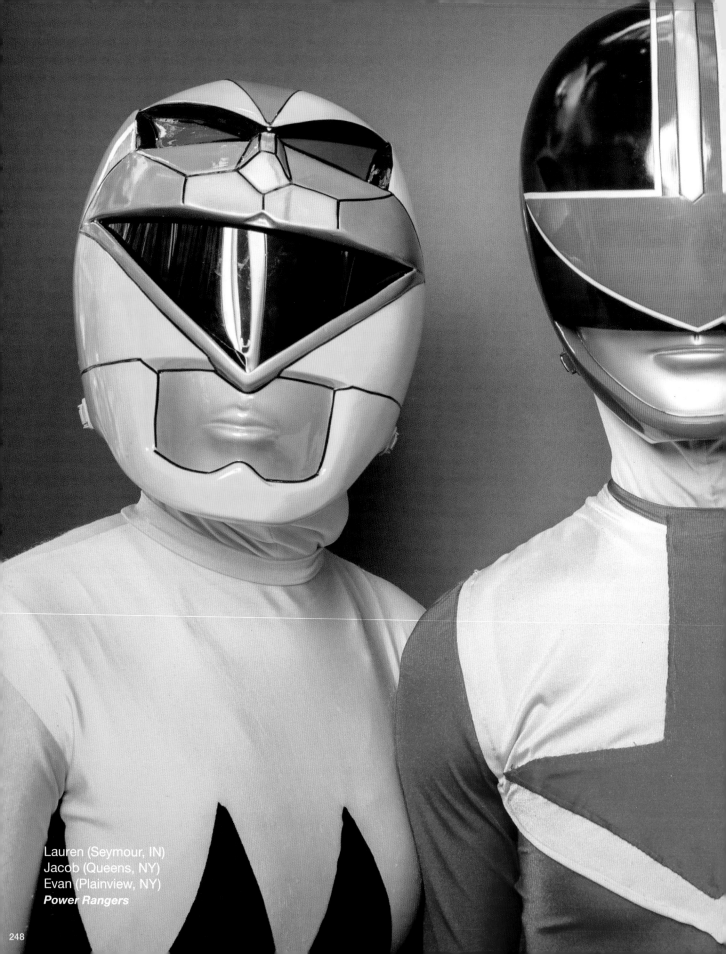

Lauren (Seymour, IN)
Jacob (Queens, NY)
Evan (Plainview, NY)
Power Rangers

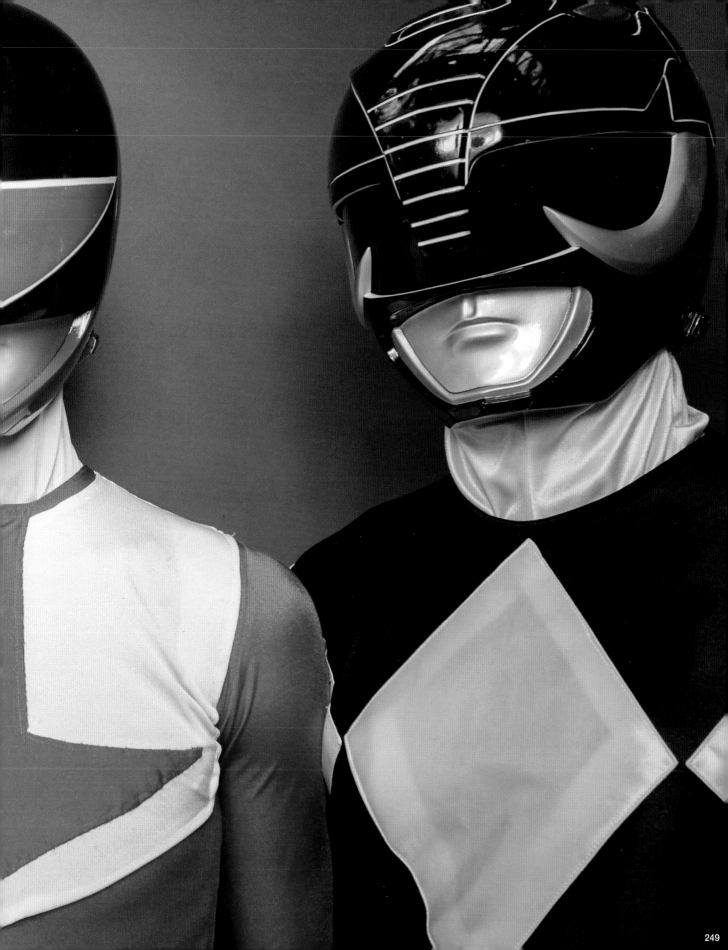

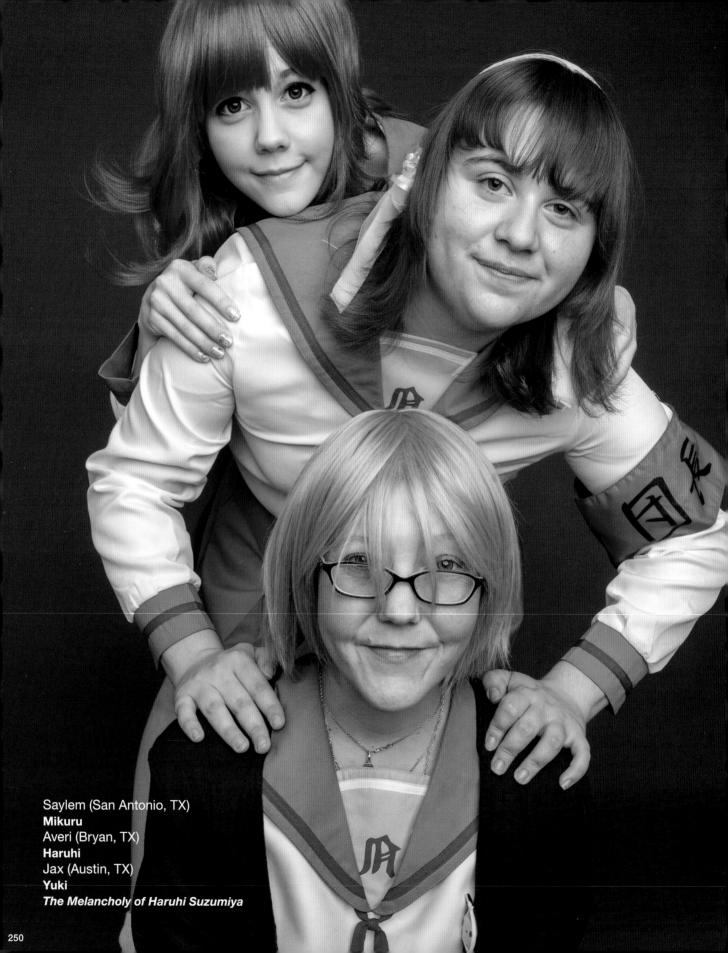

Saylem (San Antonio, TX)
Mikuru
Averi (Bryan, TX)
Haruhi
Jax (Austin, TX)
Yuki
The Melancholy of Haruhi Suzumiya

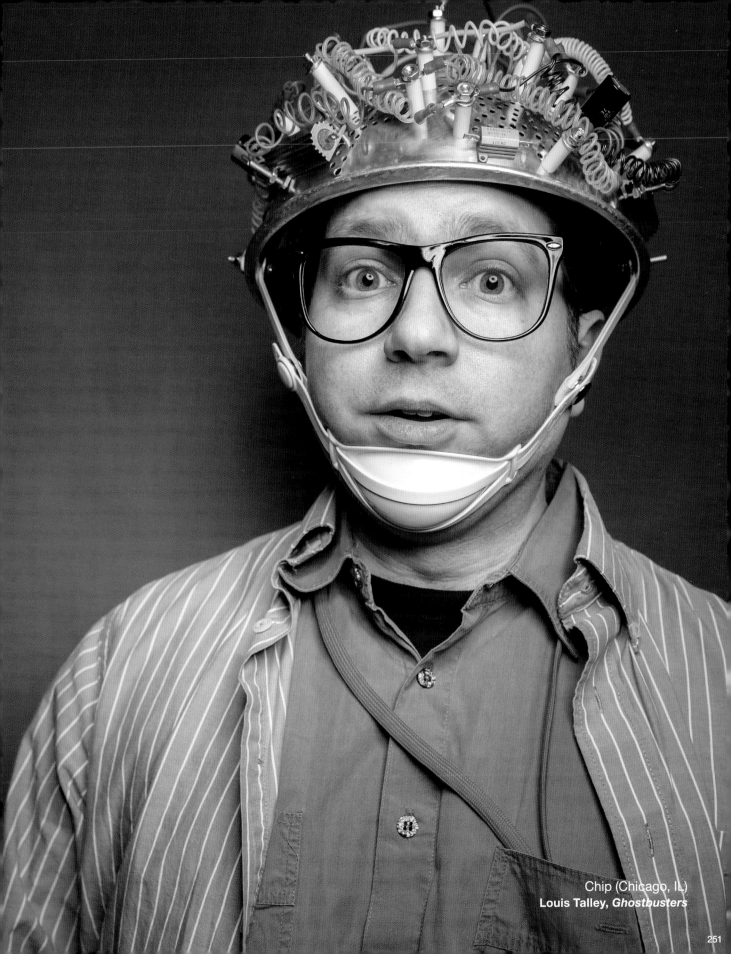

Chip (Chicago, IL)
Louis Talley, *Ghostbusters*

"Who I am now and who I was before I started cosplaying are two entirely different people. Cosplay changed my life and who I am as a person. People talk to me now and just assume I've always been this person that enjoys attention and having her picture taken.

Are you kidding?! People terrified me! I was always the rejected and ignored strange nerd baby of a child, and that followed me around psychologically for years and years. And I cosplayed for three years before I had an 'official' photoshoot, and even that was an accident! But I knew my own weaknesses and forced myself to interact with people and to stand tall and have my picture taken, and each time it got a little easier.

I became a confident person because I wanted to be that confident person I always admired. And every single person who has ever come up to me at a convention has been an overwhelming part of that."

Avis (Dallas, TX)
Lighting, *Final Fantasy*

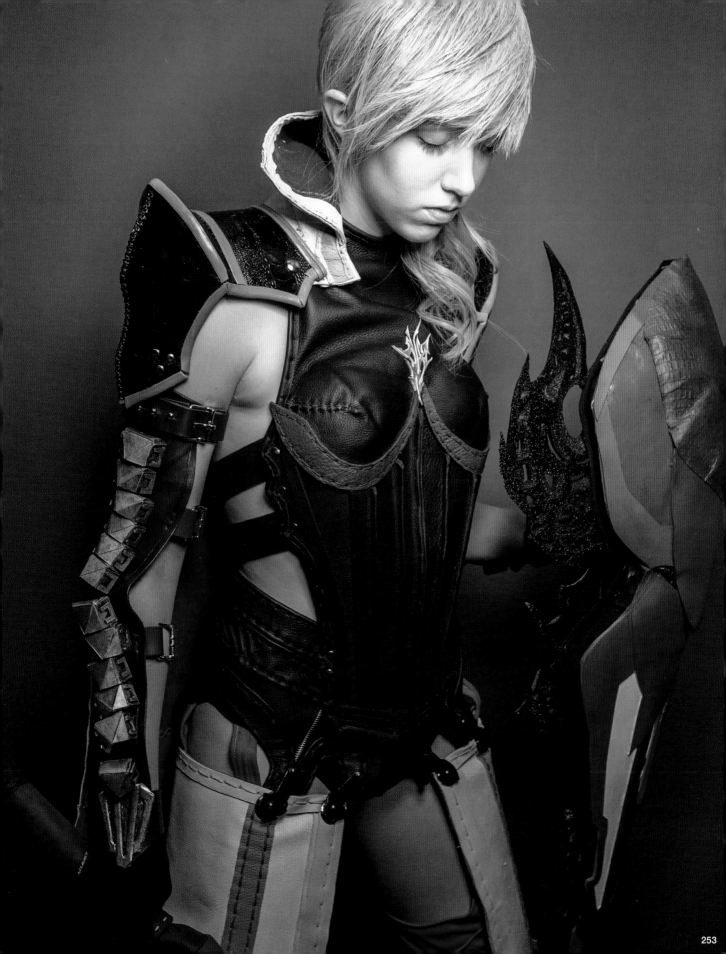

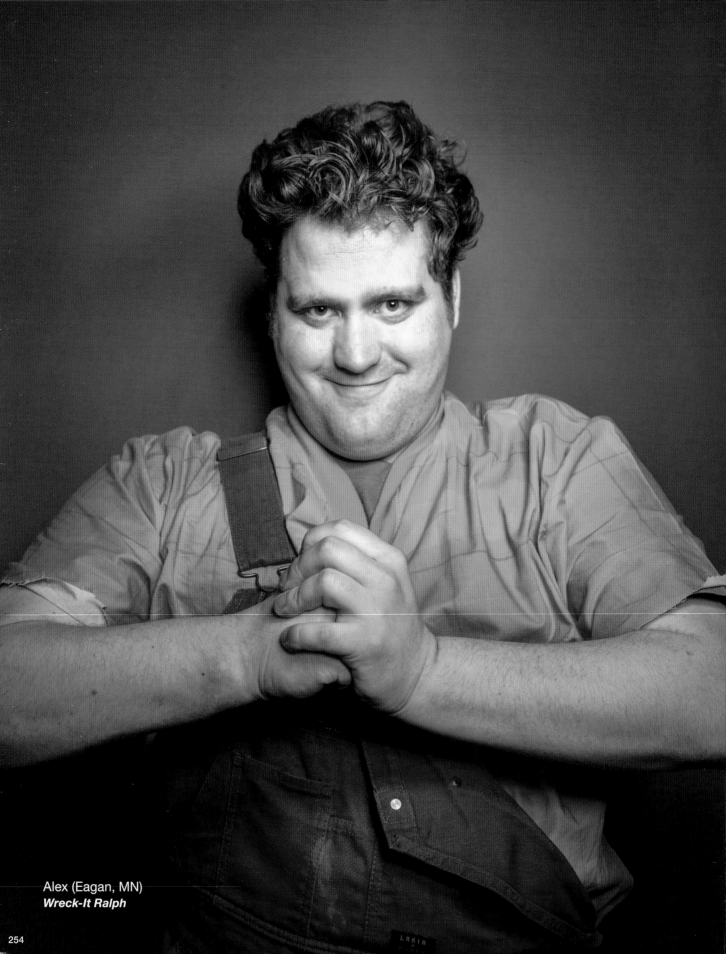

Alex (Eagan, MN)
Wreck-It Ralph

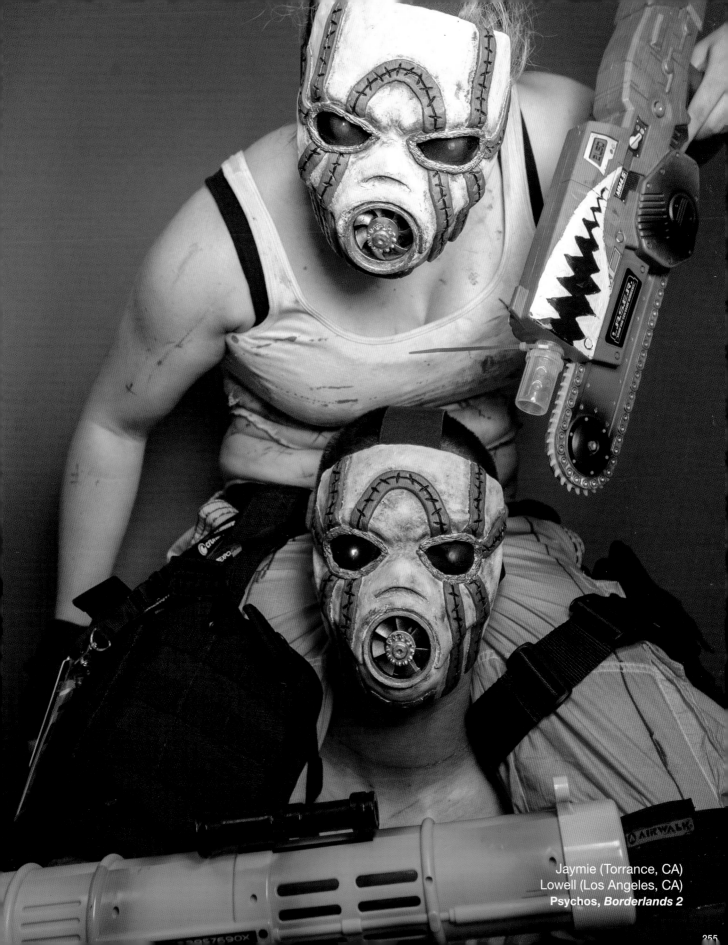

Jaymie (Torrance, CA)
Lowell (Los Angeles, CA)
Psychos, *Borderlands 2*

255

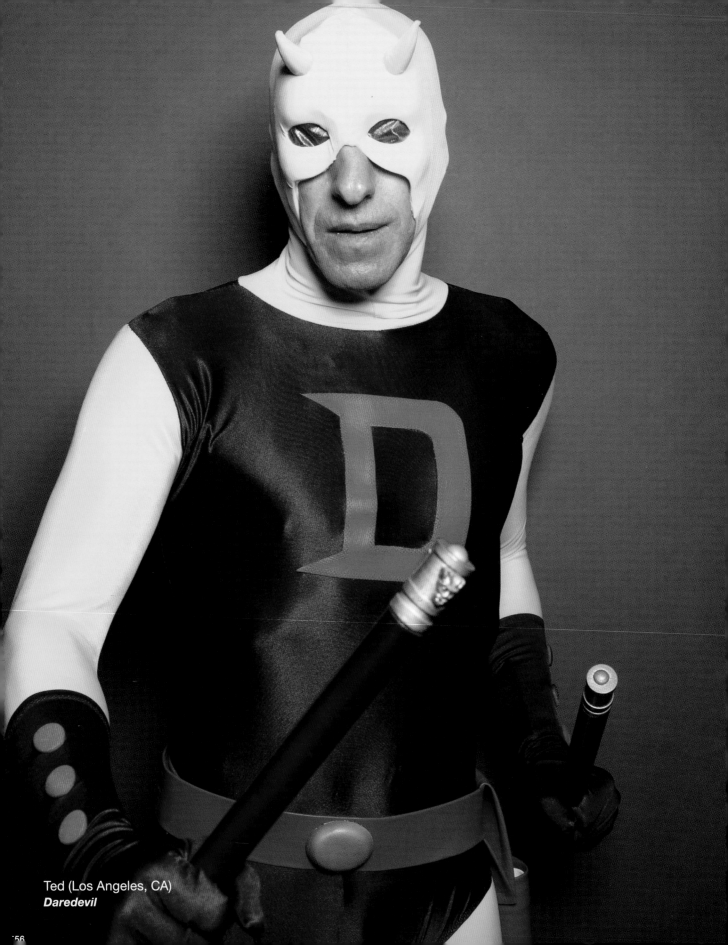

Ted (Los Angeles, CA)
Daredevil

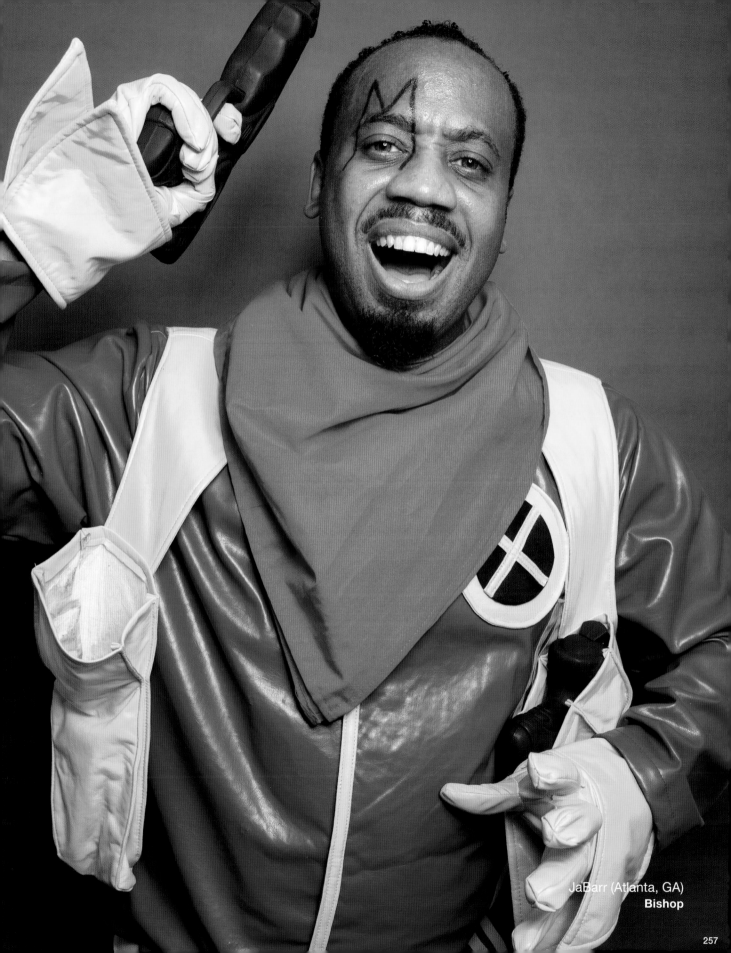

JaBarr (Atlanta, GA)
Bishop

257

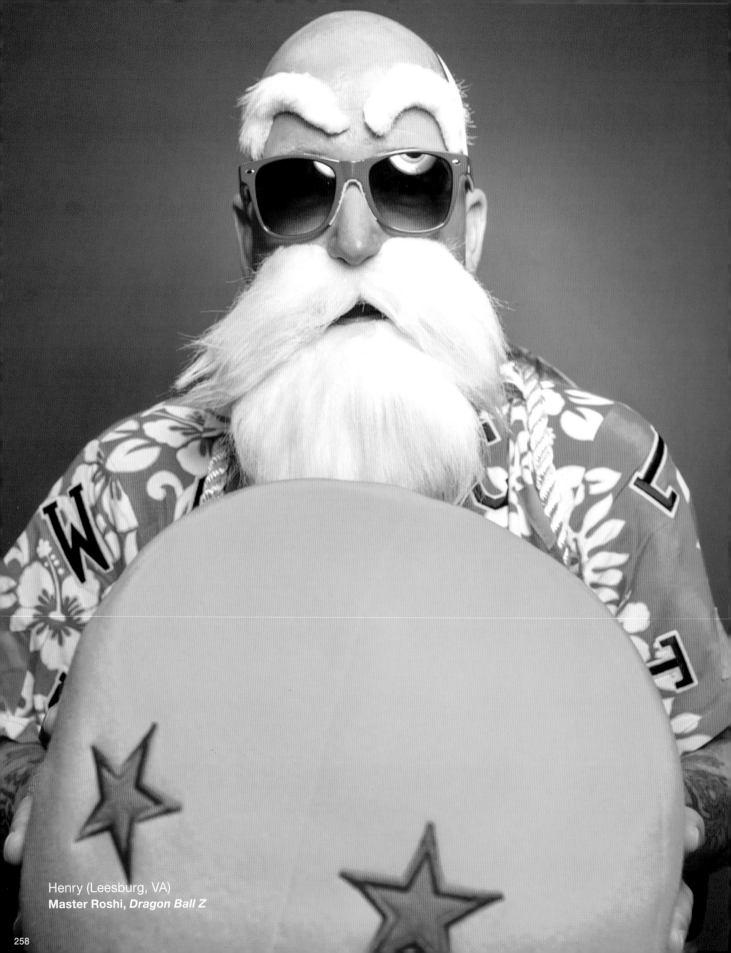

Henry (Leesburg, VA)
Master Roshi, *Dragon Ball Z*

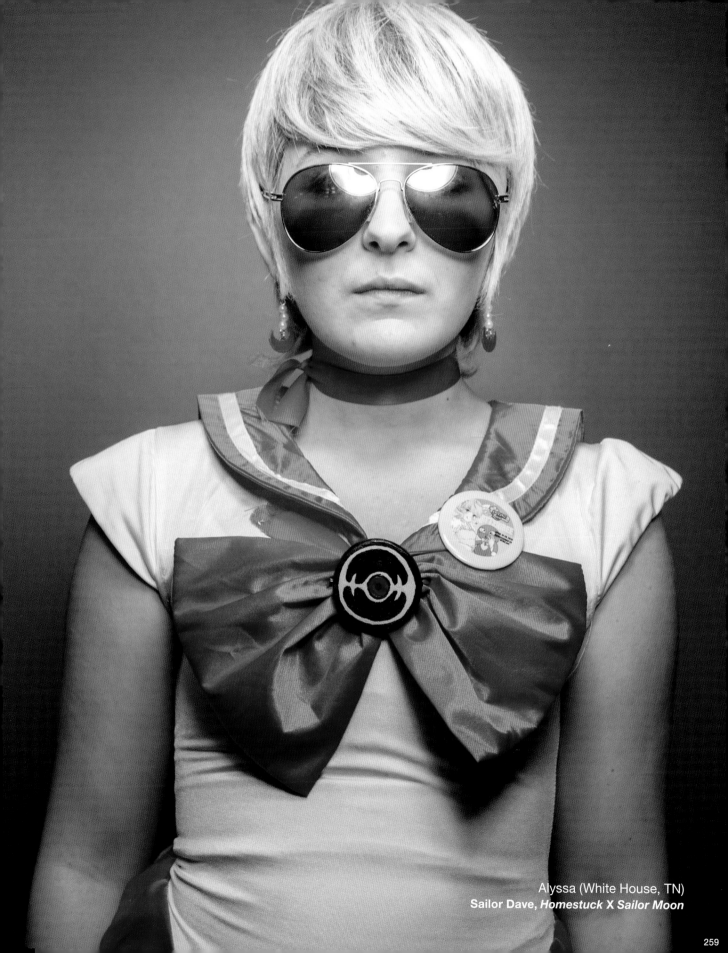

Alyssa (White House, TN)
Sailor Dave, *Homestuck* X *Sailor Moon*

Tiffany and Cassandra (Finksburg, MD)
Dexter's Laboratory

"Both of us grew up watching shows like *Dexter's Laboratory* and it has always held a place in our hearts. So when we were deciding to make costumes one year we wanted to go with shows we had loved from our childhood; *Dexter's Laboratory*, *Powerpuff Girls*, *Scooby Doo*, and *Fairly Oddparents*."

Cassandra

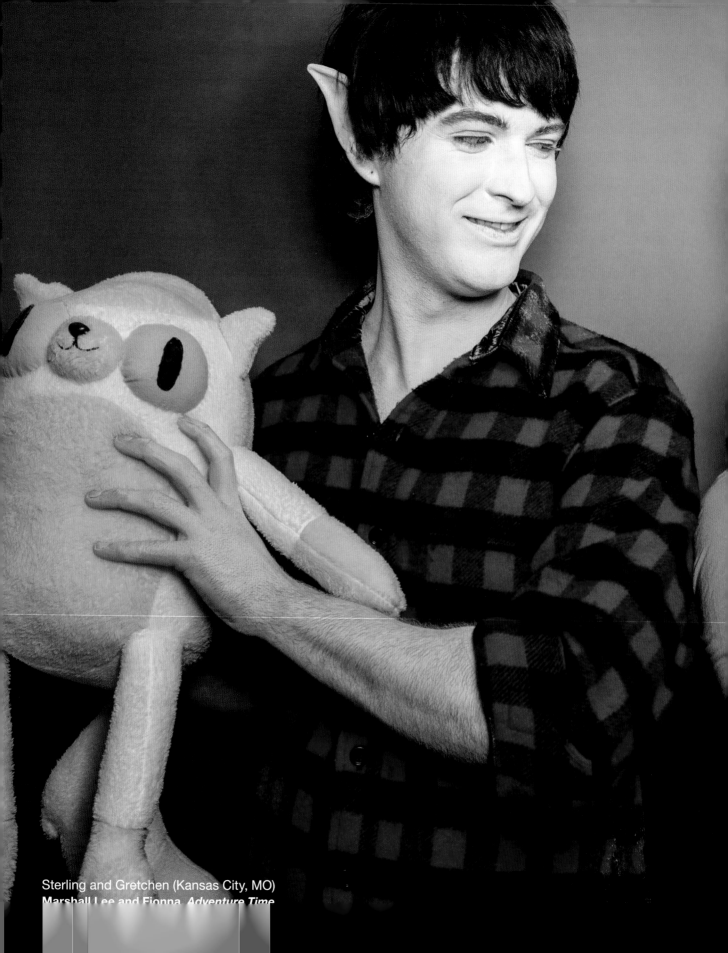

Sterling and Gretchen (Kansas City, MO)
Marshall Lee and Fionna, *Adventure Time*

"Cosplay can be really intimidating when you first start out. There are so many talented people out there who make all their costumes from scratch! But there is nothing wrong with buying your costume. I will say making your own costume, even if it's just modifying a few pieces here and there, feels so much more satisfying than buying your entire costume already made. It's hard work, but you feel so much more proud as you're wearing it."

Gretchen

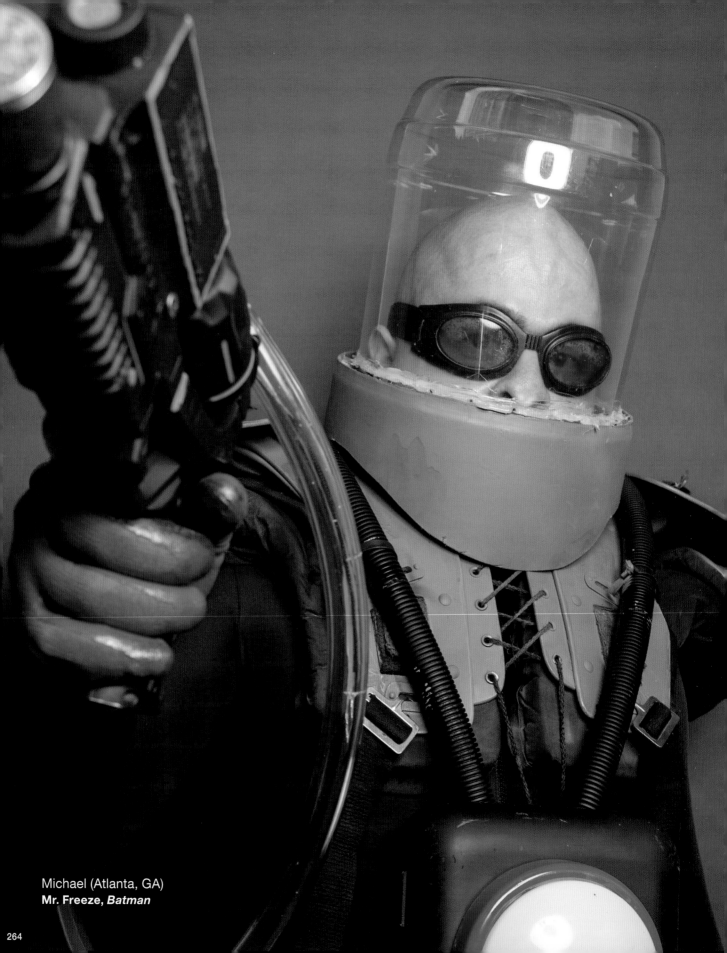

Michael (Atlanta, GA)
Mr. Freeze, *Batman*

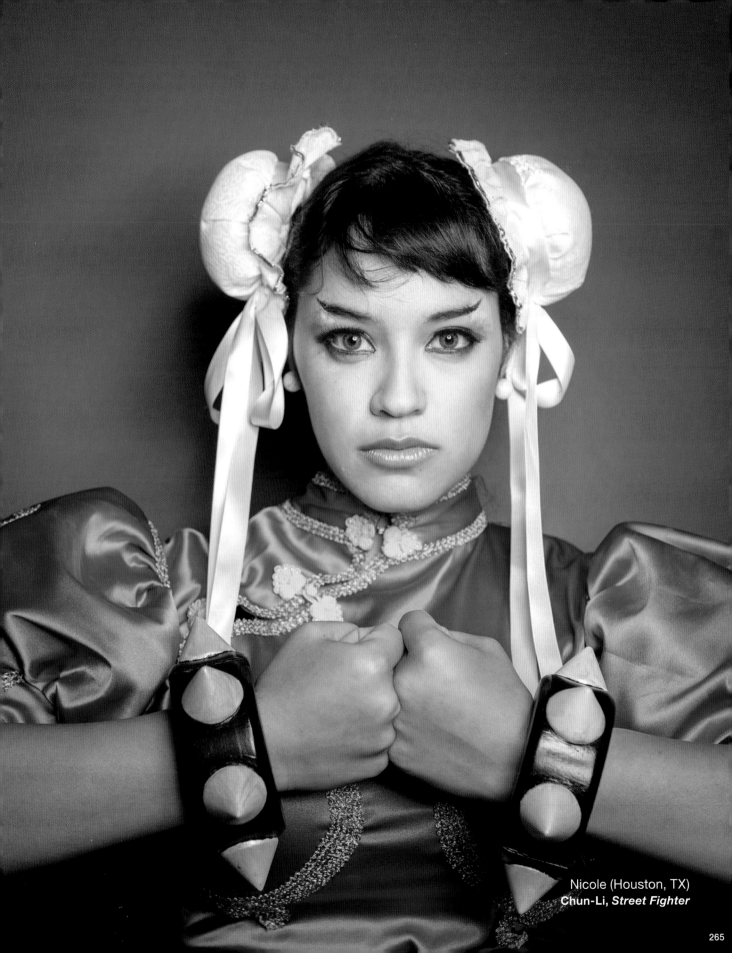

Nicole (Houston, TX)
Chun-Li, *Street Fighter*

Alex (Brooklyn, NY)
Shu Ouma, *Guilty Crown*

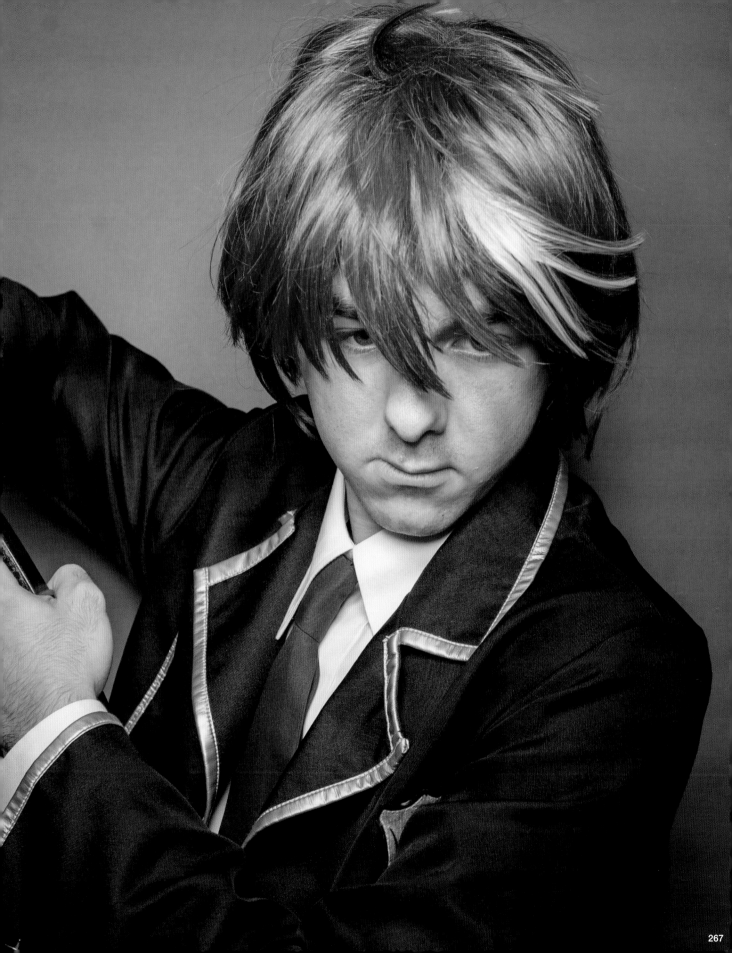

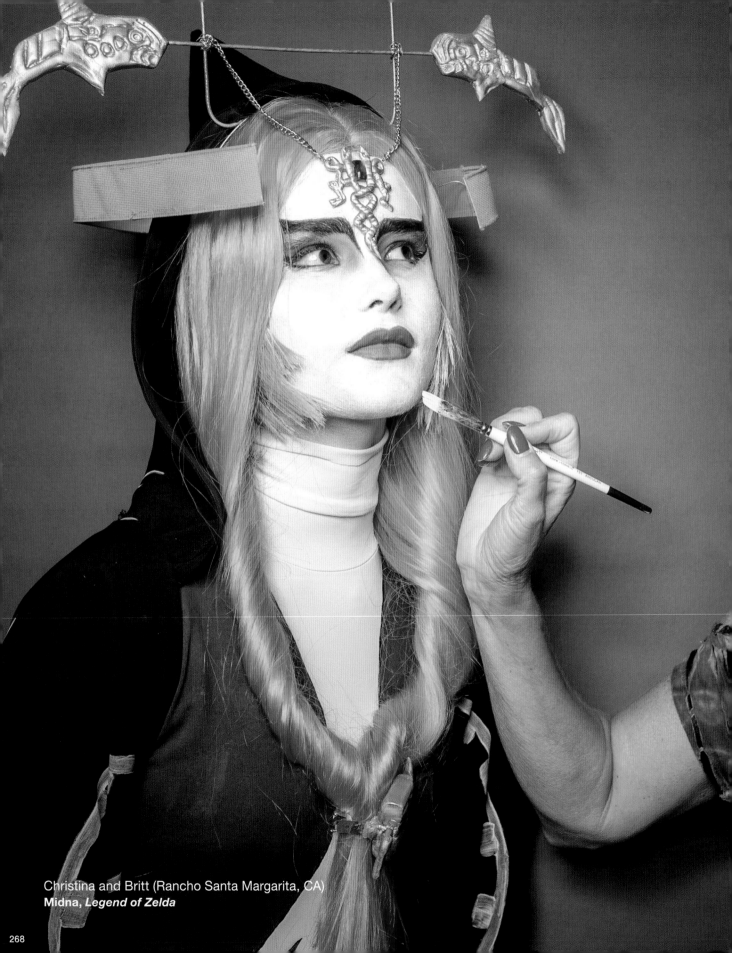

Christina and Britt (Rancho Santa Margarita, CA)
Midna, *Legend of Zelda*

"I grew up playing *Ocarina of Time* so one year for Halloween, my mother, an experienced hair and makeup artist for film and TV made the costume for me. At age eleven, I entered as Midna at *WonderCon* and was awarded Judge's Choice, My connection to the cosplay community exploded from there!"

Christina

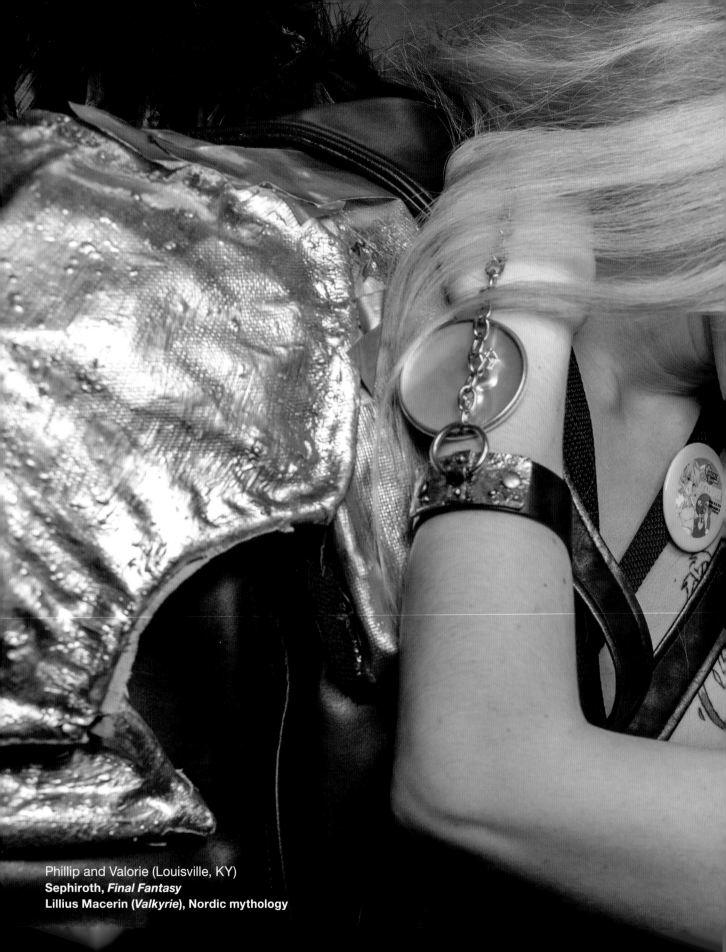

Phillip and Valorie (Louisville, KY)
Sephiroth, *Final Fantasy*
Lillius Macerin (*Valkyrie*), Nordic mythology

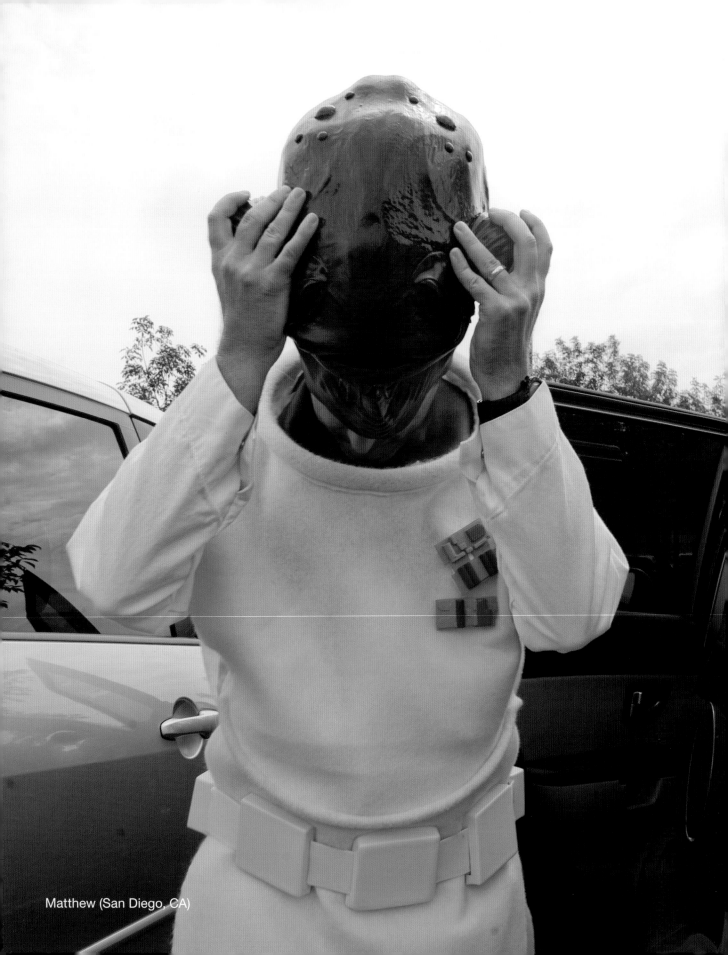

Matthew (San Diego, CA)

TO BE LIKE OTHERS IS TO BE MORE LIKE OURSELVES

ANDREA LETAMENDI, PH.D., PSYCHOLOGIST AND COSPLAYER

What might make someone want to become someone else? What would compel a person to put on a costume and assume a different identity? We might ask what flaws or deficits they are trying to conceal. What history, what personality, what life are they trying to escape? What are they hiding behind the mask?

What if I told you that persons who cosplay actually feel more like themselves when they are in costume? What if looking like someone else makes them feel like who they really are? And what if that process is a completely normal one?

It's puzzling. I'm not sure I fully understand this construct myself. In 2012, during a psychology and cosplay panel at New York Comic Con, cosplayer Holly Conrad, known for her realistic Commander Shepard costume of the game Mass Effect, revealed a very personal sentiment with a single statement. She said that she didn't feel like herself unless she was dressed as her beloved fictional character. There was a resounding agreement from the audience. This

seemed to be a universal yet unexplained feeling: the armor, makeup, props, masks or helmets, things that cover us up, actually make us feel more visible. It's as if our identities are fragmented or incomplete until we can sew, glue, and build them together with the artifacts of a costume. And then it just feels whole.

Despite an emphasis on the exterior, cosplay is an internal transformation. I define it as a visible expression of fandom that is accompanied by a psychological transformation related to personality, power, abilities, gender or sexuality. It's neither shielding nor displaying our identity; it's somewhere in between. Cosplay is an integration of our identity and the character we are embodying. It lifts up and makes accessible our own capacity to experience and express wonderful human emotions like generosity, caring, confidence, power, altruism, pride, and something we often struggle to find: a feeling of acceptance. Those who do not understand it offer their own explanations, conjecturing that cosplayers suffer from low self-esteem, psychological disorders, developmental problems or social ineptitude.

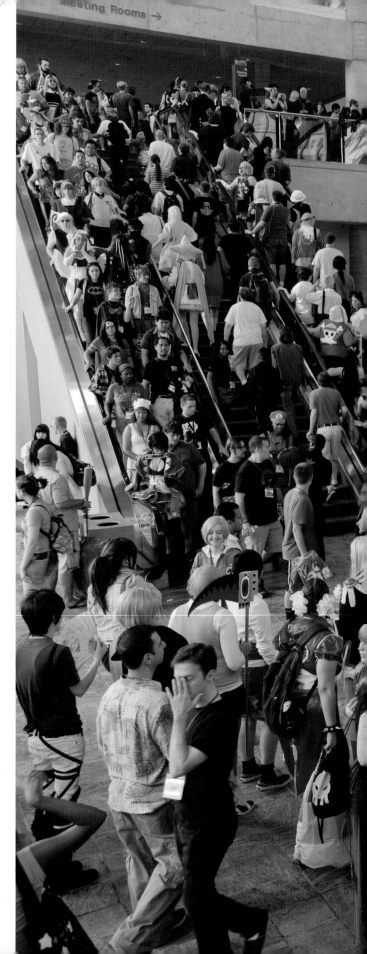

But this is a shallow perspective, one that neglects a fundamental aspect of the cosplay community: infinite diversity in infinite combinations. There are still many myths that can get in the way of celebrating that diversity. It seems that when superhero costumes are mentioned in the news or mainstream media they're associated with negative, sensational stories that involve crime, violence and antisocial behavior. Whether to blame, degrade, or pathologize, so often are cosplayers lumped together and reduced to a one-dimensional spectacle, dismissing all that the cosplay has to offer within and throughout.

In an effort to help provide a better understanding of cosplay and to move past the superficial aspects of costume-wear, psychologist Dr. Robin Rosenberg and I began to study the beliefs, behaviors, and attitudes of cosplayers. During a time of stereotyping, debasement, and misconceptions regarding cosplayers, we reached out to the community to explore their experiences firsthand. As a clinical scientist, I know that the best way for us to increase our knowledge is to rely on facts, not assumptions. As a cosplayer, I knew that I wanted to tell my own story, not have others tell it for me. Thus, we utilized empirical methods like questionnaires, surveys, and direct communications with members of the cosplay community. I was eager to find some kind of commonality, some trait that connected all cosplayers. Perhaps we're all introverted. Or maybe we're all looking for social approval. Or maybe we all have similar "day jobs" we're all trying to escape from for just a few moments.

One of our most striking findings was that cosplayers represent an incredibly diverse group, and we could find no single commonality or attribute that was shared among them. In fact, cosplayers are no more introverted or extraverted than non-cosplay populations. They're female, male, young, old, straight, LBGT, large, small, tall. Nerds cosplay. Women cosplay. Professionals cosplay. Accountants cosplay. Athletes cosplay. Psychologists cosplay. Professional athletic nerdy women cosplay.

In the Spring of 2013 I gave a lecture at the University of California, Riverside (UCR) to young adults and students who were interested in learning more about cosplay. Many had never cosplayed before. When asked about their willingness to cosplay at conventions and other public events, many of their concerns were around safety, a sense of security, a chance to experience fewer boundaries. One student confessed that she

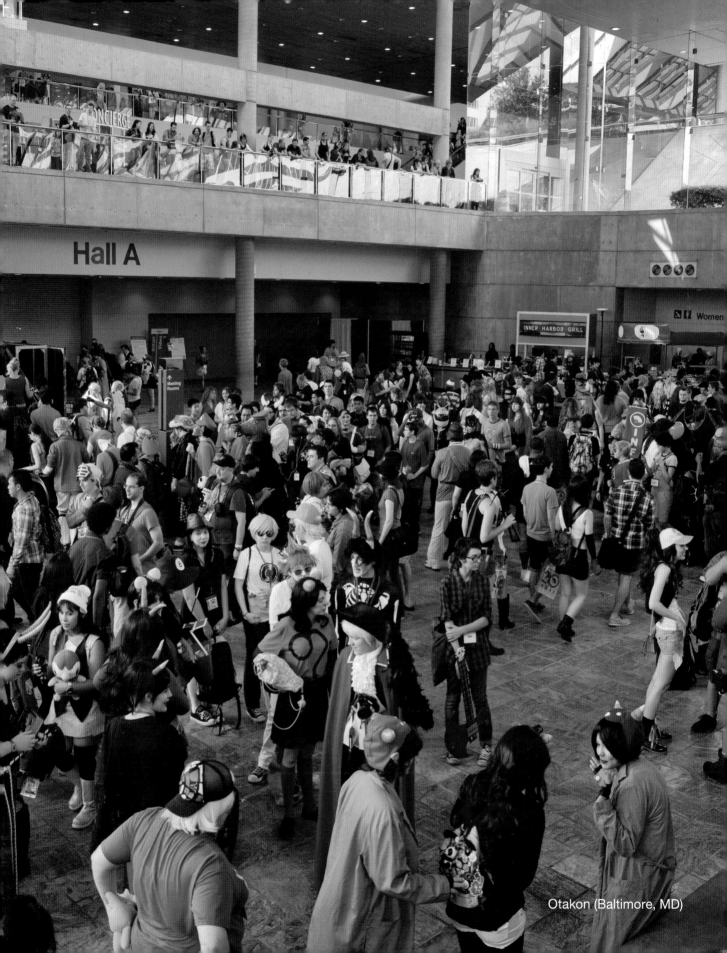

Hall A

INNER HARBOR GRILL

Women

Otakon (Baltimore, MD)

wanted to cosplay one of her favorite characters, but feared showing her face, explaining that she was unsure how she would be treated if people could "see the real me."

It is without a doubt true that cosplay involves revealing more about oneself. It is without question, then, that cosplay involves an exercise in bravery. And to enact that bravery could create an exhilaration unlike anything else. Integrating aspects that we admire into our personas is a very natural, adaptive process. Everyday transformations: professions of law enforcement, court proceedings, foster care, child welfare, and a multitude of other professions where we are wearing different hats. Rightly so, why not draw empowering attributes from fictional characters? Batman's resiliency, Korra's self-determination, Finn's innocent bravery, Vader's prestigious power, Doctor Who's wisdom, Jessica Rabbit's sizzle, or Spongebob's buoyancy.

What are the healthy aspects of cosplay? A sense of community, of friendships spanning time and cities. Large groups of people - again, of all types - banding together to celebrate their craftsmanship and hard work. People with a deep passion and a dedication to fandom, finally getting a chance to express themselves in ways that make them feel accepted and recognized. Cosplay could be an outlet, an escape to a universe that a person may not otherwise be able to participate in. In our everyday lives, do we feel out of place, uninvited, outcasted, or marginalized socially? Ironically, the act of adding costume and decoration can actually strip down those social differences or barriers.

Cosplay is a chance to safely explore emotions we may be unable or unwilling to express in our other lives, whether it's self-pride, anger and villainy, terror, sensuality, ambition and strength. Cosplay is a display of the parts of ourselves we may not have permission to show. Cosplay is a participation in the subversive. Cosplay is a sense of freedom from boundaries. And sometimes, many times, cosplay is showing the world just how magnificent we can look on the surface.∎

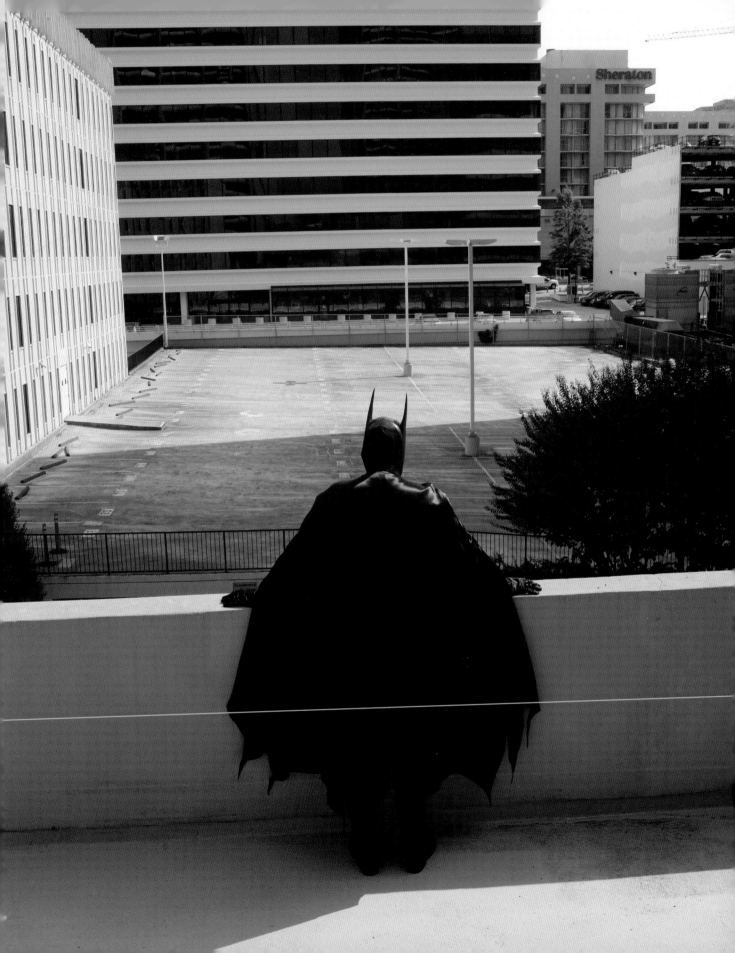

Thank you to the literally hundreds of cosplayers who opened their homes and their lives to me. You made me feel part of the family, shared your stories with me and for that I will always be grateful. Thank you to my Kickstarter supporters from around the globe for believing in this project. Finally, a special thank you to Bill Eiseman who encouraged me to do the first book back in 2009. Without Bill, there would be no *Cosplay in America*.

- Ejen

This book may not have been made possible without the following:

William Loftus
Carlos Andujar
Alex Brader
Ian Moore
James Conason
Matthew Klimenko

Collin Phillip Lanier	Jimmie Maggard	Nicolas-Loic Fortin
Felix Liljedahl Lilja	Kyra Stokes	Robbie Boerner
James Schaefer	Nader Michael Hanna Al-Shaikh	Tiffany Bullard

Amber Silver	Vincent Milum Jr	Jason Chau	Lauren Townsend
Larry Fleming	Pierce Barber	Bridget Phillips	George Chrismas
Serephita	Amanda Hickman	Mindy Tomlin	Jonathan Hibberd
Daniel Arteaga	Gilbert Arzola	Alfonso Vitela	Matt Cox
Nooshin Toloui	Auri Aminpour	Michael Miller	Storm Kristen Oliver
Edward Scarbrough	Jaimee Charleston	Erin Burgett	Brent Cantrelle
Scott Melot	Jamie Meakin	Jonas Yip	Kevin Marciniak

Andre Irawan Mulia	Foxhound	Laney	Ryan Campbell Jr
Brett Whitman	Genevieve Cote	Lauren Crosson	Samm Mielach
Bryce Masunaga	Green Mustard	Macky Pierce	Sarah Metcalfe
Casasouris Rex	Entertainment	MB	Steph Vosburgh
Catrina Tarr	Gwyneth Wilson	Meghan Temple	Stephanie Dooley
Chris Landingin	Jan A Neurdenburg	Mike Penny	Stephen Roberts
Christophe LEMAÎTRE	Joe Chan	Natasha Ramsay	Tayler Brown
Coscontv	John F Willis	Oscar Cebreros	Tiger Jackson
DavinDaLilAzn	Jonathan Ofalla	Patrick Robert Stewart	Trevor Lawrence
Elizabeth Fehrmann	Joshua Ferguson	Ria Chin	Montgomery
Emilie Gschweng	Kendra Rowland	Rich Carrasco	Windgirlcurse
Erin	Kristy A Haupt	Ricky Perez	

A Nguyen
Aaron Coventry
Abby Fellows
Abisola Fatodu
Absence Alternatives
Adam Bregar
Adam Hungerford
Adam Luchjenbroers
Adam Watson
Addie Unger
Adelita Van Wert
Adrian M.
Adrienne
Aileen Cruz
Akynom
Alan Ting
Alex Anaya
Alex Armstrong
Alex Engel
Alex Horvath
Alex Kaplan
Alexa Spears
Alexis Chang-Powless
Alice
Alice Bryson
Alice Roy
Aline Smithson
Allan Limburg
Allen Hansard
Alli Chinn
Ally Temple
Amanda
Amanda Mari Gregory
Amanda Walter
Amber Lockard
Amelia McLay
Amelia Palmer
Amy Bradley
Amy Stetzl
Anabel Martinez
AnayaSora
Andreas Schneider
Andrew Berben
Andrew Davis
Andrew Iverson
Andrew Valenzuela
Andrew Weiglein
Andy Nguyen
AnimeLover
Anna Lee Mueller
Annah Lång
Annie Vogel
Anthony Rojas
Anthony Barnes
Anthony Yimsiriwattana
Antonia Ursa
April Cornette
April Lycans
Aranya Thor
Arne Baade
Arthur Garcia
Ashley Craig
Ashley Hay
Ashley Johnson
Ashley Yutzy
Atticus Tsai-McCarthy
Aviel Solar
Ayden Gotzmer
Bamboo Dong
Battlement
Ben
BigWhiteBazooka Photography
Bill Doran
Blake Entrekin
Blue Rayne
Bobbi Fabian
Boo Shangyou
Brandon Kitchens
Brandon Trezevant
Breanna
Brendan Joyce
Brent
Brian Gonzalez
Brian Langeland
Brian McMurrer
Brian Trinidad
Briana Thurman
Britthebadger
Brontis Shane
Bryan Vu
C. Scott Kippen
Cara Elizabeth
cards344
Carlo B Ondoy
Caroline Blacketer
Carolyn Carver
Carsten Andersen
Casper Wong
Cassondra Lim
Cat
Catherine Jones
Ceri Young
Chalisa Arden Wangsang
Charis M. Ellison
Charles Piner

Chelsea Mullen
Cheryl Platz
Chris Kwock
Chris Palmer
Chris Rosario
Christine Choi
Christopher Chin-Sang
Christopher Nau
Christopher Schmitz
Christopher Sloane
Christopher Westwood
Chuck Cook
Cindy
Clarke
Clay Gardner
CliffKicks
Colin
Colin Janson
Colin Kennedy
Connie Jazzy Smeriglio
Cora A
Corinna
Cortney Chene
Cory Reese Keelen
Courtney Armstrong
CrabAndCat
Crystal Reed
Crystal Vega
Cuong Truong
Cynthia Matherly
Daamon Bintz
Dale Moyle
Dale Taylor
Dale Wones
Dan
Dan Shepherd
Dan Wrenn
Daniella Orihuela-Gruber
Darren Vallance
Davann Srey
David B. Williams
David Chen
David Francis
David Haig
David Ngo
Dawn Holley
Dea Thea
Desiree Cosplay
Desiree Grimes
Desireé Mendola
Devious Cosplay
Dewayne Ingram
Dion Yang
Dj Alexander
Dominick Cancilla
Doug Mercer
Ed Martinez
Eddie Leal
Edgar Gonzalez
Elaine
Eli Luna
Elias Göransson
Elizabeth Koziell
Ellise Heiskell
Elonweis
Elya Arrasmith
Elyse Broczkowski
Elysia Munoz
Emma
Emma Tomiak
Endy Mageto
Eric Brooks
Eric Sivilich
Erica Espejo
Erica Rapp
Erich Claxton
Erik Dahlman
Erik Hawkinson
Erik S
Erik Zetterberg
Erik Estrada
Erinn Phinney
Ernst Undesser
Ernst van Biljon
Esmeralda J Cardenas
Excalipoor
FanService Renji
Feferi
Felix Wong
Fox Williamson
Garrison Hall
Geisha VI
Gerald Tamayo
Gilbert Pacheco
Glenn Adrian
Guy Thomas
Hannah Black
Hannah Brunn
Harlee Byrd
Heath_Bar
Heather Henry
Heather Nunnelly
Heidi Shimada
Helge Nordvik
Herbie

Hilary Dunn
Hollingsworth
Holly Kraft
Holly Stotelmyer
Ian Barrow
Ilona Jurek
Ing-Long Kuo
Isabella Breier
Isabella G
J. Korra
Jack Teague
Jacquelyn
James Brunson
James Canavan
James Hamlin
James Hogan
James M McKeon
James Nishi
Jamie Davis
Janel Smith-McClain
Jason Moore
Jason Perez
Jason Rose
Javier Perez
Jean Fioca
Jean Takabayashi
Jeannette Chambliss
Jeffrey Marriott
Jellykeo
Jenna Hargreaves
Jennifer Pudlo
Jennity
Jenny M. Ovalles
Jerrell Tyler
Jessica Bohman
Jessica Hernandez
Jessica L Villa
Jessica Robertson
Jessica Steffan
Jim Soo
Jinx
Joe Auditore
Joe Regan
Joel Catalan
John Au Yeung
John Ferreras
Johnny Ricketts Jr.
Joi Weigand
Jolene Binkley
Jon Racasa
Jonathan B. Howell
Jonathan Lam
Jonathan Mallicoat
Jose Zetha (Cosplay Perú)
Joseph Eusebio
Joseph Nastasi
Joseph Ngo
Josh Cassella
Josh Crowe
JP
Judy Escalante
Julia Strain Sanzberro
Julio Lopez
Justin Reuter
Kaitlin Reid
Kaitlynn Perez
Kara Martin
Karen McOscar
Karl Jahn
Karma Savage
Kasey
Kate Honebrink
Katelyn Pineo
Katelyn Schubel
Katherine Ashley Daiker
Katherine Stocking
Katherine Wenske
Katie
Katie Ash
Katie Gregory
Katie Kubo
Katie Mallner
Kay Markert
Keith Lyles
Kellie Stewart
Kelly Coffman
Kelsey Combs
Kenneth Hadley
Kevin
Kevin Lawrence
Kevin Smith
KickChan
Kiera Blackie Vallone
Kiki Flynn Denison
Kim Williams
Kimberly
KJB
Klas Rönnbäck
Kole Montross
Kristen Hughey
Kristopher Bose
Kyle Kortvely
Laura Neocleous
Laura Wright
Lauren Bond

Lauren Forney
Lauren Peacock
Lauren Stark
Lawrence Mabilangan
Leanna Kirstan Crumpler
Li Doyle
Lilith Oya
Lillian Wong
Lily W
Lisa Sandoval
Lisa Su
Lisa Varley
Lizzie Wright
Lynne
Lyonel Shirosaki
Madeline Radike
Maeve Griffin
Malinda Mathis
Marc Jacobs
Maria Castaneda
Maria Harr
Marie-Eve Michaud
Marilyn Dozer Chaney
Marissa Tullock
Maritzalyn Mercado
Mark Denbow
Mark DiBlasi
Mark Mucciarone Jr
Markus Pedersen
Mary Ingram
Mathew Devoe
Matt
Matt Burrell
Matt Chan
Matt Murphy
Matthew Bach
Matthew M Ford
Matthew VanMalsen
Matthew Walther
May Chen
Meaghan McCormack
Megan
Megan Heikkinen
Megan Yada
Meghan Alice
Megumibish
Melissa Russell
Melissa Silvia
MG GAMES
MG Shogun
Mia Moore
Mia Morris
Michael Midura
Michael Zhang
Michal Stepien
Michele Donaho
Michelle
Michelle
Michelle Chrzanowski
Michelle D'Antonio
Michelle Flamm
Miguel Matos
Mike Brazinski
Mike Prasad
Mike Suzanski
Mike Temsupasiri
Miko Sharp
Milliondollarloser
Monica Ortiz
MP
Myke Hottenstein
Myriam Lisette Alvarez
Nancy Baron
Natalie Bottle
Natalie Daniel
Natalie Ellis
Nathan P Lee
Nevenm
Nelson Abalos Jr.
Nem Simeunovic
Nic Neidenbach
Nicholas Goll
Nicholas Lapeyrouse
Nicholas Sim
Nicholas St Gabriel
Nick Andrzejewski
Nick Giesbrecht
Nina Lynn
Noelle Paduan
Noor Dawod
Oliver Holmes
Oliver Le
Owen Day
Pat Loika
Patrick Dugan
PixieRay
Project-Nerd
PurpleFaceMcgee
Quang
Rachel
Rachel Carner
Ramon Sosongco Jr
Raymond Fuller
Rebecca Gulick
Rebecca Wheaton

Rene Foley
Ricardo Alberto Vazquez-Jacal
Rich Grimes
Richard Abreu
Richard Simpson
Richard Spaziano
Rob Dunlop
Rob Gardner
Rob Wynne
Robert Cooper
Robert E. Stutts
Robert M. Donatiello
Robert Thompson
Robin Ramkissoon
Roger
Rosia
Ruby
Russ Matthews
Ryan A Eckles
Ryan DeFusco
Ryuwho
S. Joe Walters
Samantha Ghormley
Samantha Voccia
Sammy Ng
Sandra Smiley
Saori Suzuki
Sara Pintilie
Sara Verches
Sarah
Sarah Elizabeth
Sarah Strachn
Schuenator
Scott MacQuarrie
Scott Stratten
Seamus den Hollander
Sean O'Connor
Sebastian Steeb
Selina Cox
Seth Larson
Seth Stallknecht
Shanna Marie Tucker
Shannon Flowers
Shannon McPhee
Sharayah Lucas
Shawn Marier
Shelly Rodriguez
Shirley Saunders
Sidney Dorsey
Skylar Urbaniak
Spencer King
Spring Holbrook
Steevin Love
Stephanie Chow
Stephanie Coker-Putman
Stephanie Lalonde
Stephanie Nelson
Stephen Douge
Stephen Furois
Stephen Nguyen
Steven Rosendahl
Steven Savage
Steven Suwatanapongched
Stevie Calabrese
Susan
Suzan Drew
Suzanne Smith
Sylvia Saxon
Tamara Swenson
Tami Tritz
Tara Cheung
Tekwych
Teresa O'Rourke
Terry Huber
Thi Pham
Thomas Bull
Thomas Saunders
Thontos
ThuThao Nguyen
Tiffany Nguy
Tim Vo
Timothy Quan
Tommie Boatwright
Tony Lavoie
Topher
Tora
Trey G
Tyler Conrad
Tyler Jackson
Tyler Lacroix
Valerie Timberlake
Victoria Hesner
Vitas Povilaitis
Vlada Bordewick
Wataru Maruyama
Weeaboo Workshops
Wesley J Crowther
Whitney
William Baughman
William Hong
Young Wang
Zabi De Barmon
Zoey dos Santos
Zox

Photography: Ejen Chuang
Designer: Juan Luis Garcia (www.juanluisgarcia.com)
Production: Nichole Montross and Eric Ng

Photography © 2015 Ejen Chuang
How Cosplay Can Change Lives © 2015 Liz Ohanesian (www.lizohanesian.com)
To Be Like Others Is To Be More Like Ourselves ©2015 Andrea Letamendi Ph.D

Published by
optiknerve
453 Spring St. Suite #1001
Los Angeles, CA 90013

ISBN-10 : 0-9961295-0-2
ISBN-13 : 978-0-9961295-0-3

First edition 2015

Printed and bound in China

10 9 8 7 6 5 4 3 2 1